Charles Harrison
Looking Back

Charles Harrison
Looking Back

Ridinghouse

Contents

Foreword

I have had it in mind over recent months to issue a body of material in a more informal vein than the art-historical and art-critical studies I have published previously. The idea for such a publication was provoked by transcripts of a number of interviews conducted with me during the past few years by people who had their own reasons for seeking information about such things as the journal *Studio International* during the period of Peter Townsend's distinguished editorship in the late 1960s and early 1970s, for some of which time I worked as his assistant; the exhibition *When Attitudes Become Form*, which I was responsible for installing in its London showing at the ICA in 1969 and my relations with the artistic practice Art & Language, with which I have been continuously associated since 1970. My custom with these interviews has been to work over the transcripts before returning them with my agreement to their being used for purposes of quotation, while retaining an element of copyright.

In putting together the following collection, I have treated this material in a relatively cavalier fashion. I have cut sections to avoid overlap, except where a degree of repetition was necessary to maintain the flow of conversation; I have added small amounts of text where I thought there was more to say; I have moved whole sections around – sometimes between different interviews – in order to provide a measure of continuity in the discussion of different topics; and in some cases I have slightly modified the interviewers' contributions so as to fit them better into the flow of text, although I have drawn the line at inventing questions for them to ask or contributions for them to make. I am deeply indebted to those interviewers, not only for supplying me with the original transcripts, but for consenting to the use I have made of them. They are as follows:

Jo Melvin, who conducted two interviews with me in 2008, with a primary interest in *Studio International* and my relations with Peter Townsend, but whose concerns ranged widely over the conditions of art at the time.

Teresa Gleadowe and Pablo Lafuente of *Afterall*, whose initial interest was in the curating of avant-garde exhibitions in the late 1960s, but whose long interview conducted in 2008 ranged widely over my own early relations with artists of my generation and the problems I experienced in writing about and exhibiting their work.

Juliette Rizzi, whose interview was also conducted in 2008, when she was doing graduate work on the exhibition *When Attitudes Become Form*.

The late Sophie Richard, whose interview with me was conducted in May 2003 when she was doing research into the international network of Conceptual artists in the decade 1967–77. Since this is printed in her *Unconcealed*, posthumously published by Ridinghouse in 2009, I have been sparing in my use of this material.

Elena Crippa, of the Lisson Gallery, who interviewed me about my relations with Art & Language in January 2010.

Christopher Heuer of the University of Princeton and Matthew Jesse Jackson of the University of Chicago, who were commissioned in 2007 by Ginger Wolfe-Suarez to conduct a discussion with me by e-mail for publication in the Californian journal *InterReview*, of which she is editor. This is the only text that appears here largely untransformed, and I am grateful to all concerned for their consent to its republication.

I hope that the material presented in this volume will provide those interested with some informative detail and relevant speculation regarding a crucial period in the art of the twentieth century: that moment in the late 1960s and early 1970s that saw a crisis of modernism in theory and in practice, the emergence of a truly international avant-garde and the establishment of the original Conceptual art movement. I also hope that it will prove informative about the nature of my collaborative relationship with the practice of Art & Language – at least as I have understood it.

Charles Harrison
July 2009

Introduction:
Democratise Access to Dialogue

Jo Melvin

Visual culture, art history and the critical issues arising from questions of
judgement were the driving forces behind Charles Harrison's practice as
a writer, teacher and art historian. These three strands were interlinked
through his determination to render the highest instances of cultural
endeavour transparent and tangible to as many people as possible. His
output as an art historian and teacher was prolific, and yet he was as close
to a practitioner as an art historian or teacher can get. Not only did he
make his own work, which – modest about its status or historical interest
– he kept private (see pp.115–16), but he fully participated in the complex
processes of making work through critical exchange with the artistic
collective Art & Language. As Michael Corris has said:

> Harrison's work as a member of Art & Language defies the ordinary
> boundary conditions of art history and art criticism as a discipline apart
> from the practice of art. His dialogical engagement in art is therefore both
> supremely informed by this practice and uniquely transformational of it.[1]

Harrison describes in the interviews that follow how his collaboration
with Art & Language began with the publication of 'A Very Abstract Con-
text' in *Studio International* (1970). According to Harrison it was 'a rather
silly article', 'an attempt to take my stand on behalf of Art & Language,
Joseph [Kosuth] and Victor Burgin'.[2] When it appeared in the magazine,
Art & Language's Terry Atkinson and Michael Baldwin told him, 'Your
article was a load of crap', and gave him a full page of criticism. Harrison,
who had been used to artists being more or less pleased with anything he
wrote in praise of their work, said that his immediate thought was, 'These

are people I can really learn from and with.' This marked the first moment of a practice of exchange that continued until Harrison's death in August 2009. He saw collaboration – close, intense work on a shared venture – as one of life's greatest pleasures.

From 1966 to 1971, Harrison worked in the offices of *Studio International* as assistant editor. In 1971, when he found that this role conflicted with his position as editor of *Art Language* journal, he loosened ties to *Studio International*, but remained as a contributing editor. During this period, he taught at art colleges, in particular St Martin's School of Art, and History of Art departments at various universities, such as the University of East Anglia. From 1974 until his appointment to the Open University, where he was instrumental in establishing the rigorous History of Art course, he taught the subject to foundation students at Watford Art College. Several years after he had left, as a student at Watford Art College I remember hearing intriguing stories about the art-history lecturer who had been so committed to his students that he had hired a van to drive a group to their art college interviews.

Harrison was surprised that his experiences and recollections, as well as his archive, might have a critical and historical interest, aside from the pertinence to his publications. He described visiting artists' studios with his camera and explained that in exhibitions he would take photographs of the works installed. When he was in studios he avoided portraits, concentrating on the works in situ. I asked whether this decision was a matter of principle and he acknowledged that, on reflection, it seemed an important factor to record the artwork unencumbered by the artist's presence. When visiting Jeremy Moon for instance, he took slides of his paintings as they hung; in consequence Harrison amassed an extensive slide library which he used for lectures and publications. When preparing this volume he selected slides from the exhibitions he had curated and the studios which he visited taking great care to mark the location for each image within the text to illustrate the conversation. Some of these he had used in lectures, like the view of Greenberg's apartment in Central Park West, New York, but many have not been seen before.

Harrison donated some of his substantial archive to the Tate Gallery in 1981. This important research asset documents the shifts in art practice during the 1960s. There is correspondence with artists, writers, editors, curators, teachers and students, as well as material relating to the

exhibitions he organised between 1969 and 1971. These include the Ben Nicholson retrospective at the Tate Gallery (1969), the London showing of *When Attitudes Become Form* at the ICA (1969); *Idea Structures* at the Camden Arts Centre (1970); *Art as Idea from England* at CAYC, Buenos Aires (1971) and *The British Avant Garde* at the New York Cultural Center (1971). These exhibitions subsequently acquired an increasing relevance in determining notions of curatorial strategy as well as the analysis of individual artworks. The catalogues of *Idea Structures* and *Art as Idea* are design classics, and they are illustrated in this volume along with other magazine, catalogue and book covers that were important to Harrison. The installation and the selection of works shown in these four exhibitions have become seminal research referents for artists, art writers, critics and historians.[3] That Harrison did not necessarily agree with these assessments can be seen from the frustration he expresses in the interviews that follow, and the questions he raises about strategy, inclusion and the collaborative nature of putting on exhibitions.

In 2008, Tate acquired the remainder of Harrison's archive: correspondence excluded from the original selection, his slide library and other materials from the subsequent thirty or more years. These include drafts of texts, often annotated by other members of Art & Language, postcards, used as source material and for teaching purposes, diaries from the 1960s to the 2000s, and correspondence with the Conceptual artist Joseph Kosuth, with whom Harrison entered into a brief ideological exchange. Their intense but short-lived friendship is recorded, with discussion of aesthetics, politics and their personal lives.[4] When Harrison met Kosuth on his first trip to New York in 1969, the artist was searching for a suitable vehicle in which to publish his essay, 'Art after Philosophy'. Convinced that it was a significant text and that publishing it might help secure a different type of reader for *Studio International*, and would certainly raise the stakes for the magazine's radical approach, Harrison provided the outlet. This vision for the magazine accorded with the strategies of its editor, Peter Townsend, who wished to give his assistant editors some autonomy in order to promote discussion. He was also a supporter of radical policies in the arts, new practices and young artists. Although Townsend was dismayed by the 7,000-word text which he ended up running over three issues – the fact that he published it without cuts stands as a testimony to his confidence in Harrison's judgement. It should be pointed out that

despite Kosuth's participation in *When Attitudes Become Form* at the ICA in 1969, he was virtually unknown in the UK at the time.[5] His essay has since been reprinted in numerous anthologies, including Harrison's *Art in Theory 1900–1990*, co-edited with Paul Wood, and is frequently discussed by art students today. The three-volume compilation of writings about art, *Art in Theory* (1992), a massive undertaking, demonstrates the spirit of generosity with which Harrison approached writing and teaching. His aim to democratise access to dialogue and information without a compromise in standards also shines through in his dedication to the ethos of the Open University.

In *Painting the Difference: Sex and the Spectacle in Modern Art*, published in 2005, Harrison explored gender representation in the Modernist canon and its relevance in contemporary anxieties. He showed how dilemmas about gender and identity surface on the picture plane as a site of self-critical exchanges. The book draws the viewer to reflect on his or her own perceptual responsibilities, highlighting the danger of using terms such as 'culture' and 'judgement' when interpreting art. Harrison was unabashed by relativism and fervently endorsed the need to separate what he described as 'junk' from good or interesting work. He applied this differentiation within all art movements and was determined to get his readers and students to make such distinctions.

Partly as a consequence of the group of interviews brought together here, which involved *looking back*, often through entertaining storytelling, Harrison thought of writing a book that would include the gossip, recollections, anecdotes and asides that poignantly encapsulate a moment. These anecdotes are generally left out of historical texts and movement overviews, but they personalise the events, and sometimes mark the 'notional' beginning of a movement. After all, it can be argued, understanding the context of a movement is only possible in retrospect and personal histories help to identify shared aims, ideological concerns and artistic intentions. Instead of a book of gossip, Harrison decided to allow the conversational informality of the interviews to do the talking. These conversations revisit exhibitions and collaborations made during his long career, many of which have become key to the fabric of recent history. His personal accounts provide a way of narrating art history that weaves personal recollection with historical analysis. 'The history of art is conventionally told as a history of triumphs of the will', he once

wrote. 'There is another history to be thought: a history of unredeemed incompetence, of unpainted and unpaintable pictures, a history of the wasted and unauthentic, the abandoned and destroyed.'[6] When he drew attention to this alternative reading of history, he opened up the possibility of a discursive enquiry, a conversational approach similar to teaching, where the goal was focused thinking through collaboration. In this context, analysis of the over-looked failure is not speculation or gossip leading nowhere, but the point when anecdote becomes crucial to the reconsideration of events.

The problem of recollection and memory when *looking back* at historical events was a concern that Harrison raised in conversation with characteristic wry self-deprecation. Like the American art critic Lucy Lippard, one of his friends in the 1960s and 1970s, he was suspicious of retrospective self-aggrandisement. He might well have agreed with Lippard's remark about the arguments over ownership of Conceptual art definitions:

> There has been a lot of bickering about what Conceptual art is/was; who began it; who did what when with it; what its goals, philosophy, and politics were and might have been. I was there but I don't trust my memory. I don't trust anyone else's either. And I trust even less the authoritative overviews by those who were not there.[7]

He was certainly irritated by the use of the term 'Conceptual art' as a generic catch-all for avant-garde art. Conceptual art, he emphasised, was one very specific component of various radical tendencies that emerged simultaneously to address the crisis in modernism, particularly in modernist painting; including Earth art, Arte Povera, Installation art, Performance art and Process art, all of which challenged assumptions about what defined art.

In lectures and conversations he often told a story about a review he wrote of a Morris Louis exhibition at Waddington Galleries in April 1969. The article was published in that month's issue of *Studio International*. This occasion marked a turning point in his interests and it was simultaneous with his first trip to New York. In a lecture at the Tate Gallery in 1986 he said that when he saw the Louis show in London he was still under Greenberg's influence and commitment to formalist concerns, 'driven by

an unfulfilled ambition to be an intellectual art critic'; he stood in front of the paintings and 'emptied his mind of contingencies' and 'waited for the earth to move'. In doing so, he found a way to combine formal analysis with value judgements in accordance with the responsibility of the art critic to essentially look and discuss for others. On this first New York visit, Harrison told Clement Greenberg that seeing Carl Andre's work, *144 sheets of copper* at Dwan Gallery had impressed him 'for reasons he could not understand'. Greenberg had read Harrison's article on Louis in *Studio International* and could not fathom how Harrison could write with clarity about Louis and at the same time be interested in Andre, whom he dismissed as a trivial artist. To restore Harrison's critical faculties Greenberg suggested he visit the Louis exhibition at the André Emmerich Gallery. Harrison found the experience of Louis's *Veil Paintings* in New York unsettling and alienating. Later, in lectures, he described how he could not see the works as art at all and that far from serving as vehicles and expressions of feeling – they had the aspect of 'wallpaper money'. Whilst questioning the work, he saw his review prominently displayed. Harrison's recollection of this event combined with a publically revised attitude of Louis's work, illustrates the difficulty associated with making public judgements and criticism. He often said he 'did his growing up in public'.

Artist's interviews as critical phenomena was an arena of interest that came to prominence at the time when Harrison most directly engaged with art criticism as the assistant editor of *Studio International*. Instead of the critic being a mouthpiece or mediator, art writing began to focus on the artist's voice as a measure of authenticity in the discussion of his or her work, either through interviews or the artist's writing, or, as in the case of *Studio International*, to 'artist's pages'. This term was used by the editorial office to describe spreads given over to artists to treat as they wished with minimal editorial intervention. In the September 1967 issue, for example, Harrison was responsible for the section on the British artists selected for the Biennale des Jeunes in Paris. He asked the artists Mark Boyle, Barry Flanagan, Jeremy Moon, Michael Sandle, Colin Self, Ian Stephenson and John Furnival to provide brief biographies and gave them two pages apiece to design the layout with photographs and statements.[8] The decision was notable because traditionally the critic would be expected to provide interpretation of the artist's work for the reader. It also marked a shift towards thinking about magazines as sites akin to exhibition spaces.

This trend was part of a general move towards artists taking control over the viewing conditions of their work in artist-run galleries, or in spaces outside the mainstream gallery system, as well as artist-organised studios, and information services like the Artists' Information Registry (AIR) and SPACE.[9]

Harrison's last book, *An Introduction to Art*, was a project he had had in mind for years before he completed it in the summer of 2009. Conversationally direct, it takes the reader on a journey through museums and galleries, striking a balance between historical context and aesthetics. It is as close as one can get to being with Harrison in a gallery, looking and thinking. I, for one, often look back at a conversation we had in the Kunsthistorisches Museum, Vienna in front of a painting by Bruegel, *The Peasant and the Nest Robber* (c.1525/30). Here, the peasant points at the nest robber up in the tree behind him. Walking towards the viewer, the peasant is poised to step into a ditch in the foreground, out of the painting into the gulf between the viewer and the work. Closing this gap between the viewer and the art work was one of Harrison's principal concerns as a teacher and historian, encouraging the kind of looking and perception that leads to discourse. The interviews in *Looking Back* allow us access to the experiences, the approach and the vision of this key figure in the history of late twentieth-century art in Britain.

1 Michael Corris, 'Charles Harrison tribute', Open University website, posted August 2009.
2 Charles Harrison, 'A Very Abstract Context', *Studio International*, vol.180, no.927, November 1970, pp.194–98.
3 Charles Harrison, Tate Gallery Archive 839.
4 Charles Harrison papers, uncatalogued, Tate Gallery Archive 200826.
5 Joseph Kosuth, 'Art After Philosophy', *Studio International*, vol.178, no.915, October 1969, pp.134–37; 'Art After Philosophy' part 2, *Studio International*, vol.178, no.916, November 1969, pp.160–61; 'Art After Philosophy' part 3, *Studio International*, vol.178, no.917, December 1969, pp.212–13.
6 Charles Harrison, *Essays on Art & Language*, MIT, Cambridge, Mass/London, 2001, p.180 and Tate Gallery Archive 200826.
7 Lucy Lippard, 'Escape Attempts', *Six Years: The Dematerialisation of the Art Object from 1966 to 1972*, University of California Press, Berkeley, 1997, p.vii.
8 *Studio International*, vol.174, no.892, September 1967, pp.85–99.
9 SPACE, which provides affordable artist studios in industrial areas in London, stands for space, provision, artist, cultural and educational.

Conversation One

Jo Melvin | March 2007

JM: *I wonder if we could start off with when you first met Peter Townsend. I presume it was through Alan Bowness, since I know Peter wrote to him requesting his recommendations for an assistant editor. How did the process go? Did Bowness approach you?*

CH: I was a graduate student at the Courtauld Institute and Alan was my supervisor – strange use of the word, since I virtually had no supervision at all. I was in the process of applying for teaching jobs in universities. I had this mission: that what I was going to do was put right what I hadn't got at the Courtauld, which was intellectual, serious teaching about up-to-date modern art. This was what I wanted to do. I applied for jobs in various universities and was failing to get one after another. And through Alan – I guess, with the benefit of hindsight, as a bit of a try-out – I was commissioned to do a couple of exhibition reviews for *Studio International*; one was on Gauguin and Pont-Aven, the other on Roger Fry and *Vision and Design*. This was in early 1966. I met Peter, who I liked. He struck me as a gentleman professional editor. Following that, Alan said that Peter was looking for an assistant editor and asked if I was interested. I said no, because obviously that was journalism and I wanted a serious academic career. And I drove away from the Courtauld – I was living in Islington at the time – got half-way back and thought, 'That's mad!' So as soon as I got home, I phoned Alan up and said, 'Yes I'd love the job'. I then met Peter to agree terms.

JM: *Was it all verbal?*

CH: All verbal. Two days a week for £400 a year, to include contributions. (I think it had risen to £500 by the time I left.) There was the expectation that I would provide a certain number of articles, and okay, Peter didn't have a lot of resources to play with, but it was exploitation money even then. On the other hand, I was dithering about, making a pig's ear of doing research. I mean, I had no idea what I was doing, and was working without any real guidance. I was spending time in the basement at the Courtauld, copying out entries from catalogues, and thinking, 'Is this research?' – rather than getting out and talking to people, which I enjoyed. I was really floundering. As you may know, it's quite hard to get yourself practically working under those circumstances. The thing with the *Studio* job was that I knew what I was doing. I could go in to work, there was an office in Museum Street, there was stuff to do and it was practical and I loved it. And so I threw myself into it and worked much more than two days a week while trying to keep myself alive by part-time teaching wherever I could get it, in art schools and universities, doing bits and pieces.

JM: *In that early phase in 1966 up to 1967, when you became assistant editor, did you have a lot of discussions in the pub about which exhibitions should be covered and how they should be covered?*

CH: Yes, a lot. As you know, Peter liked talking and he liked drinking, and so did I. I was lucky to get out of *Studio* without becoming a complete alcoholic. So yes, a lot of discussions took place there. This is for me the difficult, slightly grey area. It's hard to be sure I'm being straight in retrospect, trying to remember what my relations with Peter were like in the beginning: on the one hand not to sentimentalise that retrospective view, and on the other hand not to let it be too much coloured by the fact that we drifted quite a long way apart at a certain point later. I'll try and be as straight as I can about it. Everybody sentimentalises the excitement of their first working years, I suppose.

JM: *How did you feel about the responsibility for covering exhibitions and making critical commentaries on people's work?*

CH: One of the things I find difficult when talking about *Studio* is that there are a lot of people of my generation – in my bit of the avant-garde,

as it were – who talk about *Studio* and look back at the years around 1967–72 as the period when I had a determining influence over it. And that's not quite right. It wasn't the case. It's just that they simply identified with me because I identified with them – I think. On the other hand, I've also seen retrospectives on *Studio* – particularly obituaries of Peter – where I appear to have played no part in what was going on whatsoever – and that's false too. To start with I more or less did as I was told. But I guess I've never been very tolerant of indifferent art, and the more I found my feet the more I wanted to make my own judgements count. So I pushed harder for a say in what got covered and commented on. Making critical commentaries was fine. It was what I wanted to do. But I didn't want to have to be polite about stuff that I didn't like. Looking back in the calmer light of hindsight, I'd have to say that Peter generally responded to my enthusiasms – that he listened to them and maybe took some advantage from them – but that I rarely, if ever, got my way when I wanted to keep something out of the magazine, and of course, there was a lot that I didn't identify with at all.

JM: *Could you tell me about the Mondrian issue of December 1966? You wrote letters to quite a few people: Barbara Hepworth, Ben and Winifred Nicholson...*

CH: I was doing my graduate research on British art between the wars, which meant I spent some time talking to Ben and Winifred Nicholson and anybody I could get hold of who was surviving from that period. So I knew a certain amount about all that – about Mondrian's contacts in England, where his paintings had been and where he'd been and so on. I can't remember whose suggestion it was – whether it was Peter's or mine – that I act as editor for that section.

JM: *Was that your first major editorial role? It was the first one that I've seen where you were making editorial decisions.*

CH: Well, if I could go through the copies I could tell you, but I disposed of all my copies some time ago to an archive, to my regret. That could be right. I became a sort of de facto assistant editor in 1966. I wasn't named on the masthead, partly because I still received a grant for my research, which meant that I couldn't appear too obviously to have a job. I think I officially became assistant editor in 1967, but I was working in the office before that.

JM: *That's what I thought, and you've cleared something up for me. You appear on the masthead in October 1967, but there are lots of covering notes that are addressed to you before this, so you were obviously involved in receiving articles.*

CH: I was doing a lot of things, sub-editing and so on. I had overall responsibility for the book-review supplements – commissioning reviews and subbing them when they came in, and writing short reviews of stuff that we didn't want to send out to others. One of the great things I owe to Peter is that he taught me the pack of skills and requirements of a sub-editor. One of the things I always esteemed most about Peter was the sheer in-the-office professionalism, the nuts and bolts of editing. The first thing I did when I was offered the job was to go out and buy the British Standards Institute guide to proof-reading and learn how to be a proper proof-reader – which I am. I'm a good proof-reader. I've always been grateful for that time I spent. I've depended on those competences for most of the rest of my life, one way or another, especially as an editor of my own writing, and in work with Art & Language. And so I was doing that kind of work in the office, subbing articles and so on, more or less from the start – and spending a lot more than two days on it. I was doing a certain amount of legwork too: going round galleries, going to openings, contacting artists and so forth. Talking about editorial responsibility: the major thing for me, the most influential, or rather most formative bit of editorial work I did at the beginning of my time with *Studio*, was on the issue of September 1967, which covered the British representation at the Biennale des Jeunes in Paris. For that, my job was to contact each of the artists, to talk with them about their presentation and organise it and so on. Those involved were Colin Self, John Furnival, the concrete poet (whose work I found uninteresting), Jeremy Moon and Barry Flanagan, who both became very close friends, more or less immediately.

JM: *Did you know them before?*

CH: No. I liked them both very much. Jeremy remained a friend until his early death and Barry for a long time was a very close friend. Funnily enough, I saw him again quite recently for the first time for nearly 30 years. I was very pleased to renew the acquaintance. As he remarked to somebody else (so I was told), 'Charles seemed to like me until I started to do the

Jeremy Moon, *Untitled (16/67)*, 1967, installed at the artist's studio, Kingston-upon-Thames

Barry Flanagan, *4 casb*, installed for photography, 1967

hares.' He was more or less right about that.

JM: *At that time the contributing editors listed were Jean Clay, Dore Ashton and Frank Whitford, who was also at the Courtauld.*

CH: Jean Clay never put in any kind of appearance, as far as I remember. I don't think I met him.

JM: *So he appeared in name only?*

CH: Yes. Ashton was there basically as the American contact, but other than that she played no part at all. She, I know, felt very bitter towards me because she thought it was me who virtually ousted her from the magazine.

JM: *I saw Dore Ashton in New York a couple of years ago, and she made that claim about you and I said, 'There's no evidence for this', because throughout this period, while you were assistant editor, she continued to write for the magazine, and so I couldn't understand where this idea came from.*

CH: Well, I met her years later and tried to correct this. There is an element of justification in her view. Two things: one, I never thought her writing was very interesting and I thought if we were going to have a regular correspondent in New York, we could do a lot better than Dore Ashton. She was a respectable senior figure, with great contacts and so on, but obviously I was a young man at the time and she seemed like a boring middle-aged figure to me. At a time when there was a lot of exciting art being produced in New York, she didn't seem to have much of a handle on it. So I certainly felt that she wasn't doing the magazine a lot of good. That's typical of the kind of disagreement that I had with Peter. We can talk more about that. It'll come up again. It was inevitable given the differences in ages. But the other possible explanation for Ashton's view is the fact that she was teaching, I think, at the School of Visual Arts – as was Joseph Kosuth, whom I met in New York in the spring of 1969. Joseph and I became very close. He more or less latched on to me. Well, we latched on to each other, in a way. And he organised for me to give a couple of lectures in the School of Visual Arts, I think the following autumn. Maybe it was

actually Ashton who facilitated that. I can't quite remember exactly how it worked out. But I do know that she and Joseph were at loggerheads. She couldn't stand Kosuth – quite understandably, given the benefit of hindsight. And I think she saw me as having, sort of, sided with him, and perhaps as having been influenced by him to try and get her out of *Studio*. That's not quite right, but I can understand why she might have thought it. In fact, Joseph and I had fallen out before her ties with *Studio* were finally dissolved. So that's a bit of background. I never actually conspired to get her out of the magazine.

JM: *There's no evidence of it from looking in the archive, as I said to her; she continued to contribute copy. But maybe there was an element there that was related to her friend Mel Bochner, because he had a major issue with you over his sheets of graph paper in* When Attitudes Become Form.

CH: Yes, he blew it up into a major issue. As far as I remember, he complained that a couple of the sheets of paper in his exhibit for the London showing of *When Attitudes Become Form*, which I curated, had been defaced by what he called 'mindless wielders of magic markers' – or words to that effect. The work was 13 *sheets of graph paper from an infinite series* (1969). His complaint was made in the form of a letter to *Studio* – rather than to the ICA, which was the institution responsible. When his letter was printed, I think I appended a comment more or less dismissing the complaint.

JM: *He blew it up into such a major issue that he refused any kind of contact after that with Peter. He had liked Peter very much and he felt that he was a good friend, so then he felt that Peter had betrayed him.*

CH: Really? I didn't know that. And I'd be surprised if Bochner knew Peter well at all at that point. I thought it had all been relatively light-hearted – which is all it deserved to be.

JM: *Well absolutely, of course.*

CH: He made some pompous comment about the value of art not being related to the work involved. I just thought he was pretending to be upset.

He couldn't have it both ways. A piece of paper is a piece of paper, and if what you're exhibiting is a dozen or so sheets from an infinite series, there shouldn't be a problem in replacing one or two if someone scribbles on them. If you're going to get po-faced about it being a piece of paper, where's your radicalism? I only met Bochner once, very briefly, but he struck me as a bit self-regarding, which serious artists are usually not.

JM: *Did you meet him at the ICA?*

CH: No, I think it was at the School of Visual Arts. I'm not sure, but again, the ghost in that particular situation was probably Kosuth. Dore Ashton liked and was on friendly terms with Bochner. Bochner saw himself as Joseph Kosuth's teacher and Joseph wasn't going to have anybody claiming the status of teacher over him. Bochner thought Joseph had ripped him off, so Joseph characterised Bochner as some boring played-out teacher who was pretending to be a Conceptual artist. So that situation was set up long before anything happened with the work in the ICA. When Bochner wrote that letter to *Studio* it appeared to me to confirm the picture of him that Joseph had been trying to put over. I might have been a bit politer in my response had I not already been prepared by one of my close friends. Joseph was in fact delighted. So if that issue continued to simmer in New York, it probably had as much to do with the politics of relationships at the School of Visual Arts as it had to do with *Studio*. As you probably realise, a lot of the apparent controversies that washed up on the shores of *Studio International* had their origins in the New York art world. That was very much the case with the Minimal art issue in the spring of 1969, when what effectively happened was that Barbara Reise exported certain kinds of New York infighting into *Studio*, to *Studio's* benefit. We sort of knew we were doing that. It was strategic.

JM: *Do you remember the occasion when Barbara Reise arrived in the offices?*

CH: I can't remember when Barbara turned up at *Studio*. Maybe in 1968. She came as a graduate student working on Turner. And she came with connections with the New York art world. That was her currency, particularly her contacts with Barnett Newman and with some of the Minimalists. The other thing – the other currency she had – was that

early antagonism to Clement Greenberg. That again was currency in the New York art world, but had not yet really become so in England. Barbara bought herself increased currency in the New York art world with the publication of that article 'Greenberg and the Group', which appeared in two parts in *Studio*.[1] It has attained a retrospective status as an early attack on Greenberg. It's actually awful. It's easy, it's cheap, it's not very substantial.

JM: *But it got people talking.*

CH: Yes it did. And it was really that more than anything else that persuaded the American Minimalists to contribute to *Studio*'s special issue on their work. It provided them with a European platform outside the controlling patterns of the New York art world.

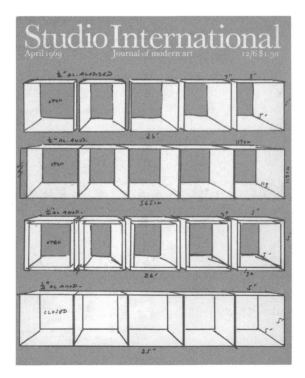

Cover: *Studio International*, vol.177, no.910, April 1969

JM: *Barbara would have had a bit of a job getting it published in the States. Interesting that it was in* Studio *and not* Art International.

CH: Yes. And it was partly that initiative that led to the special issue of *Studio* dedicated to the Minimalists in the spring of 1969. They felt that they had a position from which to fire back at Greenberg and Michael Fried; especially Donald Judd with his 'Complaints Part 1'. But it's significant that when he published the second part of his 'Complaints', he did so in the States and didn't offer it to *Studio*. It was very much a one-off.

JM: *Yes, strategic. Barbara's article actually pushed Philip Leider [editor of Artforum] into writing to Peter. He was incensed about it. He wrote on two counts: first to say how impressed he was with the magazine, and he listed various things; secondly in relation to the Reise article – which he considered to be insubstantial – he thought a critic had to earn the right to take a swipe at Greenberg.*

CH: I'd forgotten that. I have a vague memory of Peter feeling a bit iffy about it – as though he was suspicious of Leider's motives, or was damned well not going to be patronised by him or told what he could and couldn't do in his own magazine. On the question of the connections between Leider and Peter and *Artforum* and *Studio*, I have things to say, but I don't know whether you want to get into that.

JM: *I would like to, yes.*

CH: I have to get a bit personal. My ambition at the time – a quixotic ambition – was to be a serious art critic. And I was incredibly envious of *Artforum* and the sense that there was substantial modern-art history being published in the States. There were serious debates going on. The artists were engaged with the magazine, the magazine was engaged with the artists, and there was clearly a cosmopolitan, vital, aggressive art world over there. I wanted a piece of it. I wanted two things: I wanted a piece of it and I wanted to import as much of it as possible into England. Anyone who is seriously involved in art in England wants to overcome the provincialism of the local scene, of course. And I did very much. One of my ways of responding to that kind of ambition was to try when there were shows of

American artists in London – at Kasmin's or at Waddington's or wherever – to get the job of reviewing them. I wanted to write about people I might have spent some time talking about with artist friends. I reviewed shows by Kenneth Noland and Jules Olitski, both central to the American modernist canon at the time – strongly supported by Greenberg and Michael Fried. In doing so, I attracted the attention of a few people in the States, first of all John Coplans, who was then a co-editor – or co-founder actually – of *Artforum*. He sent me a telegram offering me a job at the Pasadena Art Museum, which was then expanding, combined with a position as a West Coast assistant editor or associate editor of *Artforum*, with a fast track to a job at the Modern [Museum of Modern Art] in New York. 'Come out here and make your career and don't make any visa applications until you hear from me again.' I cabled him back saying I was very flattered by the attention and I'd love to come over for a month, but I had friends in England and so on. He sent me back a fulminating thing, saying 'I'm offering to make your career for you here, where all the major artists are; why do you want to stay in that little shit-hole England?' – or words to that effect. And I sent one back saying 'Sod Off'. So that was the end of that. (An aside to that: they wrote to John Elderfield instead.) But the other thing that happened was I got a very nice letter from Leider saying he was interested in Phillip King's work, and would I write an article on it? It was a very nice letter. (It may be in the Tate archive, where I deposited some papers in the early 1980s.) Leider was a great editor.

Part of the whole strategy of approaching me, I now realise, was to do with a sense that something was happening at *Studio*. But I think more generally it was that the American modernists wanted a more direct route into the English New Generation. It was connected to the idea that the Americans had had the modernist painters and the British were now going to be allowed to have the sculptors. And so Leider commissioned an article by me on Phillip King, which *Artforum* published in December 1968. It paid for me to visit New York for the first time. The ICA was offering a deal on a two-week charter flight. I went to New York in the spring of 1969, taking with me a further article on Roland Brener, who was then working at Stockwell Depot. That followed from a piece I'd done for the January 1969 issue of *Studio* called 'Some Recent Sculpture in Britain' on Flanagan, Richard Long, Roelof Louw, Bruce McLean and Brener. I'd offered Leider a piece on Long, but it was Brener that had caught his eye – a rare case of

failure of judgement on his part. I took the article with me to New York, and I met Leider and Michael Fried at *Artforum*'s offices.

JM: *Was it when the Manet issue came out, and did that give you cause for thought?*[2]

CH: I think the Manet issue came out just after. I think I remember Philip Leider and Michael Fried talking about the Manet issue in the office, but that could just be a reconstruction. You asked whether that particular issue gave me cause for thought. It wasn't that one. The issue that really woke me up was the summer 1967 *Artforum* – the one that included Michael Fried's 'Art & Objecthood', LeWitt's 'Paragraphs on Conceptual Art', one of Robert Morris's 'Notes on Sculpture', all that stuff, the Minimalists and so on. Reading that, I just felt so jealous, because here was this sense of a real, serious controversy – of different sides engaged in a major battle. And it just was not like that in London. And I wanted to be in the middle of that... I didn't want to be on the provincial fringes. I felt so jealous of that sense of engagement and commitment. That was the call that woke me up. And a lot of other people too, I think. You need to remember that no Minimal art

Work by Roland Brener installed at Stockwell Depot, 1968

Cover: *Artforum*, Summer 1967

was to be shown in England for another two years.

Given that New York was the centre of things at the time, it was within the critical discourse of New York that I wanted to try and make my own voice heard. So of course I wanted to be published in America – and particularly by *Artforum*. But in Peter's eyes that was like working for the competition. I think he wanted me firmly identified with *Studio* and he made it pretty clear that he didn't fancy me publishing too much in other magazines. On the other hand, I was supposed to be an assistant editor and there were limits to the amount of editorial space I could be given for articles under my own name. I felt increasingly frustrated by this situation. It was difficult. I really was committed to *Studio*, but I didn't want to be contained by it.

JM: *There's quite a lot of documentation to be found in Peter's writing, about his concern to clarify certain points about what was happening in the magazine and regarding your position as assistant editor, as if he was hoping to keep you.*

CH: Really? I'm surprised. Who was he writing to?

JM: *Do you remember those little red notebooks? It was in them – it was personal. There's no documentation in terms of letters that you sent to Peter at that time. There's a letter sent much later that perhaps brings up similar or related issues, when there was a by-line added to your Art & Language piece that says something like 'This is the background to the Art & Language group.' It's two or three lines. It says your piece is a contextual background to what the group was doing. And you sent a letter to Peter saying 'In no way is this piece a contextual background; this is what it is, and take out that stupid by-line and make an apology for it.' This is after you were off the masthead, and there's no reply from Peter, and I wondered if you remembered the occasion? You were staying in Norwich and you wrote him a couple of letters.*

CH: Right. That would have been in 1972.

JM: *Yes, May or June 1972.*

CH: Was the piece called 'Art & Language Press'?

JM: *You make a comment about Art & Language as a holy cow and how it'll be interesting to see how the French will try to milk it.*

CH: Exactly. That's because the piece was originally published in France in L'Art Vivant in April. I don't remember writing that little note. It sounds very intemperate. But I know I was on my puritanical high horse at that point. I'd found my avant-garde as it were, which in a sense is what I'd always wanted since I was a teenager. I'd found that community of artists and intellects with whom I felt I could have a part to play, as a sort of mixture between companion and spokesman – a fantasy derived from a teenage reading of Apollinaire, I think.

JM: *That's very healthy.*

CH: Healthier than a teenage reading of Cocteau, who was the other one.

JM: *Probably.*

CH: My first meeting with Art & Language was when Terry Atkinson

Peter Hide, *Sculpture Number 2*, 1968, installed at Stockwell Depot, London, 1968

and Harold Hurrell came to *Studio* late in 1968 or early in 1969. I then
met Joseph Kosuth in New York in 1969. Immediately, we just got on. He
then introduced me to his contemporaries there – Seth Siegelaub, Lucy
Lippard, Robert Barry, Larry Weiner, Douglas Huebler, Carl Andre – that
generation of people, and I came back to England thinking, 'okay this
is mine, this is my generation', and desperate to find the equivalent in
England. I remember I looked through the gazetteer of English artists
published by the Artists Information Registry, just trying to find somebody
who looked as if they had the same kind of interests or preoccupations. I
found Victor Burgin and I just phoned him and I said, 'Your work sounds
interesting. Can I come and see you?' Vic had just come back from America
and was living in Greenwich and I think feeling fairly isolated and he was
completely astonished. But again, we just got on very well. And so I made a
friend. I also very quickly got involved with the rest of the Art & Language
group. And from that point on, I couldn't get close enough to that and
had an increasing difficulty with reconciling that commitment – to what
I felt was the international Conceptual avant-garde, as it were – with my
other connections and friendships that I'd made: the St Martin's New

Generation, the colour-field painters, the people at Stockwell Depot and the rest. There was conflict. It was quite interesting. (I know this is taking us away from *Studio*, but it's background.) I was teaching at St Martin's at the time, and there was a lot of paranoia there: 'What is Charles Harrison doing getting involved with these people who are trying to destroy art?' Tony Caro had asked me to do a catalogue introduction for him in 1967, but when I was asked to review his show at the Hayward in 1969, he wouldn't let me into his studio. He said 'If someone's going to write about my work they've got to really love it.' And I got called into Frank Martin's office at St Martin's – because I'd got Burgin and Joseph to come and talk there – and he said to me, 'What are you doing, infiltrating these people?' It was not altogether surprising. They were indeed setting fire to the temple.

JM: *Yes, like John Latham.*

CH: John, yes he still hasn't had anything like his due. I heard an interesting comment from somebody in America saying, 'Why doesn't somebody over here put together a joint Robert Rauschenberg and Latham show, so that everybody can see how much more interesting Latham is?' He's a much stronger artist. I think the imbalance needs to be corrected. Difficult as he was, Latham was a major figure.

JM: *He had a lot to say.*

CH: Yes certainly, and most of it very hard to follow.

JM: *There was a fair amount of coverage in* Studio.

CH: Yes. I did an interview with him in 1968.[3] It was recorded in a little cubby-hole I had at the *Studio* offices. I transcribed and edited it, then John went over it and added in bits and I think I gave it a final edit. It was printed with the title, 'Where does the Collision Happen?'. I think he was quite happy with it – certainly Barbara Steveni [John Latham's wife] was: 'My god, here's something that appears to make what John says make sense.' So I got slightly taken up by the Lathams and was drawn into meetings with the Artists' Placement Group.[4]

As I said, what happened was, there was increasing tension between

my involvement with Art & Language and my other commitments. And I worked as hard as I could to make *Studio International* a platform for the work of Art & Language and the rest of that generation, which Peter welcomed up to a point. But there was a lot of negative feedback, I think, from other people who saw this as threatening. I'd have to admit that Peter was quite right to be cautious. If the magazine was seen as unreadable – I mean in a way that an English audience was going to complain about but an American audience wouldn't have done – then it was going to affect advertising, circulation and so on. But as I say, I was an impatient young man, so I didn't want to listen to those kinds of arguments.

JM: *You saw them as spurious? You saw the commercial side as incompatible with your ideological position?*

CH: I wasn't quite that daft. But in situations where Peter would tell me, 'X exhibition's got to be covered and we need dependable copy in on time, so get onto Teddy Lucie-Smith', I'd tend to argue the toss. There was a lot of that, as you can imagine. But Peter had to bear the advertisers in mind, and I didn't have to. And there were other more personal things going on at the time, other sides to it. I became increasingly unhappy with the status of the potentially cosmopolitan exhibition organiser and critic. The harder it became to hold everything else together, the more my family life was falling apart, the nearer I was getting to a kind of alcoholic hysteria.

JM: *And working mania.*

CH: And working mania, trying to keep too many balls in the air. So some of that tends to show in some of my more intemperate responses to things like that by-line to the 'Art & Language Press' piece. That's more background than you want to a trivial note!

JM: *It's a small trace that leads towards understanding a much bigger picture. If we could just go back to New York and the spring of 1969 – the first time you met [dealer] Seth Siegelaub and [critic] Lucy Lippard and the others.*

CH: Yes. I was supposed to be meeting John Coplans, actually, at a Rauschenberg opening at Castelli's. Somebody had said Coplans had

a moustache, and I went up to this guy with a moustache, who was the strangest-looking bloke I'd seen for a long time, and I asked him if he was John Coplans. And he said, 'Am I John Coplans? Shit no! John Coplans is *ugly!*' And this was Seth. He has a nice turn of phrase.

JM: *Seth had relatively recently done the 25 Show that he'd organised with Dore Ashton and he said to me a while ago that working with Dore Ashton was immensely helpful because all kinds of people opened their doors who otherwise wouldn't have done. But you went over, later that year, in the autumn, and then in December there was that interview published, 'On Exhibitions and the World at Large' which it says in the magazine was done in September 1969. When I spoke to Seth about it he laughed and said, 'Yes it was an interview that wasn't an interview'. I looked at Alex Alberro's PhD on interlibrary loans and he'd footnoted that interview and said that you'd spoken to him about it. I wondered if you could fill me in on it.*

CH: Yes I can. I met Seth fairly briefly when I went over in the spring of 1969, through Joseph. Seth was then living with Lucy Lippard. I went back to New York in the autumn of 1969. I think I must have met Seth again in Europe, I can't remember where or how, but what I can remember is that I wanted to go back to New York again as soon as possible. Joseph and I corresponded and, for my sins, I'd commissioned 'Art after Philosophy' from him.[5] And so there was a lot of discussion with him over that, and I also corresponded with some of the other people. So I wanted to go back with my wife and small son. Seth offered us his apartment on Madison Avenue to stay in for free during September 1969, which was very generous of course. It was an apartment he kept because he had a son and it provided him with the right address for a good school, though he was living with Lucy down on Prince Street. So we had this very nice two-room apartment on Madison Avenue for free. It had one of Carl Andre's *Equivalents* in it, which my young son stomped up and down on so that it acquired a fringe of dust. There were works of Larry Weiner's – some early shaped paintings and a paint-spray on the floor – and some of Robert Barry's things there too. I remember a wire piece across one of the doorways. It was a great place to stay. But at a certain point Seth said, 'Well there's a pay-off' – he didn't put it quite like that, but almost – which was, 'I want you to do an interview with me and publish it in *Studio International*.' Basically this was

Seth establishing himself, and getting his position published. I felt a bit conned because it hadn't been disclosed, as it were, that there was a price. And at the same time I couldn't refuse. But I didn't like being used as the mouthpiece for a dealer, which effectively was what I was. So the interview was cooked up during this visit. Seth had his bits more or less already worked out. I was just supposed to supply the questions, and I wasn't very happy about being put in that position. So whenever that piece has been represented as an interview between Seth and me, and when I've been asked for permission to reproduce it, I've tended to say, 'Hang on, its Seth's property, not mine.'

JM: *That's very helpful clarification. In fact, you get a sense of it, reading the interview. When I first came across it, before I met Seth, a long time ago, there was something that felt instinctively quite uncomfortable about it. It seemed unquantifiable, the dialogue, in some way.*

CH: There was, and I'm glad it shows.

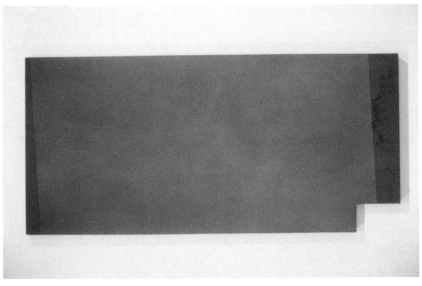

Lawrence Weiner, *Tiber*, 1967

JM: *When did Seth start to plan the July/August 1970 issue of Studio?*[6] *He writes a letter asking you to edit a section early in 1970.*

CH: I suspect he already had it in mind earlier. Seth is no fool and certainly he was entrepreneurial. I think the interview was part of his long-term strategy and also associated with planning his migration to Europe and his move out of the art world into something else. He wanted to make sure that his New York career ended on the right note and that he got to publish his own account of it. Fair enough – why not? But he wanted to control it. Seth's quite a controlling person. He's smart.

JM: *Were you involved in editorial decisions on that issue?*

CH: Oh very heavily. In fact, as I remember it, I did most of the nuts-and-

Cover: *Studio International*,
vol.180, no.924,
July/August 1970

bolts editorial work on that issue. I may be wrong. But it was Seth who planned it and negotiated it entirely with Peter and I had nothing to do with that. In fact I think I was quite surprised that Seth went straight to Peter, if I remember it correctly.

JM: *Had you introduced them? Seth, I know, wrote a letter to Peter, saying, 'I'm looking forward to meeting you. I've heard a lot about you from Charles'. That was in 1969, when he refers to the proposed special issue as 'my summer exhibition, your summer issue'.*

CH: I certainly talked to Peter about him, but I don't remember actually putting them together. Seth stayed with us in London when he came over – it must have been late 1969 or early 1970 – but as soon as he got a grip on Peter, he had no need to plan things with me.

JM: *Were there any things about that issue that you remember especially? It generated the most enormous amount of discussion at the time. How do you feel about it, now and then, so to speak?*

CH: I suppose this may be hindsight and I wouldn't swear that I'm accurately representing how I saw it at the time, of course, but I certainly saw it as achieving the sort of objectives that I had conceived to make *Studio* more directly available to artists without mediation – to make it a vehicle for art as well as for serious criticism. What I hated was coverage, in any form.

JM: *You mean journalism?*

CH: Well no. It was coverage I hated. There's good and bad journalism; there's nothing wrong with that, but it was the Ted Lucie-Smith, David Thompson kind of art writing, and Dore Ashton to a certain extent, that I had no time for. It was the negative of what I thought an art magazine should be. So in that sense I was all for the July/August issue. But that it should be something which could be *curated* in that way, I wasn't quite so happy about, I think. But that could well have been jealousy. It was what I had been advocating and trying to get into the magazine and had been able to do only to a limited extent; and Seth could walk in and do

43

it, when Peter would never have let me do anything of the kind. But as I say, there's certainly an element of jealousy in that, and I should pay full and unqualified acknowledgement to Seth's remarkable abilities as an entrepreneur – for which I have great esteem. I tried curating some exhibitions and it nearly threw me into a breakdown.

JM: *Do you mean* Idea Structures?[7]

CH: Not so much *Idea Structures*, which was local, light on installation, and in other respects easily organised. No, it was a thing I did in Buenos Aires called *Art as Idea from England*,[8] and another one more or less coincident in the spring of 1971 called *The British Avant Garde* (which wasn't my title) at the New York Cultural Center. That moment almost destroyed me. It put the mockers on my marriage, and God knows what. It was a most miserable episode.

JM: *The May 1971* Studio *that formed the catalogue for the* NYCC *show was a marvellous issue of the magazine.*

CH: No it's not – not for me, because it's full of stuff that I was strong-armed to put into the show by Donald Karshan, who ran the NYCC. He basically demonstrated that he had a kind of power and authority over every matter that I didn't, whereas I'd expected to have a controlling hand. It taught me a lot about the limits on my own autonomy and control of things. I actually felt that that combination of catalogue, issue and exhibition was a most horrible compromise.

JM: *I came across a letter that you wrote to Donald Karshan in the archive, at least a year before the show, I think it was in May 1970, and it was at the time when the July/August issue was well under way, all had been submitted, and you were at this point extremely upbeat about the project.*

CH: Yes. I was introduced to him by Joseph, who was then trying to provide a leg up to my career, because it was a way to provide more support for his. He had rather stood behind Karshan when Karshan put on the *Conceptual Art and Conceptual Aspects* show at the NYCC in 1970. I was staying in New York with Joseph and Christine Kozlov at that time in their loft at 60 Grand

Cover: Exhibition
catalogue, *Art as Idea from
England*, Centro de arte
y comunicación (CAYC),
Buenos Aires, 1971

Street. We went out with Karshan for a weekend to Frances Archipenko's house in upstate New York. In the course of it Karshan invited me to organise that show. He was the first American millionaire I'd met and I was sort of pressed into the chance of organising a show in New York. I saw it as my messianic duty (sorry, missionary – no, messianic is probably better, given an addition of bathos) to exploit the opportunity in order to help provide my English mates with a platform in New York. I knew that was what really mattered: to get the work shown in New York. My idea was for a fairly restricted group of artists, but what Karshan hadn't disclosed was that he meant the show to be part of a series of surveys of various national – and essentially provincial – 'avant-gardes'. He'd just done *The Swiss Avant Garde*, and Britain was supposed to come next, with a comparable number of artists represented, and he had his own ideas about who some of them should be – including Gilbert & George, who certainly hadn't been on my list. It actually had precisely the opposite effect to the one I'd hoped for. I therefore felt that I'd let everybody down – which to an extent, I had. A combination of over-ambition and naivety is what got me into that position, and I think I was entirely culpable. The irony is that very much the same stable got picked by Ann Seymour for her *New Art* show at the

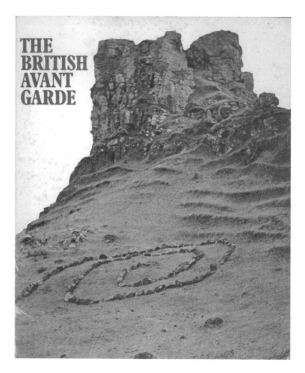

Cover: Exhibition
catalogue, *The British
Avant Garde*, NYCC,
New York, May 1971

Hayward Gallery the following year. I'd been to the Arts Council and British Council to try and get support and received nothing. The British Council didn't give a thing for the show. She then did a rather similar show and got full institutional backing, and this was suddenly 'the avant-garde'. So I felt rather bitter about that.

JM: *I'm not surprised. There's a letter requesting funds for the magazine issue and Peter writes to the Arts Council to get funds for the colour plates. It's an issue that many people celebrate.*[9]

CH: The only thing about that issue that matters to me in retrospect is that it provided the occasion on which my working relationship with Michael Baldwin of Art & Language was first established. When I had a draft of my introduction to the 'British Avant-garde' issue, I took it down to Michael's place in the Cotswolds and went through it with him. That was really the

beginning of a practice of exchange of texts that continues to this day.

JM: *I wanted to ask you about something that comes up in the quote you used to preface that introduction. It concerns the differences and distinctions between your use of 'intension' and 'intention'. I find it compelling; it's a position you have maintained for a long time.*

CH: The quote is a tag from the *Oxford English Dictionary*: 'The essence of farming on virgin soils is extension; on old land it is intension.' The distinction is not mine really; it's the focus of a sort of philosophical controversy. It was an *Art-Language* thing.[10] It was like a lot of stuff I had to learn really quickly when I first got involved in Art & Language. One of the things that drew me to it was that I had to increase my vocabulary fairly substantially. It was a different type of learning for me, which in a sense got me out of the intellectual and moral hole which I suppose my fairly unreflecting investment in the culture I'd grown up with had got me into. It coincided with what was happening in modernism, as it did for a lot of people of my generation. The ground was sort of disappearing from

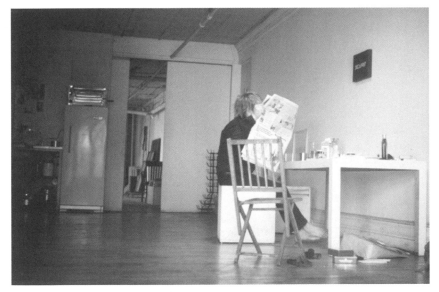

Joseph Kosuth at 60 Grand Street, 1969

under my feet. And for me it was a double thing, for class and cultural reasons as well, I think. So getting involved with Art & Language meant getting involved in a different way of thinking about things, a different take on what was going on, and a better-informed take – and one which involved using a different range of concepts, I suppose. And I remember it was one of the things I got introduced to by Michael – explicitly in his writing. Because while I was editing stuff, if I didn't know what I was reading, I would ask or go to the dictionary. I never like to put through a text of any kind that I can't represent back to myself. The initial distinction was between the idea of extension and intension, the idea of a category in extension and a category in intension. The category of cups in extension is everything that can be a cup, and the category of cups in intension is what something needs to be to be a cup – so it's a qualitative thing.

JM: *So it's what makes the thing the thing it is.*

CH: Yes. And if what you're interested in is art, it's a useful, powerful concept. I mean, the category of artworks in extension seems as far as I can understand to be completely unlimitable. But is there such a thing as the intensional category or notion of the artwork? It's quite an interesting question. Is there something here beyond the usual aesthetician's approach? Clive Bell said that what all works of art had to have was 'significant form', and everybody's been throwing that out ever since, quite rightly. But that idea – how something is what it is – does matter. It's really very important. Okay, so what about the relationship between that and intention with a 't'? If you were Richard Wollheim, I think you'd say there is no distinction, it's simply a quirk of spelling, which to a certain extent it is. So let's say the intension of something is roughly what it means – its meaning. If you asked Wollheim, 'What is the meaning of the work of art?', he'd say that the meaning of the work of art is consistent with the artist's intention, with a 't', so in that case the intention of the work of art is also its intension with an 's'. Part of the reason for keeping the two apart, then, is if you don't agree that the meaning of the work of art is necessarily consistent with the artist's intention – or, to be slightly more pedantic about it, if you believe that what artists intend is very often what they *have* done rather than what they are going to do.

JM: *Quite, and there could be a difference between what they intend and the intensional aspect of the work.*

CH: That I'm not so sure about. I go along with Wollheim so far as to say that I think the meaning of the work of art does indeed coincide with the artist's intention *so long as* you allow a) that intentions are not necessarily conscious, and b) that the intention could be retrospective, as when you put yourself behind what you've done.

JM: *Yes, but at the moment of doing it, there may be a very different relationship with it.*

CH: As far as possible one has got to keep these things apart – and then retrospectively they conflate.

JM: *I think it sounds like an interesting mode of clarification in what is often a grey sea of shifting aesthetics.*

CH: The OED tag is very useful. It's very nice. It's helpful when teaching. Students always come back to the question of intention, as though if the artist were there to whisper in their ear, they'd know exactly what the work was supposed to mean.

JM: *One other thing I'd like to ask, going back to the July/August 1970 issue of* Studio, *was whether you could tell me anything about Yusaki Nakahara, the Japanese art critic, who was proposed as one of the curators. Originally there were going to be eight curators – the other was Harald Szeemann. Seth doesn't remember who this chap was. When I asked Peter he said he was important but he didn't elaborate.*

CH: No, it's news to me. I've forgotten if I did know, anyway. I assume, with Szeemann, he was too busy, too important. Szeemann wasn't somebody who'd have happily submitted himself to Seth's curatorship.

JM: *Did you have a good relationship with him when you worked on the* Attitudes *exhibition?*[11]

CH: I didn't have any relationship with Szeemann at all, no. I got asked to do that show for a complex of reasons. It had something to do with the fact that at that time I was one of the few people who was vaguely qualified for it, who knew what the art was like. The work arrived from Bern and was in storage in a warehouse in North London. All I had to go on was the photographs from when the show was installed in Bern. It was all in a jumble and the main job was to go along to the warehouse and distinguish the art from the packaging materials, saying what was what. It then went straight to the ICA and we just installed it. There was a very good gallery crew at the ICA in those days, techy hippies and so on. As far as I remember, Szeemann simply appeared on the evening of the opening, when he and the ICA's director Michael Kustow made common cause. I was not invited to speak. Szeemann gave a silly mock speech and the whole thing just pissed me off.

JM: *I'm not surprised. It all sounds offensive.*

CH: Well, things happen like that.

JM: *Were you aware of how Seth Siegelaub and Daniel Buren had papered the walls of Bern with Buren's stripes at that time as a protest at his exclusion from the show?*

CH: No, I knew Daniel Buren a bit.

JM: *Through Studio?*

CH: I don't think so. I don't know how I got to know him. There are various areas from this period where my memory is slightly cloudy, inevitably. But what I do know is from about 1967, 1968 onwards, I had an increasing sense of the existence of a new international avant-garde, artists mostly of my generation, some slightly older, and it was the most cosmopolitan avant-garde there has ever been. And at that point – just for a short time between 1967 and 1972 (I would date the 1972 Documenta as when it all came to an end) – there was a sense of real comradeship, collaborativeness, openness. I don't intend to idealise; it really was like that. And if you knew anybody, you knew everybody. So I could go to New York and phone somebody up

and I'd be included in everything else. And everywhere you went in each of these centres, you could get a free bed. So my ambition, very quickly, was to provide that in London. My first wife and I had a large house in Islington and I wanted it to be a place where people could get a bed, where they could come. So I put the word around that for anybody who came to London there was a bed. And Daniel was one of the people who came to stay. I must have met him at a show, or maybe he just got my name from someone else – Seth, most likely. I think this was before we did the translation of 'Mise en Garde' that was published in Studio.[12] I met Michel Claura soon after and can remember having a meal with him in the Place Clichy. He was very much Daniel's exclusive defender and promoter at that time.

JM: *The decision to put the 'And babies' poster on the cover of* Studio *in November 1970 – was that something you were involved in?*[13]

CH: Not directly, no. They went directly to Peter on that. I knew about it slightly because I'd been in touch with the Art Workers' Coalition and had been along to one of their meetings, and one of their demos at the Metropolitan Museum in New York. And I met Carl Andre round that time. In fact, my wife and I gave a party for Carl, at the house in Islington.

JM: *Did you meet Willoughby Sharp when you went to the demo with the Art Workers' Coalition?*

CH: Yes, around that time. I remember someone was playing a penny whistle in the picket on the steps of the Met, and Willoughby Sharp went up to him and said. 'Don't do that man, you're fucking up the vibrations.'

JM: *Had he started* Avalanche *then? He had that piece 'Air Art' published in* Studio International *a couple of years before.*[14] *Do you know how that came about?*

CH: I have no idea. Nothing to do with me. I thought he was an idiot. He was a bit of a joke in the New York art world.

JM: *I thought he played a joke – certainly that's what he did in London. I think, then, it must have been through Barbara.*

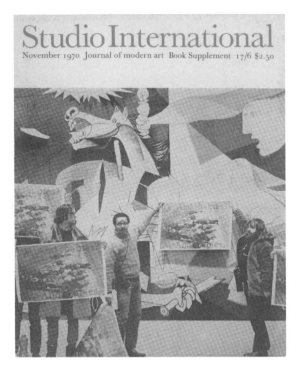

Studio International
November 1970 Journal of modern art Book Supplement 17/6 $2.50

Cover: *Studio International,* vol.180, no.927, November 1970

CH: Well she had more catholic tastes than me.

JM: *How did Peter, or how did the offices of* Studio, *perceive* Avalanche *magazine? There was some shared advertising.*

CH: Well, I didn't know very much about that, apart from the fact that it was going on in the back office and it mattered. You couldn't actually ignore it. But it was never made my chore to help with advertising. I don't think it made an impression at all. I mean, there were a lot of small avant-garde art magazines opening up and folding around then. My memory is that the only one that was really treated as a serious matter was *Art and Artists,* because it was then a competitor in the UK.

JM: *That was started just after Peter became the editor of* Studio. *Wasn't Lucie-Smith quite heavily involved in that?*

CH: Well yes, he was involved in anything and everything.

JM: *Willoughby Sharp was quite fond of Peter. He came over to see him a couple of times and there was a long interview between Sharp and Dennis Oppenheim that was published in November 1971.*

CH: I was beginning to pull away by then. I took over the editorship of Art-Language in 1971, and it became increasingly clear to me that I couldn't really be editor of Art-Language and have my feet in *Studio International*.

JM: *I think it came out a month after you stopped being assistant editor.*

CH: The crunch for me came with that trip to New York in the spring of 1971, the high point of my wonderful international career, when I flew to Buenos Aires to curate this show of British art, Art as Idea from England, and flew from there to New York in time to meet the container with the work shipped over for The British Avant Garde and put that up, leaving my crumbling marriage behind me in England, drinking like a fish, having a miserable time in New York, feeling like I'd betrayed everybody this end. I came back from there feeling completely disenchanted with the art world and my ambitions and place in it.

JM: *I have in the archive a contract that you wrote before you became contributing editor, more or less a year later, after Michael Spens had taken over. You gave several conditions under which you'd accept a post. You gave different titles, like advisory editor and so on and you stated how you'd accept it.*

CH: How pompous!

JM: *Well no. I don't think it's pompous at all. Actually, I think it's quite right, and totally understandable, since none of these contracts were ever written down. That's why I alight on it – because it is written down. I wondered whether Peter asked you to come back to the magazine at that time, or otherwise if you remember who it was that approached you, because you definitely didn't send it off yourself. Somebody asked you. Judging by the way you write it out, you were responding to a request: 'I will only accept under these circumstances', is what you said.*

CH: I'm afraid I remember absolutely nothing. I was very taken up with lots of other matters. As I say, I had a sense that I'd better pull away from *Studio*, and by the end of 1971, I was in the process of trying to move out of London. I think we'd already, or had nearly, sold our house. I resigned all my teaching posts and I think that – as part of all my grand, clearing-away gestures – I must have resigned from *Studio* around that time as well. So it may very well be then that I was offered this. But I'm surprised – and I have to say rather pleased – to hear that Peter was concerned about trying to hang on to me.

JM: *Yes, he was definitely.*

CH: I wasn't aware of it.

JM: *And you did come as a contributing editor later on, after a spell of not being in an editorial capacity, and then you were involved in all sorts of meetings with Michael Spens and Peter and Thomas Bergen and Brian Rushton. Do you remember Rushton? Wasn't he managing director or something?*

CH: Yes, Brian Rushton. He was a toad. He'd been at the Tate as director of publications or some such title. I knew him because I'd worked with him on the catalogue for the Ben Nicholson show in the spring of 1969. Yes, so I remember him. He must have got himself a foothold in *Studio*. He was very ambitious in a slightly creepy way.

JM: *He came because of Spens, when he took over.*

CH: Yes, that would make sense. He *would* get alongside Spens.

JM: *There are a couple of things from 1975. There's a letter you sent to Spens that I don't have a copy of, but I have his response. And a letter you sent in December of 1974, when you make clear your criticisms of what he had done to the magazine. And he responds to this letter that you sent and he talks about why it's necessary for Peter to go and why he wants to sit down and talk about policy with you.*

CH: Oh really?

JM: *It is quite a creepy letter, actually. He also says why he thinks you and he need to sit down and talk about the 'ontology' of the magazine.*

CH: Right, you don't have my reply to that. I think I kept a copy. I remember he'd said that the world isn't full of idle rich, and I replied that I thought he was wrong about the idle rich: there are plenty of them, it's just that they all think they're busy. And I think I said that his dictionary hadn't served him very well in trying to work out what 'ontology' means (I'd told him that the ontology of a magazine like *Studio* wasn't really subject to his control). And I said then – I think I did – what a mistake I thought he was making in getting rid of Peter, and that I didn't want anything further to do with the magazine and wanted my name taken off the masthead.

JM: *Yes, Peter told me you wanted your name taken off the masthead and that you made a stand about him being ousted from the magazine by Spens.*

CH: Oh, I'm glad.

JM: *That was in January of 1975, so maybe you sent Peter a copy. So with Spens taking over, you were sort of out of it to a large extent.*

CH: I was out in the country by then.

JM: *You were still writing for the magazine, like the 'Abstract Expressionism' articles.*[15]

CH: They were just reprinted from something I'd been commissioned to do by Nikos Stangos for a ghastly collection called *Concepts of Modern Art* (1988).

JM: *Yes, and you had to get his permission to use them. The other thing I wanted to ask you was whether you were aware of the concern to try to merge with* Studio International. *There were quite a lot of talks with Bergen, the money man, friend of Frank Whitford.*

CH: I'm not sure if I met him. The name rings a bell.

JM: *He came as a sleeping partner, I suppose, to Spens in America. He was keen to merge* Studio *with* Arts Magazine *and they had quite a lot of discussions over doing that. Somebody must have asked you if you'd do a survey of magazines and check it out. It's your handwriting. You must have been asked to provide lists of parity – not your thing at all.*

CH: It must have been because somebody paid me. I was very short of money at the time. Or it must have been a joke.

JM: *Did you meet Benjamin Buchloh?*

CH: No, not until 2001, when we were both at the Getty.

JM: *Did you have anything to do with Tommaso Trini or Germano Celant?*

CH: Celant, yes. He was one of the people who came to stay with us, him and his girlfriend. I took him down to my local pub in Islington. There was this cockney guy who was a drinking partner, called Bob. He was a window cleaner. And I took Germano down and introduced him. And Germano said, 'I am Germano Celant', and Bob said, 'You remind me of that film star, you know, can't think of his name …' Germano smirked (he used to spend hours working on his tan), and Bob said, 'I know. Peter Sellers, in that film with Sophia Loren. Can you do any other funny voices?'

JM: *Did you come across Marcel Broodthaers?*

CH: Just at Peter's house. I wasn't quite as impressed with him as Peter was, though I could understand why Peter was. He was a bit too much the Belgian poet for me.

JM: *When I spoke to Keith Sonnier, he was quite pissed off that nobody had acknowledged the slogan 'Live in your head' [printed in the* Attitudes *catalogue] as coming from him.*

CH: It was no business of mine. I thought it was a ridiculous slogan. It was just inherited from the Bern catalogue. Anyway, I felt that Keith Sonnier was a trivial artist.

JM: *I asked him because I found it quite ridiculous and we talked about it, the notion how can you claim a phrase as yours anyway.*

CH: I knew it was Sonnier, but I always thought it epitomised all the weakest aspects of that kind of work – its idealism and individualism.

JM: *The other connection I wondered about was with Athena Spear, who was then at the Oberlin College and organised a show called* Art in the Mind. *She wrote to you to ask for your recommendation of artists.*

CH: I met Athena because she was running PS1 in New York when Art & Language had a show there in 1999. And she was incredibly friendly and talked about the great old days of the 1960s and what great mates we'd been – and I had no recollection of her at all. I know I've got that catalogue somewhere, but I'd remembered it as having come completely out of the blue. It's possible I made some suggestions, though. Vic Burgin was in that show, and it's likely I recommended him to her.

JM: *And Bruce McLean?*

CH: I would have become involved with Bruce in late 1968. I was looking for an avant-garde, generally around St Martin's, where I was teaching at that time. He was friends with Barry Flanagan, who tended to pass on names to me. I saw it as part of my great mission that I should work to create opportunities for artists to show their work as they'd ideally like it to be seen. He did quite an amusing performance piece at St Martin's with Gilbert & George, where he acted out various sculptures by Caro and the New Generation. Gilbert & George were part of that same group at St Martin's, but I never quite got into their work. Still don't.

JM: *They had a very high regard for Peter and then a major fall out and I don't quite know the reasons why.*

CH: I don't know the reasons for that. Peter was sort of amused by them. I remember George Passmore phoning me up when I was busy at the Tate installing the Nicholson show. He asked about the *Attitudes* show and why they weren't in it and was very aggressive. I said the initial show in Bern

wasn't my selection, and as far as I controlled what was shown in London, it was decided and was now closed. They came to the opening and made a spectacle of themselves and claimed that was their contribution. No flies on Gilbert & George.

JM: *No certainly not. A lot of their early text pieces are dedicated to Peter Townsend.*

CH: Oh, right. They probably thought they could get round him with flattery.

JM: *Did they come around to The Plough or the Museum Tavern?*

CH: No, not that I remember, though they may have done after I'd stopped going.

Cover: Exhibition catalogue, *Art in the Mind*, Oberlin College, Ohio, 1970

JM: *But Joseph Kosuth did?*

CH: Yes, he did when he was staying with me. When he came to London he stayed with me, and when I went to New York I stayed with him – for a while at least, until we fell out.

JM: *And did Peter get on with him? Because he seemed amused but exasperated by him. He sometimes spoke as if he were quite fond of him.*

CH: I don't know. Initially Peter took some persuading to publish Joseph's 'Art after Philosophy'. I had to work quite hard to get that accepted as a three-part thing in *Studio*.

JM: *Was that because it was in three parts, or the nature of the text?*

CH: Well for a start, Joseph wasn't then known about at all in England, and here was this ambitious, large article by someone whose name didn't mean anything. And then, yes, it was very long and Peter would always get shirty about anything that was over-length – or pretend to. He was a good editor. So he'd say, 'I'm sorry but it's got to be cut. It's over-length.' And then we'd have this argument and very often he'd give in; but he was fine, perfectly reasonable. He had a magazine to run. So with the Kosuth piece, there was a problem with it being over-length, and I remember fighting for it to go in – which it did, without any cuts. Had I known exactly what hares it would set running I might not have been quite so ready.

JM: *And it still has issues running from it.*

CH: Yes, no flies on Joseph either. God, did he ever seize his moment!

JM: *Was he opportunistic?*

CH: Joseph? Is the Pope a Catholic?

JM: *Was he a bit like Seth then – was he a performer?*

CH: He was very witty, smart, fast company, completely paranoid, with

a very rich fantasy life. He was immensely entertaining. But he was a complete, unscrupulous individualist. That was what made for the crack-up with Art & Language.

JM: *This persistent rumour about Peter and the* CIA – *did you hear about it at the time?*[16]

CH: No, but I'm not surprised there was a rumour.

JM: *I can't find where it came from. Peter was very angry about it and dismissive of it. There was an issue about money in China, this was not to do with the* CIA. *Bridget Riley told a story about Peter always sitting in the corner in the manner of a spy, wearing his long mac. That was always the joke about Peter – a man possessed of a considerable vanity of a certain kind, bespectacled, diffident, secretive.*

CH: He certainly cultivated a mythology around himself and would hint at all kinds of confidences not to be disclosed. He was a good teaser, but he was also, I think, deeply contemptuous of certain kinds of political corruption and dishonesty. And I think that was really quite genuine. But he also cultivated a sense of himself – as part of his mythology – as potentially corruptible. So he catered to that one. It was part of his personality, part of the self-deprecating and self-ironising quality that was integral to his charm. And I think that people who misunderstood that – who didn't see the teasing – didn't quite know what was going on, and maybe took it seriously. But I'd be astonished if in any sense he'd acted in that way. I wouldn't be surprised to find that there could be considerable depths of corruption in Peter, but only in ways that I wouldn't want to moralise about – which I certainly would if someone were genuinely taking the CIA shilling.

JM: *Quite a lot of people have spoken to me about his sexual proclivities as if Studio was a sex-mad party –* [the critic] *Tim Hilton suggested it was a non-stop party with sex at lunchtime.*

CH: If it was, I was missing out on it. I think that's Tim fantasising.

JM: *It's like what, I think it was Weiner, said to me: 'If we were as drunk as Willoughby Sharp's always saying we were, how would we have got anything done at all?'*

CH: Well quite. I mean Peter was a serious drinker, but it generally helped him to function. Tim Hilton liked a drink as well – Guinness as I recall. I haven't seen him for years.

JM: *He lives in Suffolk. He's been very helpful.*

CH: Yes, I'm sure. He was someone in whom real warmth and commitment were mixed with a degree of insecurity. We had a slightly strange relationship. He would sometimes defer to me when he needn't have done. I don't know quite how to put it; it was as though I'd got a better class of degree than him and he thought it mattered. He took over from me as assistant editor. He wrote a long obituary of Peter in the *Guardian* recently, and he talked about the string of assistants drawn from the Courtauld, but didn't actually mention my name. I was quite hurt by that. It was strange because we were reasonably good mates at the time I was there. He was quite possessive of Peter, of his relationship with Peter.

JM: *I think so was [the critic] John McEwen.*

CH: Yes, John and I were chalk and cheese. I think he sort of disapproved of me and I didn't have lot of time for him. I saw John in essence as too far to the right – a very different kettle of fish from Tim.

JM: *Tim Hilton and I have spoken on the phone and had correspondence. He says you were the only person in Studio who had a clear perspective on an ideological position or what should happen within the space of the magazine.*

CH: Does he exclude Peter from that?

JM: *He sees him as a gentleman editor, fair and liberal.*

CH: There's more to Peter than that description might seem to allow. Some of that is, I think, the result of his genuine fascination for artists' company

61

and his extraordinary open-mindedness. He was very good at getting the best out of somebody in a conversation. And he used it to draw out their ideas. In that sense, he was far more catholic than I was. If I brought someone in who I would regard as one of my friends, he would latch on very quickly. And that's a huge gift. For somebody working on a magazine, it was really important. It was really a combination of that and his journalistic professionalism in the best sense – the practical journalistic skills. It was a great combination, quite unique. There was another thing about Peter which is really important, which I really enjoyed, and I think was one of the sources of attraction to some of the younger people like Tim, Frank Whitford, John and the others who hung around there. He had an absolutely saving streak of irresponsibility. There'd be stuff piled up on the table and he'd say. 'Fuck it, let's go and have lunch at Berts!' Also, one of the things that Peter and I shared was a taste for junk shops; going round, looking for stuff. I don't know what happened to it all, but I do remember Peter's house in Kentish Town just stuffed with all his acquisitions – absolutely piled up – some of it brought back from China. I mean, I'm bad enough, but Peter was worse than me. And on a few occasions when we got bogged down with proofs in the office, we'd just leave it all and go junk-shopping together. It was great. And again, the relief from the office tension was great.

But I don't remember the irresponsibility – perhaps irresponsibility is the wrong word – ever being sexual, the kind of carry-on Tim refers to. Perhaps I was missing something. Peter was certainly very attractive to women. But my impression was that he was quite careful with the people in the office. That's not to say that there wasn't the occasional slightly glamorous secretary. I remember one who was very street-wise. She used to come in and weigh up hash on the office scales and deal it out. I wish I could remember her name. She once brought in a batch of hash cookies and turned the whole office on its head – everyone was completely stoned. But that's the extent of the 1960s activities as I recall. Irena Oliver, I remember. She had a nice sceptical affection for Peter. I really liked her. There was an art editor called Malcolm Lauder, who was a bit of a lad, and fancied himself as an artist.

JM: *It was his decision to put that background colour behind the Judd on the April 1969 issue. Did you ever go down to the printers at Chatham?*

CH: Yes, quite often.

JM: *What was that like?*

CH: I always rather enjoyed it. As a printing works, it was very practical, and there were lots of people down there. There were the Mackay brothers, who were sort of gents, gentlemen businessmen who for some reason owned the magazine. They didn't know what the hell it was. I remember one of them – Anthony, I think, the more civilised of the two – accompanying Peter on a visit to the Venice Biennale, which I joined independently – the only time I've been. It must have been in 1968, when Bridget Riley and Phillip King were the British representatives. I drove back with them in Anthony's silver Alvis. He was a bit of a bon viveur and we stopped off in Alsace on the way back to drink the wine. At some point, the car broke down and we had to fly back the rest of the way. There was an accountant at Chatham called Colin Dyson. He was the guy who did their dirty work, basically. He was a classic: a small-business functionary with a toothbrush moustache. He looked like a junior member of the Gestapo. His job was to keep the reins on these irresponsible arty people up in London who were clearly bent on destruction. So there were lots of confrontations with him.

I remember one meeting down at Chatham when Peter must have been called to order over something by the owners, when he felt they hadn't been straight. It was the only time I ever really saw him lose his temper. It was presumably partly strategic, but it was very impressive. Peter didn't drive and I had a Mini, so I used to drive us there. Usually things were running a bit late and we had to correct page proofs down at the printers. It was hard work, but you knew what you were doing. I really like that, working with somebody else under pressure. It's one of life's great pleasures. And then we'd drive off and stop at a pub on the way back. There was one country pub, long since rendered unrecognisable, I assume, that had the most fantastic pork pies and really good beer. It was great. I'm sorry to ramble on, but it's actually quite nice to have the occasion to remember some of those very good moments and that companionship. And it was genuine companionship. I felt very sad about the fact that Peter and I parted company. There were a few times when we were both present at the same art world occasions and we didn't seem to be able to speak or even say hello

to each other. I had the feeling that I was persona non grata. It may just be that he was getting a bit short-sighted, I don't know, but I felt that he was trying to avoid me.

JM: *Well he did say he'd had this major disagreement with you and he was quite candid about it. He said last year, several times, 'I must write a letter to Charles Harrison' and I said to him, 'If you tell me, I'll write whatever you say.' This happened three or four times.*

CH: Really, I'm quite touched. Do you have any idea what may have been in the letter?

JM: *Well there was something he wanted to put right and say to you, and there was an element of regret. I don't know exactly what he would have said, but I do know he was wanting to make some form of amends. There was some sort of distress in his mind. And he did say it, and I said 'Well we'll write it together', and he said, 'Oh no, I'll do it'. He wanted to open the possibilities of communication.*

CH: Thank you for that. That's valuable. I didn't know about the funeral. I wasn't invited. I turned up at the memorial at the Tate, not quite knowing what the occasion was, more or less by chance.

JM: *I did put your name down. There was a list that I was asked to look at, put together by Peter's daughters, and the Tate used that. I think they sent most of it by e-mail. It was quite odd: the wording of it was ambiguous. It was not clear what was going on.*

CH: I arrived at the Clore lecture theatre in time to hear a series of sentimental eulogies – sentimentalising Peter. And there were displays of spreads from *Studio*, some of them covered with my own editing marks. I felt confused and alienated by the whole thing. I guess the real break with Peter – the moment I behaved unforgivably in his eyes – came with a meeting in the upper room of the Museum Tavern called to announce the plan to launch *Art Monthly*.[16] There was Peter and Jack and Nell Wendler – who were the money behind the project – and some art-world supporters, Norbert Lynton among them, I think. I distrusted the Wendlers (no doubt it was mutual in so far as they were aware of me at all). Nell Wendler was

one of the 'managers' who had been brought in to *Studio* towards the end of my association with the magazine. As far as I remember, the meeting was advertised as open to any interested parties. So I went along with some Art & Language representatives, Michael Baldwin and Philip Pilkington among them. They certainly contributed to the discussion, but not exactly in the spirit of the invitation. Their position was more or less, 'The last thing the art world needs is a kind of cosy middle-of-the road newspaper. Give us the money, and we'll show you what to do.' I suppose Peter must have felt I'd come along to help break up the meeting – which perhaps I had, in a way.

I can actually see that my sense of distance from *Art Monthly* is in part the result of a prejudice I should long ago have overcome. But it certainly seemed at the time that what Peter was doing was maintaining the currency of that kind of coverage – the sort of art-world coverage – which I'd always seen as the negation of what a real art magazine should be doing. But then on the other hand what it preserved and made a real virtue of – which was a virtue of Peter's – was his remarkable pragmatism, his sense of what will sell, what people want, what's readable, what's interesting, what's entertaining and so on. It preserved his liberalism. It's just that there are limits, unfortunately, to my liberalism.

JM: *It's of interest that Peter seems to have kept everything.*

CH: He must have thought what he was doing was important in some sense and that it had a continuing history. You wouldn't hang on to everything unless you wanted to make some kind of deposit of it at some point. And I guess it was important. What you had at the time, you had what *Studio* had been, which was this incredibly provincial magazine working out of very provincial circumstances, compared with what *Studio* became, which was something that benefited from a much more sophisticated professional editorship, but also at the same time from the fact that the British art world had been gradually opening up since the war, building up to a new sense of the practice of art, which was gathering pace from the early 1960s onwards. So it was a good moment. And that provided a golden platform for *Studio*; the moment of the crisis of modernism, of the original Conceptual art movement, of the collapse of criticism and so on – exciting times. And of course, *Studio* had its own legacy. It had

a history as the world's longest-running art magazine with continuous publication. I remember being rather proud of that. There was a sense that it could be an intellectually alive art magazine that wasn't entirely provincial. Then there's the problem of just what is such a thing, and what is such a thing in England? In America they've got a lot of different models to choose from: they've got *Arts*, *Art in America* and *Artforum*, though by then *Artforum* had truly distinguished itself from the other two by establishing a professional engagement with the art world which the others didn't have. *Artforum* set a kind of pace. Then you've got the competitors in England: there was *Arts Review*, which was still grounded in provincialism, and there was *Art & Artists*, which was basically a second-rate *Studio*, with a much less sophisticated editor running it – one who was basically feathering his art-world nest. But the important comparisons are going to be with the American magazines – with the exception of *Art International* perhaps. But *Art International* didn't quite seem to count in the same way; I'm not quite sure why, but it didn't. And then, against all that you've got the idea of a kind of avant-garde magazine which is the mouthpiece for a movement, for a generation, for an art world. And I think what happened is, *Artforum* made a very good job of edging a bit in that direction while retaining its position with regard to criticism and art history. And it could do that partly because of the difference in the American educational system, where people studying art history there studied contemporary art.

What really established *Artforum*'s intellectual pedigree was the serious art history published on Abstract Expressionism around 1965–67. You couldn't have got that in England. The teaching didn't embrace it. You had to go off on your own to study it. This was part of the grounds for my ambition to go off and teach modern-art history. And also in America you could study practical art at university, whereas in England then there was that class-distinction between art and art history, where art wasn't part of a university education. Also, there was a significant change going through the whole nature of art and the art world at that time, where what was happening was, the artists were taking over the art history – people educated in art history like Don Judd and particularly Robert Morris. Morris was the smart one, who saw that art history was the thing for artists to move into. There was no real barrier between practising artists like Frank Stella and Morris and writers like Barbara Rose in the early to mid-1960s at the time of the Minimal movement. That created completely

new possibilities. It was very different from the situation that existed in England. Though the same kind of forces were gradually changing circumstances in England in the same direction, it was happening in a rather different way. And there was still a barrier – a class barrier – between the art schools and the universities, which was crucially inhibiting. So you had people like me who went to university and some of whom tried to teach in universities, and people who went to art school who came out as artists. That's one sort of class barrier I still have with my Art & Language friends. We laugh about it, try to make the best of it, but yes, I'm very self-consciously aware of that difference. All these things bear down on what an intellectual organ like a magazine can be, on where and how it's perceived, where it locates itself and what kind of readership it hopes to attract, what kind of world it goes out into.

There was perhaps a fairly short moment in the 1960s and early 1970s when it seemed as though some of those barriers might be broken down. And of course what happened was that it all got put up again. The Right mistook what had happened in the late 1960s for a genuinely revolutionary movement and they made sure that nothing like that was ever going to happen again, which it hasn't. In a sense, those possibilities have gone. And so what we get now is art magazines as things that are full of fashion and advertising, so that's the end of art magazines. The end of *Artforum* came long ago. It was a golden moment and I do think *Studio* made the best of that moment. I was just impatient and I wanted to push it further. I wanted more of an intellectual dialogue – which wouldn't actually have worked.

JM: *Well yes, I'm sure you're right.*

CH: So the alternative for me was *Art-Language*, which still has a nominal existence. What I mean is that in theory we are still always producing another issue of the journal *Art-Language* – there is always another one in mind. That's where the dialogue is for me. And it's been a conversation that's continued for some 40 years. It's quite remarkable. But I'm very sorry that part of the price of that is that I lost my continuing conversation with Peter.

JM: *But I think I can say that he was sorry too.*

67

1 Barbara Reise, 'Greenberg & the Group' *Studio International*, vol.175, no.900, May 1968, pp.254–57. Barbara Reise 'Greenberg & the Group' (part 2), *Studio International*, vol.175, no. 901, June 1968, pp.314–16.

2 *Artforum* special issue on Manet, vol. VII, no.7, March 1969.

3 'Where does the collision happen? John Latham in conversation with Charles Harrison', *Studio International*, vol.175, no.900, May 1968, pp.258–261.

4 Organisation founded in 1966 by Barbara Steveni and John Latham to place artists in government, commercial and industrial organisations.

5 Joseph Kosuth, 'Art After Philosophy', *Studio International*, vol.178, no.915, October 1969, pp.134–37; 'Art After Philosophy' (part 2), *Studio International*, vol.178, no.916, November 1969, pp.160–61 and 'Art After Philosophy' (part 3), *Studio International*, vol.178, no.917, December 1969, pp.212–13.

6 A special edition of *Studio International*, 'July/August Exhibition', edited by Seth Siegelaub where six curators were asked to fill an eight-page section without contributing anything themselves. Each chose a number of artists to fill their space: David Antin (Graham, Cohen, Baldessari, Serra, Eleanor Antin, Lonidier, Nicolaides, Sonnier); Germano Celant (Anselmo, Boetti, Calzolari, Merz, Penone, Prini, Pistoletto, Zorio); Michel Claura (Buren); Charles Harrison (Arnatt, Art & Language, Burgin, Flanagan, Kosuth, Latham, Louw); Lucy R. Lippard (Barry, Kaltenbach, Weiner, Kawara, LeWitt, Huebler, NETCo, Barthelme; each artist was asked to pass on to the next a situation within which to work); Hans Strelow (Dibbets, Darboven).

7 *Idea Structures*, Camden Arts Centre, London, 24 June–19 July 1970.

8 Curated by Charles Harrison, *Art as Idea from England* included Keith Arnatt, Sue Arrowsmith, Art & Language Group – Terry Atkinson, David Bainbridge, Michael Baldwin, Harold Hurrell, Victor Burgin, David Dye and Bill Woodrow – was held at the CAYC, Buenos Aires in May 1971.

9 *Studio International*, vol.181, no.933, July/August 1971.

10 The introductory essay, situated through a discussion of intension and intention, was published simultaneously in the magazine and the separate catalogue. It is a distinction Harrison referred to frequently for instance in *Essays in Art & Language*, MIT Press, Cambridge, MA, 2002 and *Conceptual Art and Painting, Further essays on Art & Language*, MIT Press, Cambridge, MA, 2003.

11 Harold Szeemann was the curator of *When Attitudes Become Form* at Kunsthalle Bern, March/April 1969.

12 Daniel Buren, 'Beware', *Studio International*, vol.179, no.920, March 1970, pp.100–04.

13 Members of the Art Workers' Coalition held the 'And Babies' posters of the My Lai Massacre, during the *Information* show at MoMA in 1970 while standing in front of Picasso's *Guernica*. The poster showed Ronald L. Haeberle's famous photograph from the Vietnam War, with Lieutenant Calley's testament 'And Babies' inscribed over the top. The photograph of the protest, taken by Jan van Raay, was used on the cover of *Studio International*, vol.180, no.927, November 1970.

14 Willoughby Sharp, 'Air Art', *Studio International*, vol.175, no.900, May 1968, pp.262–63.

15 Charles Harrison, 'Abstract Expressionism 1', *Studio International*, vol.185, no.951, January 1973, pp.9–18; 'Abstract Expressionism 2', *Studio International*, vol.185, no.952, February 1973, pp.53–60.

16 The rumour, generated by Labour Party infighting at the Greater London Council, was that Townsend, who was then Chairman of the Greater London Arts Association, worked for the CIA in China. He had gone to China at the end of 1941 with the Friends Ambulance Unit, and he later worked as the English Publicity Secretary to the Chinese Industrial Cooperatives, writing reports on the cooperatives. He also worked as a China correspondent for the Reuters news agency and various newspapers. In 1949 he reported on the fall of Shanghai to the People's Liberation Army for the BBC. He returned to England in 1952; see the Peter Townsend entry in *Dictionary of National Biography 2010*, Oxford University Press, Oxford: 2010.

17 Townsend co-founded *Art Monthly* with Jack and Nell Wendler in 1976.

Conversation Two

Jo Melvin | October 2007

JM: *What's your perception of the relationship between Peter Townsend and his brother the artist William Townsend? To what extent do you think William had an influence on Peter and his decision making?*

CH: I would have thought not much. I've no idea what the private conversations between the two of them would have contained, but my guess is that Peter would have gone his own way. My sense of William was that he was an extraordinarily nice bloke, a real gent, but a bit of a bore, both generally and in his paintings. But a very nice, very decent bloke. He had a wide but rather unexciting range of acquaintances within that generation. So I wouldn't have expected him to have been much help for the magazine really, though I suspect Peter probably knew that. He was always very friendly to me. I went into the Slade to do the odd day's teaching. I don't know whether he was responsible for organising that or not. I can't remember.

JM: *I think he was, because I went through his journals and he writes about getting you in especially to teach the students they referred to as the 'Conceptual three'. I wondered about the teaching at the Slade and how it related to teaching in other places.*

CH: I only went there a few times, perhaps three days at the most. I tended to get invited to a few places where you got a little group of slightly avant-garde students who had latched on to Conceptual art – however haplessly it may have been – and they didn't quite know what to do with them. These were liberal times. At some places, when they had students doing things

that the teachers didn't know what to do with, they'd be told to stop it, but the Slade was liberal. In that regime the idea was that when you got students doing something particular that the staff couldn't cope with, you got a specialist in. I tended to be one of the specialists who they called in when they had that type of student. I remember there was a group of three at the Slade: there was a girl whose name I don't remember, there was a bloke called Tony Rothon, and there was John Stezaker.[1] They were a threesome and they were kind of working together. And I went in and talked to them a couple of times and I took copies of Art-Language, which I passed around. What usually happened on such visits was that the more ambitious students would grab them. My impression was that Stezaker was probably the least interesting of the three, but he was the one who grabbed hold of the Art-Language issues and didn't let them go. And of course, he was the one who subsequently went on and had a career. Those two things may be completely unconnected. But I never found his work of interest.

JM: *What was he doing at that time?*

CH: I can't really remember; it just seemed to be all over the place. Then he hooked up with [the critic] Rosetta Brooks. He was quite good at sorting out what the next rung up the ladder was, I always thought.

JM: *I don't find the work very interesting myself, but he did write a piece that Peter helped him with a lot in* Studio International. *It was called 'Three Paradoxes and a Resolution'.[2] It was after you were assistant editor, but I think you were contributing editor.*

CH: So it was after I'd stopped going regularly to the office. I certainly didn't have any hand in it, though had I been in the office I presumably would have done. So I couldn't keep it out, but I might have tried to.

JM: *I wondered how it came about? Obviously not through you, then.*

CH: No. I don't suppose I kept a lot out, but there were one or two people who came in with stuff, who saw me as the person to talk to, whose stuff I thought was just completely uninteresting, so I didn't pass it through.

I don't mean to sound like some sort of puritanical gate-keeper – I was very keen to find more people – but there were just some people where you thought: 'Well, no'.

JM: *Was that artists or writers?*

CH: Artists, all artists. With writers it was more simple. They could either write or they couldn't. The difficulty was always to find writers who were any good at all. But it was different with those who came as artists. I remember Jon Bird coming in with some ghastly stuff: bamboo poles on beaches with some tacky things hanging off them. I just thought it was complete junk.

JM: *Tony Rothon did a bit of writing for* Studio *didn't he? He did some book reviews.*

CH: I may have been responsible for bringing him in. I don't actually remember. But he was a nice quiet serious sort of bloke. I don't know what happened to him.

JM: *He was more interesting than John Stezaker then?*

CH: So was the girl actually.

JM: *William Townsend's journal is quite interesting. It goes up until he died in 1973. It's quite a tortuous read: this isn't the published extracts – it's small handwriting – you have to be dedicated to go through it. But he mentions all kinds of connections between people that I've found to be very helpful. He documents different situations, some more extensively than others, with comments about the people involved. There was one I wanted to ask you about. He refers to Anthony Blunt. He says Blunt wanted to come and see him because he was very upset about what Phoebe Pool had been saying about him. This is in 1967. Pool was having an affair with William Townsend. I don't know whether this is known or not, but it's clearly indicated that this was the case in his journals. He has a code for when he sees her; it's very easy to break – I did! But he documents each time. I think before, she was with William Coldstream.*

CH: Right. I think I might have heard that one.

JM: *What I wanted to ask you was whether there was a sense of other connections with Blunt? I don't mean to do with what became known as Blunt's treachery. Was this explicit in the Courtauld?*

CH: I wouldn't call it that.

JM: *No nor would I. But it's how it's generally referred to and it may qualify the question.*

CH: Whether it was explicit? The answer to that is no, I'm sure. But I can tell you a few things about Blunt and I'll try and get them in order. One: I was doing my research at the Courtauld on British art between the wars and of course that meant reading a lot of contemporary criticism, including Blunt's criticism that he published in the 1930s. It was written in a fairly committed if not entirely self-critical style – quite serious writing in a near-Stalinist vein. That's one point. So it wouldn't have taken an awful lot of imagination to work out that Blunt's political allegiances would be likely to be seriously to the left in the late 1930s.

Second point: he gave a very good lecture, while I was at the Courtauld, about *Guernica*. It was sort of reminiscing. There was no sense of him concealing anything or that there was some dark under-belly of secrets behind it or anything; he was fairly straightforward about what it meant and he talked a lot about the artists' commitment in the 1930s. And he was quite interesting. A rather anodyne version of it was published in *Studio*, as 'From Bloomsbury to Marxism'.[3] The third point is that he was a close friend of my maternal uncle – my mother's younger sister's husband, John Hilton – also incidentally brother of the painter Roger Hilton. And Blunt was, I think, godfather to the eldest in that family, my cousin Jenny, who is now Baroness Hilton of Eggarden. She was London's youngest ever woman police inspector. Anyway, Blunt was her godfather. I always thought if there was a fifth or sixth man, John Hilton was a very good candidate. He was in the diplomatic service. In fact, he retired with a KCMG and I think his last job was as Vice-Consul in Istanbul or something. He was a very intelligent man and quite amusing. He's dead now. So I suppose there was always that slight sense of possibility of some kind of connection. I was also at Cambridge with Guy Burgess's nephew, so there was a sense of all kinds of connections floating around.

Last point: while I was at the Courtauld doing my graduate work rather haplessly – and before I got involved with *Studio* – I was desperate to get a job teaching art history at a new university. I was very clear that that was what I wanted to do. I applied for a job at the University of East Anglia (UEA), which was for me the ideal job. UEA was just setting up, they'd got a brand new fine art department and I applied for the job and I didn't get it. I'd thought I was going to. I'd gone up there, had the interview and thought this is a fantastic place, everything I wanted, and then I didn't get it. I was an idealistic young man, but I really didn't have much idea about a lot of things. In fact, I made a complete pig's ear of the interview. Half the time I didn't know what I was talking about. But I was absolutely devastated. Blunt personally broke the news to me that I hadn't got the job. He actually called me in to his office. He had no reason to; he had had nothing to do with me. But he said, 'They had a strong sense of the fact that you'd really wanted the job and they were impressed by you blah, blah, blah, but not this time.' He really broke it to me very nicely and it meant a lot. So a little bit later another job came up, which was the job of assistant curator of English painting at the Tate – it was the job that I think Richard Morphet got. Alan Bowness, who was supervising me then (sort of) said, 'This is your job, the job for you, you ought to get it. Another one won't come up, you'll be made for life and this is what you want to be doing.' Well, you know, at that sort of stage in life, you take what your supervisor says seriously, and I needed a job fairly desperately and I needed a foot on the rung of the ladder. But I didn't really want that job. So I asked Blunt if I could go and see him. Again, no reason why he should agree; the only other time I'd talked to him was when he told me about the UEA job. So I told him, 'Look, I need some advice.' He said 'Okay', and I explained the situation about this job at the Tate. I told him I really needed a job, but I didn't know about this one. He said, 'Well you want to teach, don't you?' I said, 'Yes.' He said 'That's a civil service job; it would kill you. Don't go for it.' That was one of the best bits of advice I ever had and I was always deeply grateful to him – not so much for getting the advice right, but just for daring to give it and for giving the time to do it. So whatever anybody says about Blunt, my experience of him is unqualified benefit. And I'm inclined to trust whatever other kinds of things he may have done – which I suspect he did for the best of reasons, at least initially. History changes. Thank god most of us haven't been in that situation.

Incidentally – it's gratuitous – but there's a similar situation when talking about Clement Greenberg. The one unqualified black mark against him was for supposedly nominating his fellow editors on *The Nation* to the House Un-American Activities Committee – which was actually a very much more complicated process than it sounds. It's a similar kind of situation. History changes, and what you're left with – the principles – take on different meanings under different circumstances.

JM: *There's the whole parallel story with Peter's involvement with China, which is a very interesting story. There are letters and correspondences that I just can't get into now, but it's a whole area of connections that I'd like to unpack at some point. But the fact that Blunt was close to William Townsend and trusted him, and was open with him, it seems, as a confidant, is very interesting. William writes in his journals that he's concerned that there's another agenda. There are obvious allegiances and these layers of other meanings, but quite what it implies and what the consequences of it might be is something that William is concerned about. And this is really quite interesting because he's writing about it in 1967. And I just wondered if Blunt was concerned about rumours circulating that may have come from Phoebe Pool?*

CH: Well, there were rumours about Pool herself at the Courtauld because she was so odd. And she'd written this book with Blunt on Impressionism. It always seemed rather a strange combination, her and Blunt writing a book. She was always a slightly strange Bloomsbury-like figure seen around the Courtauld. Fairly eccentric. But how would I know?

JM: *I'd like to ask you about something else altogether: the show of Barry Flanagan at the Rowan Gallery in London and how it changed or raised the notion of what an art gallery is – or how its function was seen. I wondered about the experience of seeing it for the first time when people hadn't seen work in that context, hadn't been to New York but just came in off the street; what they thought and felt about it. Did it question the function of the gallery then, or whether a gallery was necessary?*

CH: This is the 1966 show? I didn't see it, so I can't be very much help to you with that. I got a sense of its importance retrospectively. It was almost entirely restricted to the pile of sand, *Ring N* (1966). That was the

most radical piece in the show. I got interested in that partly because I subsequently wanted to include it in *The British Avant Garde* show at the NYCC. So Barry taught me how to install it. I had my list of instructions on how to make the piece. He made a film showing me how to make it, and that became another piece, which was also shown in the film programme at NYCC. It was when he was just starting experimenting with film-making. It was on Super-8. I don't think it's much of a film. There was a little blackboard with the diagrams on it for the lesson. I've got some slides of it that I took at the time.

JM: *I wanted to ask you about some of the other galleries – for instance David Medalla's squat in Whitfield Street, ADF – Artists for Democracy – the alternative seat of power in the art world.*

CH: Oh dream on! I never really did understand about David Medalla – I couldn't understand why anyone took him seriously for a moment. I mean I know Guy Brett was a great advocate of David Medalla, as he was for a lot of very crummy stuff, I thought, and he had a kind of vocation for South

Barry Flanagan, *Ring N*, 1966, installed at *The British Avant Garde*, New York Cultural Center, 1971

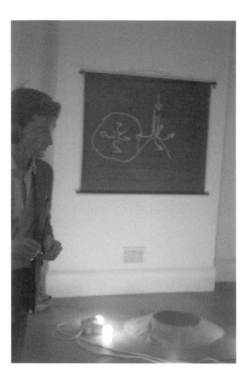

Barry Flanagan filming *The Lesson*, 1971

American art. David Medalla beat me. I don't know what it was about him. The only thing I could think of was that perhaps as he was a very pretty young man ... But the work was just a load of junk, I felt, and still do.

JM: *He was very friendly with Guy Brett and the Signals people as well.*

CH: Guy Brett would appear every now and again being serious and messianic about this stuff that wasn't getting as much attention as it ought to. And I'm sure he was probably right about some of it.

JM: *And did he come into the office to talk about this? Was it when he was critic for* The Times?

CH: I'm not sure exactly when it was. I do remember his coming in with Nicholas Logsdail when Logsdail was setting up the Lisson Gallery,

which he was doing then with a kind of Kinetic art stable which Guy Brett was pushing. They came in together and Logsdail went on and on in his typical manner – you know, the world owed him support for this particular endeavour.

JM: *He started the gallery when he was still at the Slade and then he decided to leave to run it.*

CH: Yes, largely with his uncle Roald Dahl's money. Not that his family was ever short anyway.

JM: *Did they just call in, or how did they go about it?*

CH: I remember them coming in, the two of them sitting there and being rather pious and whiney about it all.

JM: *Was it about why you weren't going along there more often?*

CH: Well, the gallery had hardly started. But it was already really clear that we owed them!

JM: *That's rather funny. What was [the gallerist] Nigel Greenwood like? Was he different?*

CH: He was a lot gayer.

JM: *He was at the Courtauld. Was he there at the same time as you?*

CH: Yes, I don't know quite what to say about him.

JM: *I wondered whether he came passing through the offices or came along for a chat or something.*

CH: I don't think he tended to show up much, partly perhaps because he was right down in Chelsea. And he had his own circle.

JM: *Yes. Lynda Morris worked for him for a time – she did the photos for the Barry*

Le Va show he did. There were two more gallerists I wanted to ask you about: firstly, Robert Fraser.

CH: I don't think he ever came to *Studio*. I'm pretty sure of this, as he had his own world.

JM: *But you and Peter had frequently been at his shows.*

CH: Oh yes. Well he had some pretty interesting stuff. He showed American Pop art.

JM: *I know that Peter at one time was very angry with him because he owed Bridget Riley £4,000, which would have been a huge sum of money in those days – selling her work and not giving her the cash.*

CH: Oh really? But was that later?

JM: *No it was 1966 or 1967.*

CH: I remember going to a show of Bridget Riley's there and I couldn't afford to spend £15 to buy a small work then – not that it would be my taste now – but it was when I was still a student. One point to fill out: you asked whether Greenwood and Fraser had shown up at *Studio* and I said, 'No, well they wouldn't have done.' And I'm wondering what I meant by that. Why not? Why am I so sure? Well it is to do with the fact that they had other circles. Thinking about that, there were various people who one might think of as being in the art world but who wouldn't have had connections with *Studio*. People working at the Marlborough Gallery didn't show up at *Studio*; why would they have needed to? And so there's a wide circle of people that *Studio* didn't catch at all, which in a way gives us a kind of a characterisation of what *Studio* did catch. Basically, what *Studio* caught within Peter's own generation, let's say, was a slightly liberal British-art middle-of-the-road constituency. It also caught a slightly genteel cosmopolitan kind of constituency. It caught people coming in from the States and I think Barbara Reise and I had the pull there to bring them in, though not necessarily people who were already well established with galleries in London, like Fraser's for instance. And then it caught a few

people coming in from the continent, but again either not very well known or avant-garde, which was also partly down to me and Barbara. And then they were people reasonably well established in the sort of middle rank of the avant-garde. But the real big money art didn't come to *Studio*. And there were probably sections of the most way-out avant-garde that didn't come to *Studio* – maybe because they were put off by the image of it as a large glossy magazine. I remember giving a talk on *Studio* at Coventry College of Art at Terry Atkinson's invitation – it must have been in 1969 – and the students were surprised when I spoke about how tight the money was and how ad hoc most of the procedures were. They tended to see it as a bit posh and high-cultural.

JM: *What about the Arts Lab in Covent Garden?*

CH: Yes well, but I had some contact with Cornelius Cardew and a bit of the fringe avant-garde there.

JM: *He did a bit of writing for* Studio. *Was that because of you?*

CH: Yes it was. I think it was partly because I went to see a concert he did at the Arts Lab. I must have gone there quite early, in 1967, or perhaps it was 1968. I don't remember very much about it, but I do remember Roelof Louw had a piece there – his 'orange pyramid' was originally done there in 1967. The idea was for everyone who came in to take a piece of fruit – to give the hippies their vitamin C. But what I remember seeing was a work I think by Morton Feldman being performed by Cornelius Cardew and somebody else. It was called *Studies in the Bowed Disc* (1963). It involved the two of them standing on either side of a large hanging disc of metal and sawing away at it with cello bows. It seemed very avant-garde. And that's about all I remember, apart from various bits of neon. There was always neon.

JM: *Peter gave Cardew some funds for the Scratch Orchestra.*

CH: And I got him to review a book. I think it was on John Cage. He was an amusing bloke; kind of tough. I liked him.

JM: *He sounded like he was seriously committed and utterly rigorous in what he*

was doing. It was terrible that he died so young.

CH: Yes awful. I'm afraid that's about all I remember about the Arts Lab. Not much.

JM: *What about the Centre for the Advanced Study of Art and Science or whatever it was called – that project of Marcello Salvadore's? Did you have any contact with that?*

CH: Oh, he was another person who came along and talked a lot and said nothing very interesting. I think Jonathan Benthall was connected with him in some way.

JM: *And what about him? He had a regular column in* Studio *on art and technology.*

CH: Yes a funny old-Etonian, he was. Again, I thought it was all a bit strange, but uninteresting.

JM: *Jack Burnham wrote a letter in about 1971 to Peter about him and his column. I think it must have been in response to a letter from Peter asking him what he thought about* Studio's *art and technology coverage, and Burnham replies that* Studio *is becoming more interesting than* Artforum *and that he's concerned about what was happening with Coplans taking over.*

CH: Yes, that was the beginning of the end, when Leider moved out. Leider's regime was the great period of *Artforum*.

JM: *Of course. But it's quite interesting to see it almost casually thrown aside in a quite anecdotal way by someone like Burnham. And also Kenneth Baker, in a different context, complained about his treatment at Coplans' hands – being hustled out of the office and sacked, effectively. Joe Masheck also wrote to Peter about this change-over – looking for other outlets as much as anything I suppose. Masheck was in England for a while wasn't he?*

CH: Yes, for quite a while. He was a funny sort of American college guy. Very bright, very well read. He had a very donnish intelligence.

JM: *He certainly didn't get on with Coplans.*

CH: No, and nor did I.

JM: *Rosalind Krauss and Barbara Rose: Peter didn't like them. He liked Frank Stella and described Barbara Rose as 'insufferably pompous'.*

CH: They're very strange these American critics and academics. They publish a book and get their name around a bit and suddenly they behave as if they're royalty.

JM: *I'd like to come back to the distinction between art school and university education and how that reflects on the context of the British art scene, from the emergence of the Coldstream Report[4] to your sense of what was going on in art schools in general.*

CH: It's a vast subject. I suppose it's quite relevant to *Studio*, because in a way it was like a doorway for both. Quite a lot of people who wrote for *Studio* were university-educated, of course, and a lot of people who came in and hung around it were from art school. So it was a place to meet. Also, its location was between St Martin's and University College, so its siting was quite important. It's really hard with such a big and open subject. Part of what animated the distinctions between art school and university was what animated the class divisions. It was not exactly that art schools were working-class and universities were middle-class – it was not quite like that, particularly by the 1960s – but maybe one of the consequences of the 1944 Education Act was that more working-class people started to go to art school. The other crucial distinction – and this is something the art schools prided themselves on, rightly or wrongly – was that you didn't need to have A levels to get in. A good portfolio would do. Certainly that idea that the art-school teacher could spot talent was a particular myth of the time – that they were the talent spotters – 'to do and not to think', and all that crap. I don't really know how typical my experience was, but while I was earning my living freelance – as you know, *Studio* hardly paid anything – my teaching was split more or less 50/50 between art school and university teaching. Everybody who came out of the Courtauld got a job in art school, because that's what the Coldstream Report did. It said everybody has to

learn art history, and at that time the Courtauld was the only place training art historians. And every deb and deb's delight who came out of there walked off with a part-time job. If they were pretty enough they'd get a job at St Martin's or at Corsham. But you didn't walk into jobs after university. And actually I think I was virtually the only person from my generation at that time teaching up-to-date modern art part-time at university. They didn't think twentieth-century art was quite pukka; so rather than invest in a full-time post, they'd get someone in to do it. I was quite conscious of the difference in teaching between the two. In the art schools it was more like teaching art-appreciation than teaching history. Anyway, it was keeping them entertained. If you were teaching art history and complementary studies in an art school, all they really cared about was that you kept the kids reasonably quiet, and if you could get them interested, great. You weren't initially expected to get them writing.

JM: *Did that come later then?*

CH: Yes, as procedures and methods of assessment got tightened up. People were teaching all kinds of nonsense – garbage mostly. But it did mean that all kinds of things could be taught. There were loads of different people teaching in art schools, which of course was partly what caused the trouble and led to the educational backlash, particularly when left-wing ideas started breeding in the schools, brought in through people teaching complementary studies. It had a lot to do with what fuelled things in 1968 and 1969. There was a kind of constructive mess in art schools, which sat over the general mess of the DipAD and transferred over into the BA degree just before the degree got sewn up. There were various attempts to try and establish more orderly regimes – led by initiatives that came out of the studio, like at Newcastle, where you had a charismatic figure like Richard Hamilton. Of course, another place where an attempt was made was at Coventry, where the Art & Language people were working, and that put its finger on two things. It put its finger on the mostly amateur and mindless approaches to complementary studies and on the irrelevant antiquarian approaches to art history. It also put its finger on the moment of the effective collapse of modernism. In doing those two things simultaneously it had a very big effect. It was very powerful. And the effect was felt not just at Coventry but much more widely. It spread quickly through the art

schools, and principals and heads of departments thought there was a takeover.

JM: *Whether they wanted a dialogue or not, Studio made a strong attempt to bring these issues into the open through discussions with different people involved. Were you behind that?*

CH: Yes, I was involved in what was going on, both as an occasional visitor to various art schools and by virtue of my role at *Studio*. What was happening was scandalous.

JM: *There were other situations happening simultaneously weren't there? Were you involved in any of these?*

CH: The only others I had direct contact with were Newport, through Keith Arnatt, and Hull, where Harold Hurrell was teaching – those were the two. And later at Nottingham, where Vic Burgin arranged for me to be an external adviser. But I think those were the only places other than Coventry where students were involved specifically in the Conceptual art movement. One of the other things behind this was that heads of departments saw the CNAA and degree status coming; so the issue was, do the art schools go for integration and downplay the traditional craft-and-workshop status in order to gain intellectual credibility, or do they go for autonomy? They had to re-think an academic programme. The ambitious ones went for integration, unless they thought they were going to lose power and authority, in which case they went for isolation. They knew that in larger departments they would be subject to more stringent controls; the timetable for teaching would be thoroughly worked out, so you might as well clear out your troublesome part-timers at this point. Clear out the bad politics. The study by Paul Wood and Dave Rushton is good on this: *The Politics of Art Education*.[5] My grip on the larger issues is coloured by what it was like for me – certainly the art schools were more fun. But I may have been teaching more responsibly in the universities.

JM: *The other thing is thinking about the relationship between Philip Leider and Peter and those relational positions between the magazines. I don't know if you've seen that piece by Pincus-Witten in October called 'Naked Lunches' where he*

describes what Artforum's editorial approaches were like for him? The sense from the Artforum people of their empowered position within the dissemination of work or ideas, especially in retrospective accounts, is one I've found problematic. This messianic attitude of Artforum seems quite different from the attitude coming out of Studio International offices.

CH: I don't think they took very much account of *Studio*. If Leider did, it was because he kept his eye out and he had quite a good nose for something interesting happening. But I don't think most of the others who wrote for *Artforum* weren't very bothered, unless they came to England and they wanted to place something in the magazine. But not many of them did. I remember Michael Fried coming over and having lunch with Peter and me at Bertorelli's. But he didn't write anything; he was entirely loyal to Leider and *Artforum*. Any American writer would have put their stuff in an American magazine rather than *Studio*; that is, unless they had tactical reasons not to – as the Minimalists did, when they were looking for support outside the New York art world. There is a complicated issue here which needs a bit of background. If you go back to the 1950s, when the supporters of Abstract Expressionism were trying to get it established and accepted in America, what they did was to organise a European tour, that 1955–56 show – *Modern Art in the United States* – that was then brought back to MOMA as the triumphant show that had been ratified in Europe. So there was always that sense that the Americans weren't sure if their art was any good until it had been ratified by Europe.

JM: *Yes, approval from the old world.*

CH: There was always a shadow of that. The *Artforum* generation either lost that attitude or fought very successfully against it. They were damned if they were going to see themselves as subordinate in any sense. And good luck to them. You get that in Greenberg's writing, that sense of being fed up with being put down by Europe. So generally speaking, as long as American artists were being supported in New York and America, and American writers were being published in New York, they didn't need Europe any more. It was when they weren't that they did – despite all that stuff about European art being over. I think it was a bit different for the post-Minimal generation, and I hope I had something to do with that. I certainly meant

to say, 'Look, lets get this conversation going over here. There is a door open for it.'

JM: *Well, I think you did.*

CH: It's a shame for all kinds of reasons that it got so far and no further. I suppose it was partly because those people got other outlets and partly because *Studio* changed.

JM: *Well Studio changed significantly under the different publishing regime.*

CH: And also, by 1972 I really wanted out of it. I wasn't involved. There was just a short moment when *Studio* genuinely offered a different base that was of some significance from the perspective of New York – maybe for three or four years.

JM: *When Michael Fried came over, was it after the time that Patrick Heron made his first polemic in Studio against the Americans?*[vii]

CH: I don't remember when it was that Heron did that, but I do remember that Fried came over when Caro had the show of *Prairie* (1967) and *Deep Body Blue* (1967) at Kasmin's in the autumn of 1967, October or November.

JM: *Okay, Heron's first article was in December 1966 and the second one was February 1968, after the Greenberg interview.*

CH: I think Fried would have seen it as frothing at the mouth – all that stuff about why Heron's stripes pre-dated Morris Louis etc.

JM: *Do you think it was more that Peter was concerned by the extreme priority being given to American work and that he wanted to introduce another layer into the discussion? Was it a conscious decision to open up dialogues with a wider community?*

CH: I think that's possible. I suspect Peter would have been likely to have been torn both ways, as many people were (though I wasn't, or perhaps I was a bit, but not as much as Peter because I was younger) between a

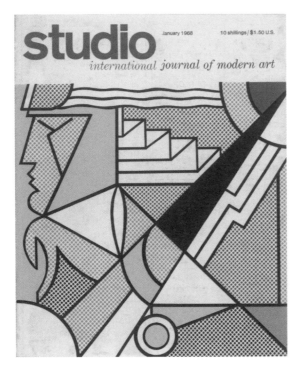

Cover: *Studio International*,
vol.175, no.896, January
1968

real distrust of American hegemony and American politics on the one
hand and a recognition of the quality of the art and the fascination with
it on the other. I'm sure that's true. I mean he wasn't a Patrick Heron.
And when there was a chance to get an American artist working with the
magazine – doing covers – he was all for it. So the Lichtenstein cover and
the Rosenquist cover are part of that.[8]

JM: *Yes, there were quite a few. There's the Alexander Lieberman one, David Diao,
Robert Natkin.[9] It was deliberate on Peter's part. He used Heron as a mouthpiece
so that the magazine could be an organ of controversy. It's ironic that the 1955–56
touring show was the one that Heron had spoken so elegantly about in Arts – the
letter from London.[10]*

CH: Greenberg maintained affection for Heron; he thought he was an
interesting writer.

JM: *Did you come across Heron?*

CH: I never went to his place at St Ives, but I saw him at *Studio* occasionally.

JM: *There's quite a funny story in a letter he sent to Peter. Apparently Peter had sent galleys of the Greenberg interview to Heron, for comment and to build his second polemic on. Alan Bowness rang on the doorbell and came straight into the kitchen where Heron's papers were spread out across the table and he saw the Greenberg interview there. And he said, 'You should be careful.' Heron was a bit worried that he'd landed Peter in it.*

CH: Alan was always telling people to be careful. He was often saying to me, 'Oh Charles you should be careful.' It was very easy to shock him.

JM: *What about J.P. Hodin? Did you come across him? All I can say about him – a piece of gossip – is that he suggested Richard Cork as a writer to Peter.*

CH: That would certainly make an awful kind of sense.

JM: *Well thanks very much; you've cleared up a lot of things.*

CH: Good. I can't think of anything else I'm dying to sound off about.

1 William Townsend refers to the group in his journals as the three Conceptual art students; they were Penelope Hawkins, John Stezaker and Tony Rothon, University College London, Special Collections, vol.xxxix.

2 John Stezaker 'Three Paradoxes and a Resolution', *Studio International*, vol.183, no. 944, May 1972, pp.214–17.

3 Anthony Blunt 'From Bloomsbury to Marxism', *Studio International*, vol.186, no.960, November 1973, pp.164–167.

4 Report published in 1961 by the painter and professor of fine art at the Slade School of Art, William Coldstream, Chairman of the National Advisory Council on Art Education. The report outlined the requirements for a new Diploma in Art and Design (DipAD).

5 Paul Wood and Dave Rushton, *The Politics of Art Education*, Studio Trust, London 1979.

6 Robert Pincus-Witten, 'Naked Lunches', *October*, no. 3, Spring 1977, pp.102–18.

7 Patrick Heron, 'The Ascendancy of London in the 60s', *Studio International*, vol.172 no.884, December 1966, pp.280–81.

8 Roy Lichtenstein cover, *Studio International*, vol.175, no.896, January 1968; James Rosenquist cover, *Studio International*, vol.175, no.897, February 1968.

9 Alexander Liberman cover, *Studio International*, vol.179, no.922, May 1970; David Diao cover, *Studio International*, vol.188, no.968, July/August 1974; Robert Natkin cover, *Studio International*, vol.187, no.963, February 1974.

10 Heron 'The Americans at the Tate', *Arts* (NY), March 1956.

Conversation Three

Teresa Gleadowe and Pablo Lafuente, *Afterall* | October 2008

TG: *I'd like to start by getting the history in place, so most of the first questions I've prepared are to do with establishing that narrative. Immediately before your involvement with* When Attitudes Become Form, *I believe you had been working on Ben Nicholson, and you said somewhere that through that work you absorbed quite a lot of Nicholson's attitudes to modern art. Could you tell us a bit about how your work with Nicholson educated your thinking about what art was or could be at that moment?*

CH: Okay, I can try. From about 1963 to 1967 I was in theory doing a PhD at the Courtauld Institute on British art between the wars, and the main artist I was engaged with and interested in was Nicholson. I had been out to see him in Switzerland at a fairly early stage. In fact I did a mini undergraduate thesis on Nicholson at Cambridge as part of a first degree in art history there. So I had quite an early interest in Nicholson. I suppose at that stage, when I was very young, he kind of stood for living modern art for me. I hadn't seen very much by then.

 At some point – I can't remember the exact date, but it would've been fairly early 1960s I think – I went to see him in Brissago. It must have been after I left Cambridge, when I was at the Courtauld, because it was partly arranged through Alan Bowness and partly through a very nice bloke called Cyril Reddihough, who was an old friend of Nicholson's. I'd been to see him and he recommended me to Nicholson, who wasn't easy to get to see. But he was very hospitable to me and I got on with him very well and maintained a correspondence with him during the time I was doing my research and for quite a while afterwards. Partly as a result of that, and the work I had been doing at the Courtauld, I was asked to

curate the Nicholson retrospective at the Tate in 1969. I can't remember when the work on that started, but it must have been certainly during 1968, so Nicholson was very much on my mind. The Nicholson show was in the summer of 1969 and I moved straight from doing that to doing the *Attitudes* show – which was quite strange.

There were two reasons for my particular attraction to Nicholson: one was that he seemed to me to be England's most cosmopolitan artist – he was the best modernist if you like – and the other was because of the extreme abstraction in his work. I was just interested in abstract art. I remember something Clement Greenberg said about what got him going as a critic: he said it was when he thought he could see abstract art – it must have been about 1937 or 1938. That meant Paul Klee for him, but for me it meant Nicholson, and I thought I could 'get' abstract art. I don't claim common ground with Greenberg, but it was quite a telling point about twentieth-century art.

The thesis at the Courtauld was a fairly hapless mess. I had no idea what I was doing – what doing research meant. I spent a lot of time sitting in the basement of the institute, when it was still in its old quarters in Portman Square, searching through dusty catalogues from the 1920s and 1930s, and copying out lists and making notes, thinking 'Is this research? Is this what it's supposed to be?' That was one part of it. The other part was chasing round trying to find people who were still alive, and going to see them. That bit I really enjoyed. I remember going to see Barbara Hepworth – who was also very welcoming – Henry Moore, who I really didn't get on with very well, and various other minor artists such as Ivon Hitchens, who was very sweet – not much of an artist but very nice – and David Jones. But as far as the actual thesis was concerned, it was a complete mess.

PL: *Was there an argument to it?*

CH: No, I think that's why it was a mess. At the time I was fairly young and intellectually immature. I didn't know enough about what putting an argument together meant. I had a very standard and slightly conservative style of education, and education in the arts isn't really very good at teaching you how to mount an argument. I didn't really learn what a proper argument is until a lot later, after I got involved with Art & Language. I learned from them.

TG: *Much later, by the time your book* English Art and Modernism *came out in 1981,*[1] *you were asking big questions about autonomy and art and revolution, but do you think none of those questions were in your head at that time?*

CH: Not really, or only as fairly empty abstractions. I think I had to learn quite a lot more before I knew how to put a proper text together. Some of the book I eventually published was made out of work I'd done for my supposed thesis. In fact, partly to save Alan Bowness's blushes – because he was my supervisor – he arranged that I would be given a PhD for the book. He could then see it as a successful supervision, which it certainly wasn't; it was a disastrous supervision. Nice bloke, but appalling supervisor. Much too kind.

TG: *The other person you've described as being an important influence at that time in your thinking was Barry Flanagan.*

CH: It was around the middle of 1967, one of the editorial jobs I got was doing *Studio's* coverage of the artists who had been selected for the Biennale des Jeunes in Paris in September of that year. So I went around making contact with the artists who were chosen, and two of those artists then became close friends. One was Jeremy Moon and the other was Barry Flanagan, so that's how I met him. I think I met him at the Rowan Gallery and I remember he was carrying a large home-made hessian bag, in which there was a twenty-foot length of rope. He was carrying this round like a sort of animal. I was completely fascinated. Barry was then a much more avant-garde and strange artist than he became, or he seemed strange to me. I hadn't met a lot of artists up to that point, apart from the older generation of people like Hitchens and Moore, and Barry was my generation.

The other person was Jeremy Moon, who was then very much at the centre of the group of English New Generation sculptors and abstract painters. I think he was teaching part-time at St Martin's. I used to go out and see him from that point on in his studio in Kingston and talk to him about painting, and particularly about the Americans, people like Frank Stella and Morris Louis.

Barry Flanagan on the other hand was part of the new sort of postmodernist generation that emerged at that time, and through him I

Roelof Louw, *Rope Piece*, 1968, installed at Stockwell Depot

got to know several other people who had been on the advanced sculpture course at St Martin's: Roelof Louw, Gilbert & George, Bruce McLean, Richard Long.

In 1967 I also got a part-time job teaching art history and complementary studies at St Martin's, so I was ploughing a fairly constant furrow between the *Studio* offices in Museum Street and St Martin's on Charing Cross Road and then driving up to the University of East Anglia or South to Maidstone Art School. I was dashing around, as you do when you're young and you have to scrape a living together.

TG: *Did Barry Flanagan's way of talking and thinking about art strike you then as being very different from the way you'd been talking and thinking about art in the context of Nicholson's work?*

CH: Yes, very, obviously. I don't think I had any great difficulty in getting my mind around it. From about the age of 15 onwards, I had a very strong sense of what I wanted to do, which was two things: I wanted to write poetry and I wanted to be at the centre of a group of avant-garde artists. I

didn't have a sense that I could be an artist myself. I was from the wrong cultural background. I didn't really know that at the time, but I was.

TG: *What does that mean? What was your cultural background?*

CH: Hereditary artistic cultured middle class. My mother was a musician, my elder sister was a painter, my father was a sort of writer. There were art books; there was always art and music around the house. That's what I grew up with.

TG: *So you didn't come as a fresh arrival from a completely different background, as many artists do?*

CH: Exactly. I mean I had too much art in my background, art of a slightly traditional, conservative kind, and that's not a good preparation for being an artist. My sister was a very good painter, but she was a very good painter in a style that was derived from an earlier generation. She went to Corsham and was taught by William Scott. She was heavily influenced by Winifred Nicholson. She made that sort of painting very well. But what I wanted was to be part of an avant-garde – my generation's avant-garde.

TG: *When you met Flanagan and others from St Martin's, did you recognise that as your generation's avant-garde?*

CH: Sort of. I don't think I had a very clear sense. I didn't know enough of modern-art history really to get a very strong sense of that then. I got it when I went to New York in the spring of 1969. Barry Flanagan was living in Belsize Park with his first wife Sue, and my first wife Sandra and I made a foursome with them. We used to go out together occasionally. They came down and stayed at my mother's place in the country for a weekend. Barry was looking for a place to store his work, and we arranged for him to hire a barn in the village that my mother lived in, so there were various connections.

TG: *Did you talk to Barry Flanagan about art?*

CH: Well, we would go out to pubs together. You don't sit down and talk art

theory. But I'd try and talk about his work if and when he showed it to me.

TG: *Did the art that he was interested in or making feel very different from the art that you were discussing with Jeremy Moon, Louis or Stella?*

CH: Yes, it was different.

TG: *Could you characterise that difference?*

CH: This is complicated. We have to get into more specialised art history to sort this out. It has a lot to do with the different paces, as it were, at which abstract painting runs out of steam and modern sculpture runs out of steam. I would say now, with the benefit of hindsight, that the possibility of modernist abstraction had been on the wane since about 1960. There's still very good painting being done, but Stella himself even made this point: that the promise of the 1960s never really got fulfilled in the 1970s. A larger history of the development of modernism will tell you now, again with the benefit of hindsight, that the great twentieth-century adventure of abstract art turns out to be fairly contingent and limited. It's about a fairly specific set of artistic changes and possibilities and it's not going to go on forever. So it sort of runs out in painting. The first signs of that are in the late 1950s and 1960s and it's certainly fairly clear by the 1970s. It looks as if sculpture's got a longer life, partly because of the very different nature of sculpture. I mean, a painting is a self-contextualising thing – it has a certain natural autonomy in a way that a sculpture doesn't. Sculpture has to acquire it in a different way. Sculpture could play with the limits of its own autonomy in a way that gave it a longer life at the margins of modernist orthodoxy than I think painting could have.

St Martin's was a very interesting locus of where that was happening. In retrospect, you could almost *see* it happening. In the late 1950s and early 1960s you have Anthony Caro teaching a very articulate sort of modernist sculpture, and at that time, seeing this as something with endless possibilities, and there's a sudden efflorescence with the New Generation looking as if it's a new dawn for sculpture. And then it all fizzles out, and in fact it turns out that the new people who are going to carry on something rather quirkily and perversely called 'sculpture' are a quite different generation of people, who are sitting around not making anything at all

apparently, like Long and so on. Opportunists like Gilbert & George can go on using the notion of sculpture to kind of dignify avant-garde activities in a way you couldn't do with painting. So it looks as if the transition from a kind of modernist sculpture into a new sort of avant-gardism in the area of three-dimensional work is much smoother than it is in painting; or rather, with painting there really is no transition. Once you lose the framing edge, you might as well just call it something else.

One of the things we have to remember is that the crucial difference between the English context and the American context between 1967 and 1969 is that we hadn't seen any Minimal art here up until 1969. There was none shown until 1969, whereas Minimalism – the work of Donald Judd and Carl Andre and Robert Morris – is absolutely crucial in America to that move out of high modernism. It's very significant that Judd refers not to sculpture but to 'three-dimensional work', as if this will open up a new kind of category that will leave both modernist painting and modernist sculpture behind. Maybe it does, maybe it doesn't. I mean Judd can be seen as the most perfect modernist. But Minimalism opens up a kind of avant-garde practice in America in a rather different way from what happens in England.

TG: *In the essay that you wrote, 'Against Precedents', for the London catalogue of* When Attitudes Become Form, *you quote a statement of Flanagan's that was printed in the Bern catalogue: 'It's not that sculpture can be seen as more things and in new ways within an expanded convention, but that the premise of sculptural thought and engagement is showing itself as a more sound and relevant basis for operation in the culture.'[2] So you were already understanding that this was art that aspired to a philosophical condition, perhaps.*

CH: I wouldn't have called Barry's position very philosophical; it was very perceptive in many ways, but not philosophical. He had quite a powerful, intuitive sense of what he was doing and in funny ways he was very articulate, quirkily so. For instance, there was that letter to Caro, which also gets quoted, the one he wrote in 1965 saying, 'My dilemma is that I might call myself a sculptor and do everything else but sculpture.'

TG: *So was moving in Flanagan's circle or being friends with him one of the things that started your thinking about art having different ways of expressing itself,*

different ways of being?

CH: I wouldn't want to over-dignify my thought processes at the time. One kind of bounces off people and artworks. The other very important person at the time was John Latham. I first met John at Barry's. He was very important to Barry as well. They had a show together in Bangor in 1965. He was a very influential person, John – still underestimated. A lot of people are now saying that, but he still hasn't got his due by any means. I certainly picked up a lot from Barry in practical terms, but there was also a lot of stuff you could read, so in a way I was ready to see the kind of work he was doing. I mean anybody with access to *Artforum* could have a strong sense of what was going on. *Artforum* first became widely available in England, I think about 1966. I was in touch with the editor Phil Leider in 1967 or 1968. He commissioned some stuff from me and he sent me back copies of the magazine, so I had access to those.

TG: *In Vienna you talked about the moment when you were in New York and you had this experience when looking at work by Morris Louis. All of the questions we're asking at the moment I suppose are around the realisation that there had been a major shift from a kind of modernist to what might be called a postmodernist consciousness, or that something very major had happened.*

CH: I'm sort of half an art historian, so nowadays I tend, with the benefit of hindsight, to try to explain things in art-historical terms. But it wasn't quite like that at the time. At the time I think I felt what was going on partly through the language. What happened was that the fairly articulate, slightly conservative and slightly posh vocabulary I'd grown up with and was educated with just stopped working. It just started sounding, well, conservative and empty, even to me.

PL: *Did it stop working only with the new art or also with other work?*

CH: Just generally. The aesthetic vocabulary and the aesthetic assumptions just started to feel a bit bogus. It was the art that did that, because what artists were producing was a kind of work that was indeed designed specifically to circumvent those kind of evaluations and certainties. That's what art does; that's what artists have to do. And writers

who fail to see what's being done to them deserve what they get (careers usually). So that's how I felt. I tended to feel it as a series of discomforts with what I was doing, hanging about in art galleries while dealers were making cooing noises. I couldn't stand it. I felt bad about what I was doing.

PL: *In your later writings you talk about art itself somehow setting a series of ways in which it has to be written about, or about art providing you with its own parameters to you as a writer. Did the new art also set similar parameters to those of the old art?*

CH: It changed the conditions for writing about it.

TG: *If one takes something concrete like say the text you wrote for the Nicholson catalogue, which came earlier – in the summer of 1969,[3] so you must have written it in 1968 or early 1969 – and 'Against Precedents', the essay that you wrote for the Attitudes catalogue...*

CH: Which was awful. One of the most embarrassing things I ever published.

TG: *Well, we'll get on to that. I might not agree, but they are very different in tone. The Nicholson catalogue is written in a very restrained, factual kind of way. You start by talking about his biography; there's no flourish.*

CH: It's a very well-behaved and careful piece of work. Sort of dull.

TG: *Well very careful, and each work is dealt with piece by piece and it does what a good art-historical study can do: it directs your attention to look at certain things in each work that would otherwise have been missed.*

CH: It was also very much written to please Nicholson himself, as these things have to be.

TG: *But this was written in a style that you might describe as conservative.*

CH: Yes, sure, I would.

TG: *And then 'Against Precedents' you've described as having this quite 'missionary' feeling ...*

CH: Yes, I came back from New York in the spring of 1969 (I was only there for ten days or two weeks) having met Greenberg and Joseph Kosuth, and through him, Larry Weiner and Bob Barry, and Douglas Huebler and Seth Siegelaub and Lucy Lippard. And Robert Morris I went to see, and Carl Andre very briefly, and various other people. I don't think I met Sol LeWitt then. Joseph and Larry Weiner were the people I was most affected by. And I saw the Carl Andre show at John Weber's Gallery, which I was completely knocked out by: three works in three rooms – each a 144-piece square of a different metal: copper, lead and – I think – magnesium. I thought it was fantastic – still do. I think Andre is a major artist. And Greenberg gave me entrée to a couple of big private collections: Ben Heller's and William Rubin's. I remember walking round this room-divider in Heller's large apartment – and the room divider was Jackson Pollock's *Blue Poles* (1952) (that was before it went to Australia). So I got to see a lot of very good first-generation American art, and obviously the stuff that was in MoMA

Carl Andre, *144 sheets of copper*, Dwan Gallery, New York, April 1969

and so on. I was completely knocked out by the Rothkos and Pollocks in particular.

TG: *And this was the same visit during which you had your Morris Louis experience, which I think for the sake of the record we should ask you to repeat.*

CH: But it's becoming a bit hackneyed by now.

TG: *Still, a good story.*

CH: Okay, I'll try and keep it short. One of the last pieces I wrote before I went to New York was a review of a Morris Louis show at Waddington's. I suppose it was the last piece I wrote where I felt confident that the way to assess a piece of work was to stand in front of it and wait for the aesthetic experience, as it were, and weld that together with a kind of formal analysis in the production of a value judgement. And my value judgement was that Morris Louis was not just a major painter, but a great one. I sent that article off to be printed in *Studio* just before I left for New York. I talked to Greenberg about Louis and he told me that there was a show of Louis's *Bronze Veils* at the André Emmerich Gallery, which I ought to go and see if I was interested in his work. So I went to see the show some time into my trip to New York. By then I had already seen quite a lot of other stuff. I'd met these other artists, these Conceptual artists of the first generation. I'd also been through what New York does to Europeans on a first trip, making you feel provincial – a bit small-town – and I went to Emmerich's and felt completely oppressed by the whole environment and by the exhibition. I couldn't see the paintings as other than a sort of wallpapered money.

TG: *I think you described even the way they were hung. Were they framed?*

CH: They had those little, thin, gilt-baguette frames that became modernist standard fare for Kenneth Noland and Louis and other painters, with a little soft lamp over each one and a deep carpet in the gallery. The whole thing smelt of money in a way that, to give it its due, Waddington's in London didn't quite, and I just found the whole experience oppressive. Then, on my way out, I looked at the table where the usual apparatus of publicity was laid out, to find that in central place was my article that had

Clement Greenberg's apartment, Central Park West, New York, 1983

come out in *Studio*, saying what a great painter Morris Louis was. That experience was fairly formative. It was very confusing, sort of shaming, not because I was sure that I had been wrong, but because I knew that I couldn't be sure what had produced my sense of the value of the painting – whether it was something like an aesthetic experience and whether the painting had caused it, or whether it was my investment in the culture, my ambition as an art critic, or my desire to stand up alongside Fried and Greenberg that had really produced it. If you can invent a sense of aesthetic experience like that, then you need to be able to distinguish between the invented experience and one that's caused by the work of art. And if you can't tell the difference between the two, you have no business putting judgements of taste into print. That was my conclusion. And I knew I couldn't tell the difference at that point; so that was the end of my budding career as a critic. Or at least, it was the end of my budding career as a critic in that mode. So I was in a sense forced back, rather reluctantly, onto my capabilities as an art historian. I'd never particularly wanted to be involved in the social history of art, but that was one way of learning about how the sense of value is produced when it's not produced by the works of art

themselves. So that was the learning project I found myself driven back into.

PL: *So after that you didn't publish writing that attempted to produce a value judgement?*

CH: Well, you can't write without values. I mean, even to describe something is to impregnate it with value. You can't get out of it. But I certainly wasn't inclined to parade value judgements in the same way. I did go on trying a bit. I published a terrible article in November 1970 in *Studio*, 'A Very Abstract Context', which was an attempt to promote the generation that I'd by then become associated with, which was Art & Language, Vic Burgin and Joseph Kosuth, saying how important it was. And in a sense that was carrying a strong value judgement.

TG: *You described yourself as coming back from New York with a kind of 'missionary zeal'; I think that is the phrase you used. The other thing that occurs to me just as an aside is that having worked on British art in the early part of the twentieth century you must have had a strong sense of how there has always been this avant-gardist kind of minority who had to stand up against a kind of provincial conservative majority in this country, and so if you were writing about Louis as you did, in a sense it was in that modernist tradition, I suppose.*

CH: Sort of. From my research I knew two things – two or three things. One was that you get avant-garde moments and they are very important and they occur when there are, for whatever reasons, significant changes working through the nature of art, the character of art. Among other things, those changes are liable to change the kinds of qualifications – social and moral and intellectual – that are required to make somebody an artist. These are the kind of changes that are beyond the control of any individual, but they shape practices and careers. In the period I was working on there were two such moments, one just before the First World War and the second one in the early 1930s. In both cases, the English avant-gardes that assembled at those moments were very largely working in response to larger and more powerful movements from elsewhere. One of the most secure conclusions that I derived from my research was that the artists who were strongest in those moments were the ones who had

the strongest identification with the international aspect of the art; that is to say, who were not closed to the idea that this was a storm in a provincial teacup, as it were. The smaller the confines of the area, the easier it is to be possessed of a sense of drama. But the significant changes are those that operate over a broader area, and it is to these that the strongest artists are alert. So overcoming provincialism was crucial. And if that was true for artists, then it had to be true for writers and it had to be true for me. But I've had a thoroughly English upbringing. In that sense, I am rooted in English culture. So it seemed to me that it was something I had to consciously work against in myself if I was to make any sense of the art.

The other thing my researches told me was that in the early moments when a provincial avant-garde gathers, or perhaps when any avant-garde gathers, there is a very considerable sense of fellow-feeling among a potentially wide group of artists. You get this moment of sort of communal excitement and friendship – you know, the kind thing that Herbert Read rather mawkishly described as 'a nest of gentle artists', about this wonderful feeling of everybody pooling together. Well that never lasts. It's a symptom of an early phase, particularly in provincial circles – the early phase of avant-gardism. And you've probably got a year, maximum two years, before you get schism, before the ones who have some strong sense of the basic and more cosmopolitan forces driving this change separate out from those who are only half-way there, whose basic commitments are provincial. That was why Nicholson was my hero, because everybody else regarded him in the 1930s as such a single-minded bastard. His idea was you had to be a bit of a single-minded bastard if you weren't going to be a provincial artist. He would never have represented himself like this, but that was how everybody else saw it and they were right. And, for all his mawkishness in other respects, Nicholson did retain that sense to the end – that the people he measured himself against were Braque, Miró and Mondrian, and so on and not, I don't know, Ivon Hitchens or John Piper or whoever.

Okay, so I found my avant-garde generation in the late 1960s and early 1970s and by then I could sort of see what was happening. My art history had taught me enough by then to have a sense that this large and congenial and cosmopolitan avant-garde that grew between, say 1967 and 1969, and that had its expression in *Op Losse Schroeven*[4] and *When Attitudes Become Form* – where artists came together from all over and had a good time and

were all good friends – that that wasn't going to last. That moment maybe lasted a bit longer than it did in some other periods, but by the end of 1969 or 1970 everyone was jockeying for position, and Conceptual artists were trying to separate out. Kosuth's little ambitious gambit with 'Art After Philosophy' was a clear symptom of that. And Art & Language's very deliberate sloughing off and slagging off of other people around them was another symptom. In a way, rather that any real theoretical common ground, it was perhaps this that established the connection between Kosuth and Art & Language to begin with – that sense of determination in the face of the stuff they didn't want to be identified with. And that was the faction I had put my money on by the end of 1969, partly as a result of the experience of *Attitudes*.

TG: *So we will go back to* Attitudes. *You came back to London from New York and you had what you've described as this 'missionary zeal', and the sense that perhaps this was in some way a revolutionary movement as well?*

CH: Sort of. Given the political and intellectual climate in 1968 and 1969, you couldn't avoid making some sort of connection, but I never saw the art as powerfully revolutionary in a political sense.

TG: *But in terms of its consciousness, which is what you wrote about?*

CH: Well that's one of the things I really don't like about that essay. A sort of immature idealism shows: that sense that the superstructure can crank the base, if you like.

TG: *It's interesting to read it in parallel with Piero Gilardi's essay for* Op Losse Schroeven.[5] *His is very much a Maoist functional understanding of art: that art really can change society. I think he talks about the actual conditions. But then in your essay you become more removed from that position. You talk about a change of consciousness, which is not quite the same thing.*

CH: In 1969 I was very politically naive. I got educated to a certain extent by the people I became friends with in Art & Language. It was quite an abrupt and uncomfortable education to start with, in 1970–71, because they were people from a different cultural environment from mine, and

Cover: Exhibition catalogue,
Op Losse Schroeven, Stedelijk
Museum, Amsterdam, 1969

they knew what was wrong with mine in a way I didn't. But I learnt.

TG: *Had you read Gilardi's essay in* Op Losse Schroeven? *Had you read his
article in* Arts Magazine?[6]

CH: I don't remember reading the one in *Arts*. I certainly read the essay in
Op Losse Schroeven because I got a copy of the catalogue more or less as it
came out and I quoted him in my introduction for the London showing of
Attitudes, but I don't particularly remember reading it. I vaguely remember
Barry Flanagan talking about him as a good bloke. I was a bit suspicious at
that time of anything that made too close an association between art and
politics, partly because of an instinctive conservatism in my own politics.
I got over that in the end. I had my own Maoist phase, but it came later.

TG: *So when politics came in through Art & Language it was Marxist politics to some extent?*

CH: Art & Language wasn't a Marxist group in the sense that Marxism was understood in the late 1960s and early 1970s, when it was associated with the de-Stalinising enterprises of French intellectuals. I know it's seen as Marxist, but its roots were much more sort of old-fashioned sceptical working-class left. For most of the original members, that was certainly very strong. Art & Language's explicitly Marxist phase was strategic and slightly artificial, and that was really not until 1974–75. Marxist theory was then adopted as a kind of strategy for dealing with the Art & Language contingent in New York, and with the apparently instant Marxism that surfaced in *The Fox* and 'Artists Meeting for Cultural Change'. It was an attempt to kill one kind of Marxism with another. That was the sense in which Art & Language was Marxist. Okay, most of the people in Art & Language had read some Marx, but then so had anybody with half a brain at that point.

TG: *And did the artists that you were working with, or seeing, or hanging out with, or discussing work with at the time, have any of this political concern with leftist worker politics or with any kind of radical leftist tradition at the time?*

CH: There were artists with explicitly leftist commitments, who wore their left-wing politics on their sleeve. I always thought they were fairly crummy artists. Conrad Atkinson comes to mind, but there are many others. He shouldn't be singled out particularly, but I never found the art at all interesting.

TG: *But it wasn't true of Latham and wasn't true of Flanagan. Okay, so, just telling the story, you came back having had this clearly extremely important experience in New York, and it was at that point that you proposed an exhibition to the ICA, when you got back from the States, is that right?*

CH: I think it must have been. I'm not absolutely sure of the timing of that. It could have been before I went. I certainly had already met the artists I wanted to involve.

any *affecting* the society they were opposed to.
his light "art for art's sake" becomes an attem~
stablish another society of sorts. Also, it's in~
sting that Dada, one radical attempt by art~
ffect society *directly*, espoused what cor~
alled the Romantic ideal of emotional
Of course the contrast to both this sc~
ectivity and Dada is the radical tac~
and the Paris Commune, which w~
ealism, in facing social issues h~
eresting, I suppose, that the ~
as generally been overlook~
Given what had become a~
however, Technicians w~
ect themselves as hig'
ment still holds tru~
cians, the art wor'
nore mass-cult~
ole (substitur~
erent elitis~
his mora'
and yo~
ocial'
sm
~

~cy
~ trea
~ to ea~
cidental.
voice of t~
ncovering of
ole of criticism
~ some kind of
neory, its task is t~
individuals (creating
he worthiness of thin~
ne, no method, and mak
nciples and commitments-
ould be to destroy its specio~
nus appears, since it makes no
explicit but relies on being a
functionary, as unassailable. It has
in significance, clearly. For instance
d as "rational," a right God-given, tha
ic "appraise" art-work. But suppose the
should criticize the critic? If so, it is mos~
ten off as sour grapes. Under this kind of
ole-dogmatism, there are standards of intelligil~
such as experts/laymen teachers/learners dom~

Cover: *The Fox*, Vol.1, 1975

TG: *Because they were all British?*

CH: Yes, all the artists I wanted to involve, with the exception of Victor
Burgin, whom I didn't meet until I returned from the States, and whom
I contacted after reading about him in the Artists' Information Registry
address book. He was the only one that looked at all interesting. I don't
know which other artists Victor knew at the time. He certainly knew
Michael Craig-Martin, who I think had been at Yale at the same time, but
I don't know who else. He'd been in the States for some time and had only
recently returned. Before that, he'd been at the Royal College while most of
the people I knew were at St Martin's. There wasn't much traffic between
the Royal College and St Martin's in those days. The Royal College was a bit
of a hotbed of late Pop stuff, late Surrealism, general junk.

TG: *Did you have to make a social bridge between Burgin and all the others?*

CH: Well I didn't have to, but I suppose I tried out of a mistaken belief that one's friends should be friends with one's friends – my Home Counties liberalism showing again. I mean at some point – this was later, in 1970 or 1971 – I thought I could make a bridge between Vic and Art & Language. It was quite interesting. It was like introducing one tom cat to another crowd of tom cats, so that didn't work. I used to see Vic and his first wife. We went over to have meals with them and they came round to have the odd meal with us. They lived right over in Greenwich and we lived in Islington, so it was quite a trek. But he also arranged for me to be an external assessor at Trent Poly in Nottingham, where he was teaching, so I would see him there as well and talk to him about his students and his teaching, that kind of thing. He was a good friend for a while. I also introduced him to Joseph Kosuth, and he and Joseph got on alright. Vic went to New York and stayed with Joseph for a bit as well.

TG: *So to get back to 1969, the artists you wanted to work with were Burgin, Flanagan, McLean, Long and Louw.*

CH: Yes. In fact I'd made a proposal previous to the one I made to the ICA. That was to the Whitechapel, but it got turned down.

TG: *When was that proposal made?*

CH: I think just before, in 1968. It was to Mark Glazebrook, who was then director of the Whitechapel. Given Mark Glazebrook, I'm not surprised it was turned down.

TG: *Was that with the same artists?*

CH: Yes, it was the same artists, obviously without Vic Burgin, but with the addition of John Latham. I may not even have got so far as to pinning down all the artists, but it was certainly to have involved Barry Flanagan, Richard Long, Roelof Louw and John Latham. The idea for that show was that each artist would do one substantial work in the gallery and one substantial work somewhere else, in the landscape or wherever, to which there would

111

be directions from the gallery. The proposal had somewhat personal origins. Partly as a result of Barry's work, partly through Long's, and partly as a way of working through my interest in Nicholson – and what I saw as a possible way to modernise Nicholson – I had the idea that I wanted to try some of this stuff out; to make a kind of art myself. So I had a phase at the end of 1968 of going around and doing things in the landscape, floating white polystyrene circles and lines down rivers and spraying circles on grass and snow and so on.

TG: *Taking photographs?*

CH: Taking photographs. My idea was to use minimal physical materials, but to make some kind of intervention that would provide a focus and a kind of content for the view of a particular place. It transpired that there were some unpredictable technical constraints. The circles needed not to be too large or too thin. Size and thickness mattered, as did the balance of circle and surrounding area, and of course the quality of light. There was something crucial about the transparent quality of the slide that recorded the image. I took 35 mm transparencies and my idea then was to have these enlarged, have them printed on small free-standing glass or Perspex sheets that could then be placed in a window or on a desk or whatever. But there wasn't the technology to do that at the time and I didn't have the money, so it never got any further, and by the time I got involved with Art & Language, activities of that kind came to seem simply embarrassing. Funnily enough, the technology now exists and I have got the money, so I've actually had some of the old transparencies made up. They're sort of pretty. But anyway, that was what I was doing in 1968, so that is partly where that idea came from of getting together a group of artists who would do one work in a gallery and another somewhere else. But I certainly wasn't going to include myself among them.

Okay, so after that proposal was rejected by the Whitechapel, I proposed this show to the ICA. The principle was that five artists would be given roughly a fifth of the space each to do one substantial work and they were to be paid a fee; the fee was to be £100 – peanuts now, but worth a lot more in 1969. And that show had been agreed and it was scheduled for September 1969, which would be a month after I was to install the Nicholson show at the Tate.

Charles Harrison, *Mill Reach*, 1968

PL: *Why did you abandon the idea of doubling up the show in the space with the show outside of it?*

CH: It was just a different idea for a different show. And I might have even come to see that first proposal as a little bit sentimental, or slightly avant-garde in the wrong way, trivially avant-garde. And I had a strong sense of wanting to concentrate attention on the work of these artists. I wanted everybody else to think they were as good as I thought they were.

TG: *Presumably the experience of installing* Attitudes *was quite different from the Nicholson show.*

CH: It was completely different. The Nicholson show was a one-man show. Ben was around when the show was being installed, so he had the last

Charles Harrison, *Duntisbourne*, 1968

word, whereas I had much more freedom with *Attitudes*. It was completely different work. The only thing in common between the two was my rather impetuous sense of responsibility for the work, a kind of commitment to it. I was absurdly intemperate in a way, wanting to get everybody to take the work as seriously as I did.

PL: *Was that to do with identifying the artists' intentions?*

CH: I'm not a curator, but in so far as I've done any work as a curator, I'm very clear about the fact that you try and install the work as the artist ideally wants it. So you do the best job for the work you can. You certainly don't have ideas of your own. That's one of the things I couldn't stand about Harald Szeemann: the idea that the curator is someone with initiative. I didn't want initiative. I wanted to discharge what I saw as my sole responsibility in my rather stuffy English way.

TG: *That raises a question that I was going to ask. I think already in 1969 there was discussion about the tension between the artist and the curator; for instance*

Lucy Lippard quotes Peter Plagens criticising an exhibition that she organised saying that Lippard was playing the artist and her medium was other artists. I wondered if you were aware of those kinds of emerging tensions at the time?

CH: No, not then. I became aware of them much later. I mean, it never occurred to me. I suppose in my little plans for shows with stuff out in the country and things like that I perhaps unwittingly played the creative curator, but I certainly didn't think that was what I was doing, and I never liked the idea. Still don't.

TG: *But when you talk about Szeemann and the way you felt about Szeemann, was that something that hit you later, or were you already in 1969 beginning to have some concerns about his being too much of an auteur?*

CH: That was brought home to me when he came over for the opening of *Attitudes*. He and the ICA's director Michael Kustow got on like a house on fire, which pissed me off slightly a) because it was all going on, as it were, over my head, b) because Kustow was a theatre person, and didn't

When Attitudes Become Form, installation at the ICA, London, 1969

115

have much of a grip on the art. They did a little staged double act at the opening, which involved Kustow doing a fake interview with Szeemann, and Szeemann giving this fake speech – just gesturing and mouthing and not actually saying anything. I thought that was completely stupid and childish, and drawing a kind of attention to himself at the expense of the show. It completely pissed me off.

TG: *Were you given the opportunity to say anything at the opening?*

CH: No, no.

TG: *So did you talk to him?*

CH: No.

TG: *He didn't make a comment on what he thought about the show in London?*

CH: No. When he and Kustow stepped down off the stage, it revealed a kind of placard with a text saying 'Harold Szeemann would like to thank Charles Harrison for making *Attitudes* happen so well in London', or words to that effect. And then there was a big dinner at Manzi's in Leicester Square (of sad memory, the best fish restaurant in London), which was quite a congenial affair, because there were a few artists around. But that was the only contact I had with Szeemann at all.

TG: *And any contact subsequently?*

CH: Absolutely not. I don't think either of us would have wanted it. He, because I was a person of no significance and I because I thought he was a wally.

TG: *But you also described your difficulty when you actually had to install this work. I mean, apart from the work where the artists came to install. For instance there were flocking pieces by Keith Sonnier that had been installed in situ at the Kunsthalle Bern and that had then been peeled off the walls and you had to find a way to re-install them.*

CH: Absolutely nothing, no, no. I don't know whether he communicated with the ICA management, but if so it didn't filter down to me.

TG: *I noticed, reading your essay, that there are certain artists you refer to, and I think you don't refer to any of the Arte Povera artists in your essay. Was that symptomatic?*

CH: Well, you have to remember that the essay was written well before the show opened, and I hadn't seen much of their stuff at first hand before it arrived. And I never thought much of the Italians. I mean I liked Giovanni Anselmo and Mario Merz. Merz was crackers but a good, amusing bloke. Anselmo was a bit of a gent. I couldn't connect with Gilberto Zorio. Paolo Calzolari was completely out of it. Emilio Prini was crackers. Halfway through the opening he got vilely drunk and I had to take him back to his digs in a taxi and hold him out of the window while he was sick and then come back to the rest at the end. Alighiero Boetti was a bit of a lad. He tried to steal one of Hanne Darboven's books. He obviously couldn't put it down – which says something. It was only salvaged by a keen Sue Davies, the gallery manager at the ICA, who went through Boetti's bags and found it and averted a near crisis. I've never been terribly charmed by Arte Povera. It was quite interesting to see that show at the Tate a few years back.[7] The work just looked like what it had always seemed to me – a collection of large avant-garde jewellery.

TG: *You mentioned that Robert Smithson also came over.*

CH: Yes. He made a work out of mirrors and chalk. We had to find him a chalk quarry, I can't remember where. The ICA's gallery guy – the fixer guy – was the one who found it.

TG: *I seem to remember you telling me that you'd gone on some day trip with all the artists.*

CH: Yes, I took a party of artists – in fact I think it was just Reiner Ruthenbeck, Jan Dibbets and Ger van Elk – to see the Cerne giant.

Robert Smithson, *Mirror displacement with chalk*, 1969,
installed in *When Attitudes Become Form*, ICA, London, 1969

TG: *At Cerne Abbas. Why?*

 CH: Because prehistoric art and Land art were currently fashionable and it was a nice place to go. Smithson wanted to come, but Nancy Smithson wanted to shop for a jumper, so he did that instead.

TG: *So were silly photographs taken around the Cerne Abbas giant?*

 CH: I think I took a couple, but I can't remember. It was before everybody walked around with a camera.

PL: *You were talking before about this community of avant-garde artists; was there communication, for instance, between the London artists and the Italian artists?*

 CH: Well as I said, for a while – certainly, I would say up to the end of 1969, beginning of 1970 – for some people that sense of common cause continued, maybe even into the early 1970s. But I don't remember the

Arte Povera artists mixing much with anyone else. They tended to stick together. In general, some artists tend to be more clubbable than others. I certainly happened to throw in my lot with the least clubbable ones.

TG: *But were there tensions there already at the time?*

CH: There was always a potential for tensions, but in fact I don't particularly remember any during *Attitudes*. The time when tensions really became evident was at the 1972 Documenta. By then, careers were really on display. It was a bigger kind of location and by then most of the artists also had dealers to razz them up.

TG: *In social terms, I remember you talking about the years of the late 1960s: you could arrive in New York, just sort of whenever, and you could pretty much ring up a network of people and be sure of a bed.*

CH: Yes. I tried to make sure that people knew we had a house in London. I quite deliberately put the word around that anybody who needed a bed in London could come around to our house. A lot of people did come. Some people were a pain in the neck; some of them were great. Germano Celant came, Konrad Fischer came. I'd met Konrad for the first time in 1968, when I went to Germany and saw the *Prospect* exhibition which he helped organise. He had a Long show at the same time, in that very small narrow gallery he had in Düsseldorf then. I can't remember why he came to stay. I wouldn't have thought I'd been that close to him, but perhaps he knew we were on the circuit and wanted a free bed. Daniel Buren came, Larry and Suzanne Weiner came, more than once. Seth Siegelaub came, Lucy Lippard came – they both stayed for a while. Gerry and Ursula Schum came. Klaus Rinke came – the German guy who worked with water – huge bloke, very tall with frizzy hair, with an incredibly beautiful girlfriend. They got into a kind of performance art. Ian Wilson came and insisted on talking as his artwork. Boy, he was boring! Kosuth came a few times. That situation lasted till the end of 1971. We left London for the country early in 1972.

TG: *I think the Flanagans also had a household where people came by, and again there was a kind of sense that there was an international group. His wife Sue was a very good cook.*

CH: Yes, she was a good hostess; she was great. I really lost touch with Barry at the point when he split up with Sue, which is sort of more or less the time I was getting more closely involved in Art & Language. Art & Language had this exclusive side, so it wasn't easy to remain committed to them and keep a wide liberal circle of other friends.

PL: *You've written about attempting, in the context of Art & Language, to elucidate and demystify art practice. Was that something you were thinking about at the time, or is it something you thought of later?*

CH: Well, it was connected to that sense that I mentioned earlier about the language having given way on me. The language I was used to deploying and thought I was comfortable with was one that involved a high degree of mystification. And what I saw that the Conceptual art movement was engaged in was a kind of necessary process of sterilisation, both of the practice of art and of the conceptual vocabulary of art. The realistic aspect of that sort of hard-nosed Conceptual art was its recognition of the fact that this culture was failing, and that it was failing because of certain kinds of presumptions and investments that it depended on that were no longer sustainable. So something had to be done, something had to change. Not, I think – and this is where Art & Language parts company with somebody like Kosuth – as a basis for a new permanent kind of career, but as a necessary and contingent part of a particular moment – a sort of crisis in art. So it was like a sort of forced re-education programme – certainly it was that for me – which made it possible for me to start writing again, but writing in a slightly different way. I would like to think, in a slightly more intelligent, slightly more useful way. I remember there was this quote from Walter Benjamin talking about Brecht – or reporting a conversation about Brecht. Somebody says to Benjamin, 'Well, the trouble with Brecht's plays is that you don't have the magic', and Benjamin says, 'Yes, that's the job: to get rid of the magic.' Of course, he doesn't mean that art has no transcendental properties, or that we have to dispense with art altogether. But it means that you can't go on making critically significant culture out of certain kinds of illusion any more. I think that was the spirit in which Art & Language was working in the late 1960s and early 1970s.

PL: *But in some way your contribution as a writer to that project was to work*

towards this elucidation and demystification process, wasn't it?

CH: How do you mean?

PL: *That as a writer you were contributing to this demystification process.*

CH: I think I saw my contribution rather more as that of an editor. I mean, I was attracted initially to the writing of Art & Language and in particularly of Michael Baldwin, because it was so hard to understand, because it was so difficult. I was fascinated by the difficulty and I sort of thought I could understand it and therefore make it transparent so that other people could understand it. That was completely misguided. It was a hangover from my old sense of patrician responsibility.

TG: *Public service, as it were.*

CH: Yes, a sort of public service. It was completely wrong. Because of course it has always been the case with Art & Language writing that when it's opaque, it is strategically and deliberately opaque and it's not aspiring to be transparent; so when you render it transparent you turn it into something else. So in fact, the only job for me to do as an editor was basically to correct the spelling mistakes and the punctuation and sometimes to get some of the syntactical confusion straightened out. I have to say, I was probably about the only person around who had the rather strange mix of competences to be able to do that, so it was sort of useful. I can understand the stuff. But I have learnt that understanding it doesn't mean rendering it transparent, because in doing that you change its substance and its meaning. It's a funny kind of balance to strike. So there wasn't this overseeing, responsible position. The only way to get involved in the work was literally to get involved in it – to join it.

TG: *To be part of it and not to provide a meta-discourse or explanation of it.*

CH: I kept trying. I kept trying to organise Art & Language. You know, I thought that was my job – to organise it. I was completely mistaken, and I made a fool out of myself every time I tried. If you're an author, you're an author of your own stuff. It's not a good idea to try and be an author of

someone else's stuff. There are other things you can do with other people's stuff. You can get other people interested in it, you can read it yourself, sometimes you can collaborate with it and make something else. But you shouldn't try to be an author with other peoples' materials. And I had to learn that that sense of responsibility I had – that somehow it was my responsibility to be in charge of things and to help spread them and so on – that that was crap. It took me a long time to learn that lesson, and every now and then I still fall back and make mistakes. But I've had to learn that I should never be in charge of anything.

TG: *Well, with* Art in Theory *you were collaboratively in charge. It was quite a big project.*

CH: It was joint work. It still is, because Paul and I are working on an extension to the series at the moment. That's different. It's collaboration. I like collaboration. I've always liked collaboration.

TG: *You mean you should never actually direct something because you feel you're temperamentally unsuited to it?*

CH: It draws from the wrong part of my character, my psychology, my background, my education. And it draws from all the parts that are not very creative and probably are in the end conservative.

PL: *But there's no big ethical claim about it?*

CH: No, it's just a personal thing. It simply has to do with some ways in which we all have to move away from our origins, our background.

TG: *However, there are some ethical things that are buried here, about professional ethics, about making lines between what you're doing and what you seem to be doing. I mean this question of authorship and being clear about what's your work and what's someone else's work which came up perhaps even when you were talking earlier about the Whitechapel proposal and the fact that you were making work outside in that idiom.*

CH: Yes. I would say that I was too close to making work out of other

people's work. One of the things that Art & Language gave me was the possibility not so much of doing that, but of actually collaborating. I really like collaboration.

TG: *Then it's declared, it's shared and it's understood.*

CH: The best kind of collaboration is where you can't tell the difference between what you've made and what someone else has made. That's the best kind of collaboration, I think.

TG: *But what was curating like in that respect?*

CH: Awful. Because it is always ringed round with odious compromise. Because of the compromises that I necessarily found myself involved in. All curating has to involve compromise, obviously, but I felt that in each case it involved a sort of betrayal of the work that I saw myself as responsible for. I never felt as a curator – or very very rarely – that I was really in a position to do what I think a curator should do, which is to give the work its own best case. This involves a standing back. It's very hard to do that standing back if at the same time you are there as the advocate, the manager, the fixer and so on. I just found that combination deeply uncomfortable. I was actually terrible at talking to the press. They would just get up my nose. I was just rude to them. It was disastrous.

PL: *Is this condition you describe necessary to any type of curating, or do you see it as particular to the conditions when you were curating at the ICA?*

CH: I wouldn't want to blame the ICA or the *Attitudes* show. I think a lot of it was to do with the limitations of my personal psychology.

1 Charles Harrison, *English Art and Modernism 1900–1939*, Yale University Press, New Haven, 2nd edition, 1994.
2 Charles Harrison, 'Against Precedents', *When Attitudes Become Form*, exhibition catalogue, Institute of Contemporary Arts, London, unnumbered.
3 *Ben Nicholson*, Tate Gallery Publications, London, 1969.
4 *Op Losse Schroeven: Situaties en Cryptostructuren*, Stedelijk Museum, Amsterdam, 15 March–27 April 1969.
5 Piero Gilardi, *Op Losse Schroeven: Situaties en Cryptostructuren*, Stedelijk Museum, Amsterdam, 15 March–27 April 1969, unnumbered
6 Piero Gilardi, 'Primary Energy and the Microemotive Artists', *Arts Magazine*, New York, September/October 1968.
7 *Zero to Infinity: Arte Povera 1962–1972*, Tate Modern, London, 31 May–19 August 2001.

Conversation Four

Teresa Gleadowe and Pablo Lafuente, *Afterall* | October 2008

TG: *You have spoken about your lack of interest in curatorial history or exhibition history, or maybe it was curatorship in general. You talked about exhibitions as constructions that you have to see through to get to the work, and suggested that that is why, on the whole, you like monographic shows rather than essay exhibitions of the* When Attitudes Become Form *type. I wonder if you could tell us more about this, what might be described, I suppose, as a lack of interest in the meta-discourse around curating.*

CH: It's really a question about priorities, and obviously my primary interest is in the art. And yes, there are things you have to pay attention to, to get to it, but I would put the analysis of curatorship fairly low on the list – or alternatively, as something which is not so demanding that you have to put an awful lot of time into the analysis of it. I was probably shooting off at the mouth a bit in talking about a preference for monographic shows, because I would have to say that big survey exhibitions have been quite important to me. They tend to be mostly things I saw at quite an early stage I suppose.

I remember a show called 54/64 at the Tate – a big Arts Council show curated by Philip James, Alan Bowness and Lawrence Gowing.[1] That was important because it was an opportunity to see a lot of stuff, and to try and make discriminations. It is often the case in these large shows that you get alerted to certain artists – that they stand out. I have always liked that process of discriminating among a lot of stuff, from big mixed shows to going around Portobello Road trying to find something that's worth looking at – whatever it might be. I just like doing that. I like exercising discrimination. So that's the sense in which I like big mixed shows. But I

would see trying get one together as a horrifying enterprise.

TG: *So what kind of a mixed show was* Attitudes? *I mean it sounds like it had the virtues of having this big pool.*

CH: Yeah, yeah, it was great. It was a big survey show. In that sense it was very good. It introduced a lot of stuff. But I'm not sure how well you could actually see the stuff. I would say that with *Attitudes* – partly because of the nature of the stuff – unless you really had a bit of an inside take on what's involved in putting the stuff together, it would not have been too easy to sort the worthwhile from the rest. I certainly came out of it with a stronger sense of which artists I'd put my money on, but then I'd been fairly closely involved with the stuff. For instance, I'm not sure that somebody who came to it entirely fresh would have picked out the steel floor piece by Andre. For me, that was one of the best works in the show, but I don't know quite how easy it would've been to pick that up.

TG: *I guess I understand your reservations about the current preoccupation with curatorial activity, but when we last talked about this, what I argued was that in the late 1960s, around the time of* Attitudes *and a bit before, there was a convergence of what might be seen as a kind of curatorial endeavour, at least a certain discussion about how space was going to be used, and how work actually made in the space of presentation, rather than the studio, would be communicated to the public. And so the whole notion of curatorial activity really changed; in fact, you saw it dramatically, I suspect, between the Nicholson show, where a number of works selected from the artist's whole career were hung on walls in preordained spaces, and* Attitudes, *where you were trying to re-enact, recreate, re-perform this kind of chaotic space of creation.*

CH: Yes, it was a completely different sort of experience. It was a lot more fun – partly because it was a lot more social; there were a lot more artists around, whereas at a place like the Tate everyone was walking around with a poker up their ass. It wasn't like that at the ICA, so it was much more liberating in that sense.

TG: *The other point is about the convergence of curatorial activity with the making of art.*

Works by Bollinger, Andre, Flanagan and Morris, *When Attitudes Become Form*, ICA, London, 1969

CH: I understand what you are getting at, and to some extent I guess it's sort of true. I think there are two ways of looking at that, which are not mutually exclusive. One is that the nature of the art is such that it is sort of emancipatory and liberating in a sense that it allows a wider range of people to have an input into the decision-making stages, into the creative process. So in that sense it is kind of co-opting in a positive way. That is the positive case for it. The negative case for it is that, despite all the aims and claims to be democratising and liberating, the actual effect of that work was to extend the reach of management into art and into the creative processes and to help usher in the kind of age we have now, where what you get is a form of collaboration between institution, creation and artist, leading to the management of public spectacle. It seems to me that both those things are true and they are not so easy to pull apart. They were not so easy to pull apart at the time. I'm not even quite sure where you might say that there was a possibility of exercising ethical choice at some stage of the process, to push it one way rather than the other. To be fatalistic about it, you could say that it's just one of the ways in which art has inescapably changed the whole nature of art business, art display,

art curatorship and the relationship between them all. That relationship has necessarily changed in correspondence with all kinds of other ways in which the world has changed in the last 45 years or so. We might try to pick out moments and possibilities of decisions, and nodes where things might have gone one way or the other, but that process would be really difficult. I would say now that a lot of processes and tendencies that I, along with a lot of other people, really welcomed in the late 1960s and early 1970s may not necessarily have been benevolent. Some of those tendencies have unquestionably been important factors in leading to the situation now, which I deplore and decry, where it seems to me that we have lost a crucial kind of autonomy in understanding the character of art and in evaluating it. Things happen like that.

TG: *Can you expand? What do you mean about the loss of autonomy following on from the changes that happened?*

CH: Right. Some of this is technical. Take a painting, an abstract painting, say a Rothko. There is a sense in which it is very importantly self-contextualising. He was very clear about the kinds of conditions under which he wanted it seen. These were conditions that were designed to concentrate attention on the things that he felt he had made, so that the values involved would be protected from certain kinds of outside incursions. We don't have very many circumstances in which we could reliably say of the experience of an individual work that it can possibly be seen like that anymore. That's partly because of the ways in which art itself has technically changed, and partly because of the consequences of all those changes in our ways of criticising and conceptualising and writing about art that have occurred over the last 50 years or so – some of which have been inescapable and necessary. It is partly, I think, a consequence of the erosion of certain kinds of traditional boundary between art and fashion, art and commerce, art and popular culture, and so on – boundaries which were crucial to the modernist sense of value and autonomy in art. These were the aspects of culture that were heavily criticised in modernism. The sense of separateness from fashion and popular culture and so on was crucial to modernist art's establishment of its defenses. That separation is itself, of course, open to criticism. The breaking down of the separation has certainly hugely enlarged the market for art, and

the public for art. But there has been an inevitable loss of certain kinds of possibilities for concentration and depth. Whether concentration and depth are lost as it were in the practice and production of art, or whether it's in the experience, or whether in some combination of the two, I think is really hard to tell. I don't know. But a third possibility is that the reason I feel this has happened is simply because I'm out of touch and I'm an old fart, and because that's what old farts always think is happening. That is also a distinct possibility.

TG: *Would you put the beginning of this process at this moment in the late 1960s?*

CH: I would put that as the point at which these things become quite overt and describable. But you can take the point of crisis back to 1915 with Marcel Duchamp.

PL: *You could think of high modernism as a blip in art history, and what happens in the late 1960s as a return to the 1920s. Or do you think that the key is the development of late capitalism?*

CH: I think the two are connected. One of the things that capitalism seems to require – and I have seen this most at close hand in the area which I know about, which is in higher education, where there has been strong pressure from above, and I don't just mean from the management of the university, but from the government and so on – is an erosion of specialisation, a movement into interdisciplinarity, a crossing of boundaries and so on. So where traditionally you might have people producing literature courses that concentrate on the nature of literary language, and art history courses that concentrate on painting, let's say, there is now much more institutional pressure to produce interdisciplinary courses that are organised on a broad thematic basis. These are supposed to facilitate the transferability of skills and to offer greater possibilities of consumer choice and so on. Okay, there may be something in those arguments, but if you go in that direction, one of the things you lose is the intensity and depth of study that specialisation produces. Of course, we know about the kinds of limitation that specialisation also entails. But there is a kind of automatic assumption that breaking down disciplinary barriers is progressive – which it may not be. The argument for breaking

down barriers between artistic media operates in precisely the same way. It may facilitate all kinds of expansion of choice, or may lead to a degree of democratisation of the study or the experience of art, say, but it also unquestionably leads to loss of certain kinds of specialisation and of the intensity and depth which go with them. That's not an argument for saying that everybody in art school should learn how to draw, how to model, how to carve and so on. Of course, you can't put the clock back technically. But it is important to recognise that not all arguments for the breaking down of barriers actually lead to intellectual improvement, or improvements – to use that dangerous word – in 'quality'. These are just real problems. It may be that loss of disciplinary specialisation or medium-specificity is a price we inescapably have to pay for other things necessary to the products of modernisation. Maybe we don't have any choice. But at the same time, it doesn't follow that all the outcomes are unmistakably good.

TG: *But maybe one of the things that this pursuit of curatorial innovation has done – this way of operating that curators often describe as self-reflexive, or that you might simply describe as rather self-conscious – is to try to focus on certain very specific forms of presentation that are bracketed in a certain way. Artists do it as well. In answer to what you were saying earlier about Rothko, one thinks of someone like Chris Ofili, who has gone much further than the scheme for the Seagram Murals and asked an architect to design him a special room in which his paintings are always to be displayed, so the institution acquiring the paintings also had to acquire the room in which the paintings were going to be shown. This might be described as an attempt quite consciously to pull things out of this inter-disciplinarity.*

CH: Yes. Artists used not to get that power of manipulation until they died. And it's probably better that way. I mean, the Tate's now stuck with Ofili, who may look very different from the perspective of 20 years ahead.

TG: *To get back to the essay, which was also published in* Studio, *'Against Precedents', which we've been circling a bit: it began with that sentence, 'Art changes human consciousness' and then you go on to propose that: 'We stand to gain by the impact upon our consciousness of a variety of experiences relatively unrestricted by particular circumstances. By opening ourselves to such experience we render possible the realignment of our own consciousness in favour of the*

constant rather than the immediately insistent factors of human life.'[2]

CH: Oh God.

TG: *Which does rather suggest that you saw contemporary art as in some way,
well, revolutionary or capable of changing human consciousness, which may not
be the same thing. Was this the first time you thought about the potential of art in
that way?*

CH: No, no, no, I'd always seen art as part of a changing culture. But all that
stuff about human consciousness is ghastly. Ghastly!

TG: *How did it seep into you?*

CH: I shudder to think. It's just pretentious, over-inflated. It smacks of the
pulpit.

TG: *Well, you did talk about 'messianic zeal'. But if one moves on in that essay,
you clearly felt that you had some kind of responsibility to advocate this work to
a British audience, and maybe you over-advocated it because you felt there was
going to be a resistance. At the end of the essay you even talk about how London
galleries should pick this work up and about how none of it has been shown in
Britain.*

CH: The practical bits are alright. There's some stuff on Andre, I think,
which was okay, but the figure in the pulpit looms in front of the art. It's
awful.

TG: *But did you anticipate that there would be a pretty limp response from the
public? Do you think that is part of why you thought you had to get into the pulpit?*

CH: I remember a sort of anti-climax. The response was typically English.
It was fairly open, but there was no sense of enthusiasm or commitment.
I had felt completely absorbed in the exhibition and the work. I had a sort
of missionary feeling about it. I took it very seriously, very earnestly. Too
much so probably. I wanted everybody to see that it was the most fantastic
exhibition there had ever been, the most wonderful art that ever was.

So I was disappointed by the reception. Other people didn't take the work as seriously as I did. This is one reason why I learned that I shouldn't do things like organising exhibitions. I was frustrated, and I was deeply suspicious of the press. I had to do an interview with someone from one of the quality Sunday papers, who was going to do a feature on the show, and I insisted that he showed me what he was going to publish, which he said he never did. It was printed with a photo of me in a floppy hat with Morris's felt sculpture behind and the title 'A Deeply Felt Experience'. And I think that was the most substantial coverage of the show. It was pretty ghastly – composed of general arts kinds of comments. I thought the press coverage was neither here nor there. It's the usual thing with generalist art criticism: people pretending to be on top of stuff and to have insights when actually they know nothing about it. I was just not very good at these public relations. I felt confused by the response, and in a way also by my own commitment. For me personally, it was great to meet the artists and so on. I very much enjoyed working with artists. I had to learn that artists were just like anybody else. You learn that some are great, some are nice, some are interesting, some are boring. I think I was quite idealistic, then. I certainly believed very powerfully that this was a new movement, that it was historically very important. Which I still do, in some ways, though I think, inevitably, the major artists of the movement were only a small number.

TG: *But it was an important show.*

CH: It was.

TG: *You know, it did bring to London for the first time a whole raft of artists who certainly should have been shown in London by that time and would have been if London hadn't been the provincial place it was.*

CH: Absolutely.

TG: *So your 'messianic zeal' might be seen as heroic, actually.*

CH: No. I wasn't responsible for bringing the stuff to London. I just installed it and then played the advocate.

PL.: *There's a passage in the text which is quite curious, where you start saying that there is an imbalance between the attention that the artists who made the work gave it, and the amount of attention audiences normally give it. So you start off, before the show even opens, with a dig at the conventional attitude of audiences attitude towards this type of art.*

CH: Yes, I was prone to that – slightly paranoid.

TG: *Or realistic.*

CH: Also quite realistic. It was certainly borne out by the general reaction to the show.

PL: *When you were involved in this process of 'organising' art, were you thinking of an audience?*

CH: Not really. It's a failing of mine, generally, not to think about audience, particularly when I'm writing – except when I'm writing teaching material, and then it is very different; then you've got to have the audience in mind and their expected level of comprehension and so on. It's a completely different job. I think it's dangerous when teaching and criticism get confused. I don't think it's the critic's job to teach. I think the critic's job is to discriminate and in some sense to try and serve the art. If you have an audience in mind, it bends your discriminations. The two just don't belong together.

TG: *You talked about a powerful element of the theatrical, especially from the European artists, and I got a sense, again, reading this essay, of some ambivalence about theatricality.*

CH: Yes.

TG: *Maybe more than ambivalence – maybe hostility or lack of interest in theatricality?*

CH: Lack of interest, that's it. I'm not far off being a Friedian on that issue. I like the theatre by the way.

TG: *Yes, as theatre, but the work that attracted you was the work that was more factual in its use of materials?*

CH: More material – or more concentrated.

TG: *Where its presence arose more out of the nature of the materials?*

CH: Yes, yes.

TG: *Which you described precisely in terms of Andre's use of materials in a way that their nature suggests. So were you at that time really beginning to define for yourself what Conceptual art was, and if so, were you thinking that there were certain artists in that constellation who met that definition and certain artists who didn't?*

CH: I was certainly thinking of that and was certainly strongly influenced by the artists I was talking to, in particular, Joseph Kosuth and Michael Baldwin and Terry Atkinson. Terry not quite so much, because Terry's talk tended a bit to the managerial side of things. But very much Joseph between 1969 and 1971. We were very close then, though we became less so after that. He and I corresponded constantly over that period. And certainly Michael Baldwin and Mel Ramsden, who I got to know really from 1970 onwards.

TG: *So had you met Baldwin at the time of* Attitudes?

CH: Yes. By the time of *Attitudes*, in fact, I was already beginning to throw in my lot with the Conceptual art strand. I first met Terry Atkinson and Harold Hurrell before I went to New York, so it must have been at the very beginning of 1969 that they came to *Studio*. Then I met Michael Baldwin fairly soon after coming back from New York. I went up to give a talk at Coventry and met him and Dave Bainbridge there. The point at which I really saw my relationship with Michael develop was after an article I had written in *Studio* in November 1970. It was on Art & Language, Kosuth and Burgin, trying to draw attention to what I saw as the importance of their work. Michael and Terry came to visit us in London at about the time that came out. And I remember Michael walked through the door and the first

thing he said was, 'Your article was a load of crap.' It was the first time I'd ever heard an artist whose work I'd praised suggesting that there might be something wrong with the terms in which I'd done it. It really impressed me. It was very refreshing. Generally speaking, you could write any old crap about somebody and so long as you said their work was good, they thought what you'd written was wonderful. And he was entirely right. He wrote about a page of comments and criticisms on the article. I remember thinking, 'These are people I can really learn from and with.' And that was really the point at which I started to get to know Michael. So when I organised the ghastly *The British Avant Garde* show in New York, I wrote an introduction for the catalogue – it must have been in February or March 1971 – and I thought, 'I'm not going to make that mistake again.'[3] So I got a draft of the article and drove down to see Michael – he was living near Chipping Norton then – and I said, 'Okay give this a read through before I publish it; this time tell me what's wrong with it before I publish it.' So he went through it with me and he actually didn't have too many criticisms. That was the beginning of a kind of collaborative relationship with Michael that persists to this day.

TG: *They were in that show as well?*

CH: Yes, I had talked them into being in the show.

TG: *Was it difficult to talk them into being in the show?*

CH: Yes. Some of them more than others.

TG: *Because they didn't like the company or what?*

CH: They were suspicious of mixed shows, and quite rightly. I remember I drove up to see them in Coventry or Leamington; that's when Art & Language still meant Terry Atkinson, Dave Bainbridge, Michael Baldwin and Harold Hurrell. It must have been the previous year, in 1970, before I did the *Idea Structures* show.[4] Somewhere in an archive I've put together there's a letter outlining the various projects I had in mind that I wanted to involve them in – which included *Idea Structures*, then a show at CAYC in Buenos Aires, *The British Avant Garde* show and one or two other things

David Bainbridge, *Lecher Lines II*, 1970, in *The British Avant Garde*, CAYC, Buenos Aires, 1971

which I forget – and assuring them of various conditions. I sent this letter after I'd driven up and had a meeting in a pub with the four of them. This was the point when I really committed myself to Art & Language. But I was still seeing myself as this sort of responsible entrepreneurial art-world figure who was going to explain to the world how important Art & Language was. I can't remember very much about the meeting because we drank an incredible amount. I nearly fell asleep driving down the M1 on the way back to London.

TG: *Dangerous, yes.*

CH: Different days. Red Label Bass.

TG: *So that was the point when you had to persuade them to be in the New York show. Was there for you a kind of tension between your previous life and these important new intellectual relationships? I mean, was there a moment at which you discovered it wasn't possible to sustain both?*

Art & Language works installed at *The British Avant Garde*, CAYC, Buenos Aires, 1971

CH: It became increasingly clear. My attempts to help Art & Language get published in *Studio* brought me the suspicion of other artists whom I'd thought were friends. By 1970 I was beginning to understand that the price of 'success' as a critic/curator would be considerable personal unhappiness and frustration – a large address book but no real friends. Art & Language offered a different possible model of working relations. It was one that was very unfamiliar to me, but probably the more attractive for that. One thing that made the change clear was that having been a very welcome visitor at St Martin's, I was suddenly regarded with the deepest suspicion, largely as a consequence of inviting Joseph Kosuth and Vic Burgin in to talk to the students. I'd put myself beyond the pale. So I learned at that point ...

TG: *That you were a pariah?*

CH: Well, that the art world was certainly split – which reinforced that sense of one regime breaking up as another one became established. That was coming from both directions because the Art & Language people, both Dave Bainbridge and Harold Hurrell, were completely contemptuous of the

teaching regime at St Martin's. Dave was briefly a student there and Harold was taken on as a technical assistant. He described a situation where all these people were making art with all this machinery they couldn't work and didn't understand. He described his first day at St Martin's. The head of department Frank Martin said to him 'Right, there is an aluminium-foil machine over there which seems to have something wrong with it. Can you attend to it?' Half an hour later, Harold was in the canteen with a cup of coffee. Frank came in and said, 'I thought I told you to sort that machine out' and Harold said, 'I have. Here's a list of the parts you need', and Frank was completely flabbergasted, because what he had in mind was that Harold should go in and wrestle with this machine.

TG: *Blindly?*

CH: Harold's a trained engineer. That's his little encapsulation of the relationship between the St Martin's sculpture department and new technology. Harold and Dave regarded people like Phillip King as completely primitive – which he was. Nice guy, but completely primitive. Within Art & Language there was that kind of animosity and hostility to modernist pretension within the art world.

TG: *But then people like McLean, Flanagan, Gilbert & George and others who had been students at St Martin's had themselves had some problems with Caro's teachings, so was it immediately also a difficulty for you to maintain your relationship with Flanagan and McLean, for instance?*

CH: No, there was no problem maintaining a relationship with the other generations at St Martin's. There were intermediaries like David Annesley, who was a complete devotee of Caro on the one hand and a sort of sup-porter of the younger avant-garde people on the other. And Caro was fairly supportive of Long in his way. I remember photos of Long's work being pinned up outside Frank Martin's office. That must have been in 1968 or 1969, when I was teaching there. There was pride in a kind of St Martin's tradition. It was Conceptual art that was different.

TG: *Right.*

CH: It was seen as quite different. What even Gilbert & George and Flanagan and so on were doing was seen as art of a kind. But Conceptual art was seen as not-art, as against art.

TG: *But we're actually talking about a particular kind of Conceptual art. We're talking about analytical Conceptual art, because McLean's work was still seen as art.*

CH: Bruce McLean wasn't a Conceptual artist.

TG: *No.*

CH: At all.

TG: *No.*

CH: He was a kind of performance artist at that time – with a Pose Band.

PL: *When did the tables turn? When was this kind of practice not acceptable any longer?*

CH: 1969–70. I mentioned before that sense that there was a time when everybody could share in the glow of the avant-garde moment, but that at a certain point more serious directions get singled out – as a kind of purist abstract art did in England in the mid-1930s. And suddenly the avant-garde splits and people are taking sides. You can see what happens in the mid-1930s – a bit of art history I do know well. People like Geoffrey Grigson and John Piper had been a part of this larger avant-garde circle, but by 1936 they are coming out in favour of a kind of slightly dilettante, literary consciousness, which they see Nicholson as out to destroy. They are being terribly gentlemanly about it, but that's how they see it, no question.

PL: *Just one more question – how did* The British Avant Garde *show in New York come about?*

CH: That came about partly through the manipulations of Joseph Kosuth. He'd got alongside a guy named Donald Karshan, who ran the New York

Cultural Center – one of the world's great shits! He'd put on a show called *Conceptual Art and Conceptual Aspects* at the New York Cultural Center (NYCC) in 1970, which was the first real show of Conceptual art – as opposed to the wider avant-garde – and he'd done that with Joseph's hand up his back. Joseph and Ian Burn were sort of standing over Karshan when he was curating that show. So Joseph had a kind of client-like relationship with Karshan – as did Ian. Ian was actually also close to Frances Archipenko. She was the young widow of the sculptor, and was having an affair with Karshan. I stayed with Joseph and Christine Kozlov, I think it must have been in the spring of 1970. We went out for a weekend with Donald Karshan to Frances Archipenko's place in upstate New York – a lovely house, full of Archipenko's collection of primitive art, which was fantastic. So we spent a weekend, an awful weekend, playing competitive board games, eating out at McDonald's and going to bad movies.

Part of the whole programme for this was that Karshan had organised a show called *The Swiss Avant Garde* and he had this plan for a series of national avant-garde shows. I didn't know that. But Joseph was pushing me as a mate of his, and through me, Art & Language. The idea was that if I curated this show at the NYCC, then I could put Art & Language and other mates into the show. Joseph suggested to Karshan that I would be a good person to organise the show, so a deal was struck that I was going to organise a show of British art at the NYCC. It wasn't until things got pretty advanced that I found out that this was supposed to be one of a series following *The Swiss Avant Garde* or that it was supposed to be called *The British Avant Garde* or that what Karshan required was x number of artists. My idea was for a fairly select show, rather like a New York version of *Idea Structures*. But Karshan wanted it as a survey show with a much wider catchment and he insisted on certain people being in it, like Gilbert & George, whom I would have kept out of it at all costs – well actually, not at all costs, since they were included. So the show ended up as a kind of survey. I had to run around finding people to put in it, and the whole thing was the most ghastly mess. I was also absurdly overstretched with the various things I'd taken on. I'd done a Conceptual art show for CAYC in Buenos Aires that same spring.[5] I actually had to drive around London picking up the work for New York and taking it to Pitt and Scott's warehouse so it could go into a container, and I was editing the catalogue as a special issue of *Studio International*, teaching all over the place, and

doing all the kind of mad things you do if you are trying to be a sort of creative entrepreneur, and my marriage was breaking up at the same time – I wasn't fully aware of that at the time – and I had a kid. I had this mad trip when I flew to Buenos Aires and did a couple of lectures and tried to re-install this show that Jorge Glusberg had made a complete mess of in Buenos Aires. I had a completely unreal week, giving a couple of lectures and meeting artists, then flew direct to New York in time to find out that the container full of stuff had got held up at the docks and Karshan had gone away and locked the offices. I was told that I wasn't to be allowed access to the administrative level and so on. And meanwhile there were things to do like finding out where you get a ton of sand to be delivered to Columbus Circle in mid-Manhattan for the Barry Flanagan piece, and sorting out the difference between British tape recorders and American tape recorders so that the tape pieces could play and so on. You can imagine. I think we had two weeks. I was staying at Joseph's and I was stoned out of my head most of the time. When Karshan got back I completely fell out with him. And after that he organised this terrible struggle session where he got his staff in to say what an impossible person

Barry Flanagan works from 1965–67 installed at *The British Avant Garde*, NYCC, New York, 1970

I'd been and how hard to work with and so on. They all came up to me afterwards and apologised and said they'd been told to say it. The whole thing was a nightmare, an absolute nightmare. I finished up the day of the opening having shovelled a ton of sand into the Barry Flanagan pillars – in the middle of a hot May in Manhattan – and I had sand all down my back, and at that point the press came in. I didn't want to talk to them and all I could do was tell them I was busy. The whole thing was a nightmare. The show got panned. It got panned by people who hadn't even seen it. It was even worse when it got condescended to by people who were trying to be nice. The whole thing was frightful, and I just felt I had let all the artists down. The work looked ghastly in the Cultural Center, which has this sort of art-deco panelling and round windows. Imagine trying to put stuff in there. The flooring was a sort of fussy patterned parquet. Richard Long's piece was a spiral of little wooden twigs and they just looked terrible. The whole thing was a nightmare. That's when I learned that the curator's life wasn't for me.

TG: *Didn't you say that show had some relationship with* The New Art *at the Hayward in 1972?*

CH: Well, I went to the British Council to try and get support for the New York show and got absolutely nothing.

TG: *That's when Lilian Somerville was there.*

CH: Yes, but I didn't see Lilian. I got on well with her. I saw some junior person. I didn't know how to go about it – which is a great big part of the job. I just thought you phoned them up, you gave your spiel and you got your money. But I got virtually no support, no backing, nothing. And as I say, I really did do all the work – literally collecting the art and so on. And nobody in England took any notice of the show. And then the following year *The New Art* show opened with full institutional backing, with virtually the same list of artists.

TG: The New Art *at the Hayward in 1972?*

CH: I felt a bit pissed off with that.

Roelof Louw, *Sculpture*, June 1968, at *The British Avant Garde*, NYCC, New York, 1970

Works by Colin Crumplin, David Dye and Andrew Dipper, *The British Avant Garde*

IDEA STRUCTURES

KEITH ARNATT
VICTOR BURGIN
ED HERRING
JOSEPH KOSUTH
TERRY ATKINSON
DAVID BAINBRIDGE
MICHAEL BALDWIN
HAROLD HURRELL

LONDON BOROUGH OF CAMDEN
SURVEY '70
JUNE 24-JULY 19
AREA 1
CAMDEN ARTS CENTRE
Arkwright Road
London NW3
AREA 2
CENTRAL LIBRARY
Swiss Cottage
London NW3

Cover: Exhibition
catalogue, *Idea Structures*,
Camden Arts Centre,
London, 1970

TG: *Yes, understandably. Can you tell us a bit more about* Idea Structures.
I don't know anything about it.

CH: It was at Camden Arts Centre. The artists involved were Keith
Arnatt, Vic Burgin, Art & Language, Joseph Kosuth and someone called
Ed Herring, who I don't think I ever met. He was there simply because he
was a hangover from a previous plan. There was a guy who worked at the
Camden Arts Centre, and whose name I had better not remember. He'd
been supposed to organise a show and Ed Herring was a mate of his. He
just sort of collapsed. So I was asked to take it over, with the condition
that Ed Herring got to be in the show. So I tried to absolve myself of all
responsibility for his being in the show. In fact, I've learned only quite
recently that it was him that took photos of Keith Arnatt's early works

while Keith was still living and teaching in Manchester. So I beg his pardon.

TG: *Had you had any previous contact with Keith Arnatt?*

CH: Yes, he was a friend through Barry. I saw quite a lot of Keith. He would come up to London and we'd spend the night down at my local pub in Islington playing darts and he would always refuse to stay. He'd always insist, no matter how much beer he'd drunk, on driving back down to Tintern. We always offered him a bed. I used to go down to Tintern to see him. He'd send postcards with little proposals for artworks. His main piece in *Idea Structures* was a metal box with an LCD read-out of numbers which counted down the duration of the exhibition in seconds. It was started at the opening and finally read out as a line of zeros when the show closed. We just had that on its own in one large room.

TG: *So not* Self-Burial, *1969?*[6] *There were no jokes?*

Keith Arnatt, *Liverpool Beach Burial*, 1968

CH: No jokes in the show, though *Self-Burial* was printed in the catalogue. The other big gallery at the Camden Arts Centre had this piece by Vic Burgin. I think it was something like twelve sheets of A4 paper, each with a sentence printed on it, wallpapered at even intervals around the gallery. You came into the gallery and it just looked as if there was virtually nothing in there at all. There was another piece of Vic's with sentences on acetate sheets that were stuck to the windows. A pretty minimal physical presence. The Art & Language stuff was mostly essays stuck on the wall, together with a machine by Dave Bainbridge called *Lecher Lines* [*Lecher System*, 1970] and a piece by Harold called *Ingot* (c.1969), which was a collection of aluminium ingots on a plinth. The Joseph Kosuth piece was just a file box with various mathematical puzzles typed on cards. I think Ed Herring's piece was just a small file box as well. That was it; that's what you got.

TG: *Were you satisfied with it?*

CH: Yes.

TG: *It sounds quite uncompromised, this one.*

CH: That's what I thought a show should be like. It's the only show I've ever done that I was satisfied with. I don't think many people even noticed it, and if they did, they probably thought it was a ghastly avant-garde aberration. I think there was a review in the *Hampstead & Highgate Gazette* saying 'What's this rubbish?'

1 *54/64 Painting and Sculpture of a Decade*, Tate Gallery, London, April–June 1964.
2 Harrison, 'Against Precedents', *op. cit.*, unnumbered.
3 *The British Avant Garde*, New York Cultural Center, 1971.
4 *Idea Structures*, Camden Arts Centre, London, 1970.
5 *Art as Idea from England*, CAYC Buenos Aires and tour of South America, 1971.
6 A series of nine photographs depicting Arnatt gradually sinking into the ground. It was later inserted into the programming of WDR3 television each evening between 11 and 18 October 1969. As Arnatt explained, the series was: 'originally made as a comment upon the notion of the "disappearance of the art object". It seemed a logical corollary that the artist should also disappear.'

Keith Arnatt, *2188800–000000*, 1969, *Idea Structures*, Camden Arts Centre, 1970

Victor Burgin, installation, *Idea Structures*, 1970

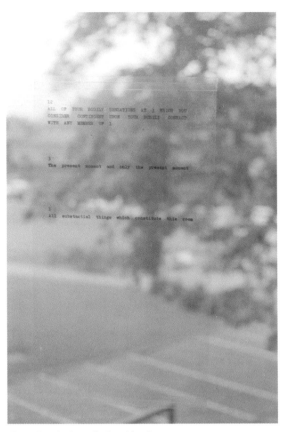

Victor Burgin, installation, *Idea Structures*, 1970

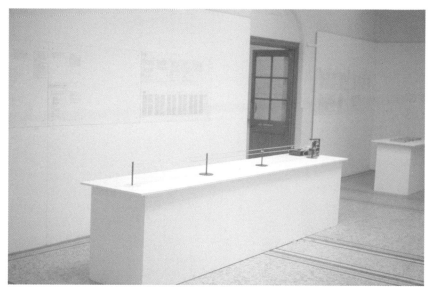

David Bainbridge, *Lecher Lines 1*, 1970, and works by Terry Atkinson and Michael Baldwin installed at *Idea Structures*

Harold Hurrell, *Ingot*, 1970, at *Idea Structures*

Conversation Five

Juliette Rizzi | May 2008

JR: *How did you get invited to curate the English version of* When Attitudes Become Form *in September 1969?*

CH: I had proposed to the ICA an exhibition of a group of English artists. If I remember rightly: Richard Long, Barry Flanagan, Bruce McLean, Roelof Louw (who was then working in England), and subsequently Victor Burgin. These were the artists I had written about in an article titled 'Some Recent Sculpture in Britain' for *Studio International* in January 1969, minus Roland Brener and plus Burgin. The idea was that each of them would have a large space within the ICA, they would install their own work, they would choose what to show, and the ICA would pay them a fee. That was negotiated with the ICA and agreed with the artists. But the ICA was short of money – they were always in financial crisis – and they were offered the *Attitudes* show by Philip Morris, who sponsored it, with a lot of back-up money. This was going to help the ICA out of their problems. But they were offered it for the period in which my show was supposed to take place. I was called from holiday by a man called Harry Kissin, who was a banker. He had been put in to help manage the finances of the ICA, and he demanded that I come and see him at his office in the city of London. He said that the ICA had been offered the *Attitudes* show, which had had a big success in Bern, with a lot of publicity, and that they were proposing to put that on in place of my show. He said that he would like me to curate the *Attitudes* show instead of this other one. I said no, because they were committed to the exhibition I had proposed, and to the artists involved. So we had quite an argument. I said 'I do not want to do this.' He said 'Well, if you don't do it we'll cancel your show and put the *Attitudes* show on anyway.' So in the end, what I said

was that if the artists who would have been in my show got to be in the *Attitudes* show with the works that they there were proposing to install at the ICA, and if the ICA paid the money they were supposed to get, and if the artists agreed to this, then I would do it. As it turned out, the artists were all happy enough – all but Burgin had been in the Bern show and I guess the prospect of a substantial contribution to the show in London was attractive enough. In fact, for most of them it might have been better to be able to present their work in the more competitive setting that *Attitudes* provided.

Why was I asked particularly? For two reasons. One was because I had already proposed the show to the ICA and they presumably had to deal with me somehow. The other, I think, was because I'd been working for two or three years as assistant editor at *Studio*, which was a place where a lot of artists came – not to mention catalogues and magazines full of stuff – so I knew about a certain number of the exhibitors. In 1968 I'd been to *Prospect* in Düsseldorf and to Documenta; and I had also recently been to New York – in spring 1969 – and had met some of the American artists involved; and I had written a little bit about some of that kind of work. So I was probably one of about two people in London who had some understanding of the art – the other one being the American writer Barbara Reise.

JR: *Had you already heard about the Bern show* When Attitudes Become Form?

CH: I'd heard about it, mostly from Barry Flanagan, who was then a close friend and who had been there to install his work, and who was very enthusiastic about the show. I think he was the only one of the people I'd spoken to about it – maybe Roelof Louw also. Both were connected with St Martin's, where I was then teaching.

JR: *How much freedom did you have?*

CH: I was given a more or less completely free hand, partly because nobody else knew what the work was. I mean, the first thing I had to do was go to Pitt and Scott's warehouse in North London, where all the materials that had come from Bern were, and explain which were the works of art and which were the packing materials. I had a set of photos to help. I became a

Victor Burgin, *Photo Path*, 1969, at
When Attitudes Become Form, ICA,
London

bit of an instant expert, though I'd have to say that there were some works
that may not have been quite properly installed at the ICA.

There were, I suppose, three decisions I had to take, and that were left
to me. One was which works to install and which to leave out. A lot had to
be left out for two reasons: one, because many pieces that had been shown
in Bern were not made of permanent materials, so there was nothing to
bring; a lot of the materials were intended for temporary exhibition. And a
lot of the works in Bern had been dependent on their installation by artists
who weren't available to come to London. Secondly, the ICA was much
smaller than the space in Bern, so some works were going to have to be left
out. It was left to me to decide which works would be included and which
would be omitted, but to a certain extent those decisions were taken for
me because many of the works were not there anyway.

The second decision was how to install the works, and which to give

plenty of space to. Well, what I did was to start by allocating space to those English artists who would have been in the show I was going to organise anyway, to make sure they had adequate room: Burgin had his long *Photo Path* down the centre, Louw a large hanging rope sculpture on a kind of scaffold at the back. They both came and installed their own pieces. Flanagan had a large rope on the floor with three canvas pieces on the wall. They more or less placed themselves. Bruce McLean had a group of large works, which he called *Landscape Paintings* (1968). He went to Scotland, with a lot of wallpaper, which he sort of dragged over the landscape and he painted whatever was underneath the paper on the top. I remember being anxious that he wouldn't turn up with them in time, but I had reserved space for him next to Louw's piece at the far end of the gallery. All had a large space to show their work within the exhibition. They were given priority. That was my decision. After that, everything else was fitted in around them. I had photographs from the Bern show. Sometimes things had to go on the wall, others on the floor. Some pieces by Keith Sonnier and Bruce Nauman had neon, so they needed to be in a safe place and near electric points, etc. There was a very good team and a very good gallery manager. They were great at putting the stuff up and they did all the technical work. I'd have given Long space within the show as well, but he just wanted to be represented by his piece in Gerry Schum's *Land Art* (1969) film, which was shown during the exhibition.

JR: *How did you get to know Richard Long's work?*

CH: I was alerted to Long's work by Barry Flanagan, who knew him at St Martin's. I went to see him down in Bristol, I think, though that may have been later. I remember him taking me on a long circular walk in Leigh Woods and then up and down the side of the Avon Gorge. I was suffering from a bout of flu at the time, so it wasn't the best of experiences. I was certainly very interested in his work, but he wasn't one of the artists who became a friend. He was not easy to get to know – it was as though the conceptual fragility of his work had to be protected at all costs – and I was not going to court him.

JR: *Do you know why he didn't want to do anything special for the show?*

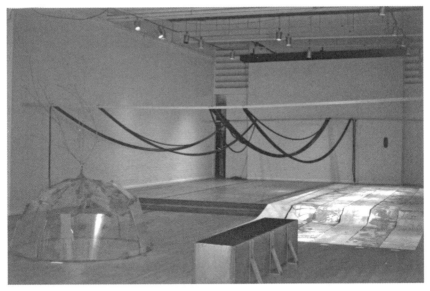

Installation of works by Mario Merz, Sarkis, Roelof Louw and Bruce McLean at *When Attitudes Become Form*, ICA, London, 1969

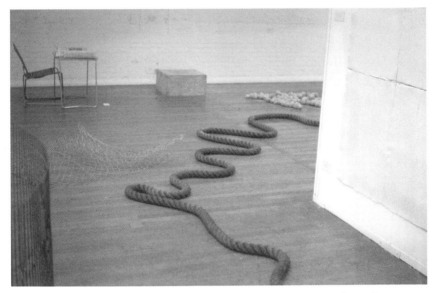

Barry Flanagan, *2 space rope*, 1968–69, at *When Attitudes Become Form*, ICA, London, 1969

CH: Well, I think Long was chary of mixed shows. He took a fair bit of persuading before he would participate in *The British Avant Garde* show I organised in New York in 1971. He made me rehearse the installation of his piece in a car park near the *Studio International* offices to make sure I got it right. He was always quite smart, Long – quite professional in his way. He knew how to play the international role quite well, and maybe he had a sense that showing in *Attitudes* in England was not as important as showing in a similar exhibition abroad. He may also have suspected, with some justice, that his work would get lost in the melee of the ICA gallery.

The other decision that was left to me was which artists to invite to come and do new work at the ICA. Philip Morris made a budget available to invite a certain number of artists, so it was up to me to choose which to invite. Many of those I invited didn't come; they weren't interested in coming, or they were busy, or London at that time was not important enough, or they had already been to Bern and didn't want to get involved in the exhibition a second time. I can't now remember for sure which were the artists I invited who didn't come. I think one was Robert Morris, whom I'd met briefly in New York and whose work I liked. The only case where things might have been very difficult was with Joseph Beuys, whom I invited. I'd seen his work at *Prospect* in Düsseldorf in 1968 during a trip to Germany. I also remember him cooking Schweinhaxe at Daniel Spoerri's restaurant in Düsseldorf – with his hat on – and taking forever over each order. I tried to get hold of him, but instead I got his agent, and his agent said 'Yes, we have a great new work by Joseph Beuys which is a Volkswagen Microbus with 22 sledges with fat and felt, and it just needs four assistants to come over, and they'll bring the microbus with all the material and you just have to pay for the transport.' This would have used up most of the budget for the show, and it would have taken up most of the space – which was presumably part of the point. So I said no. The work was shown at Documenta 7 in 1982, where it did indeed fill a large gallery. So we didn't get Beuys, and we didn't get Morris. I think I asked Walter De Maria. I'd met him briefly in London. The artists who came were Robert Smithson, Richard Artschwager, Jan Dibbets, Ger van Elk, Reiner Ruthenbeck. And I invited Giovanni Anselmo from the Arte Povera group, but in fact what happened was that the group shared the airfare and they all came overland.

JR: *Why did you initially pick Giovanni Anselmo among the Arte Povera artists?*

Joseph Beuys, *The Pack (Das Rudel)*, 1969, installation at Documenta 7, Kassel, 1982

CH: Because he was the good guy of the group. He was the nice bloke. I think I'd met him before, I can't remember where. He was also the one who sort of took charge of the others, the one who looked after them. He was the competent one.

JR: *Did you like his work?*

CH: So-so. I wasn't crazy about any of them, to be honest. Pier Paolo Calzolari I was quite interested in because he was so weird – as a person – and his art was quite strange; you know, over there somewhere. Gilberto Zorio, I didn't much like.

JR: *And Luciano Fabro?*

159

CH: He didn't come. I've never met Fabro. I don't particularly like his work; it's too theatrical for me.

JR: *And Michelangelo Pistoletto?*

CH: Pistoletto, I've never met. I like him by reputation, but I was never crazy about his work. It's so various and hard to get hold of. Those mirror pieces that everybody made such a fuss about: I couldn't really see much in them.

JR: *And all of the artists from the Arte Povera group exhibited in the London show?*

CH: Calzolari, Zorio, Alighiero Boetti, Marisa and Mario Merz and Emilio Prini, Anselmo, all came. Prini didn't include anything; he just got drunk and stoned. They all got stoned. Zorio just showed work that he'd had in Bern, as did Calzolari and Anselmo; they didn't do any new work. Smithson did a new work; Ruthenbeck just installed his *Ash Heap* (1968) – or rather, Dibbets largely installed it for him. It involved a large sack full of ashes

Reiner Ruthenbeck, *Ash Heap III*, 1968, at *When Attitudes Become Form*, ICA, London, 1969

poured over a tangle of wire. Ruthenbeck was a small bloke, and the ashes that were delivered were wet and too heavy for him to lift, so Dibbets did it for him. He came all that way from Düsseldorf for the big moment, only to have another artist do it! There was an amusing sequel to that episode. Jannis Kounellis's contribution to the show was a set of sacks filled with different grains. We installed them on the stairs leading down from the entrance. The hippies would come in and take a handful of grains and chew a few and throw some away. Some landed in Ruthenbeck's ash heap. Conditions for germination were ideal and by the end of the show the ashes were covered with a fine green film of sprouts – as though in figurative expiation of German war guilt. Dibbets brought some new work with him. Ger Van Elk did a new work. I also invited Alain Jacquet from France – which was a mistake. I had seen a show of his of paintings at Robert Fraser's Gallery that I quite liked, but he came and did a stupid thing with lacquer on the wall. He wasn't really much of an artist.

Ger Van Elk wanted to polish the pavement outside the ICA and he had to get permission from Buckingham Palace, which was refused, so we installed the application and the refusal. The 'wall removal' of Lawrence Weiner wasn't done. He sent a new piece, A River Spanned (1969). I just got the title printed on a card and stuck it on the wall. There was a piece by Keith Sonnier that was originally done in Bern with latex and flocking directly on the wall. It didn't make a great deal of sense in the ICA. The only thing to do was to hang it up and peg it out, but the sense of process was largely lost. A lot of the work which came over from Bern didn't make a great deal of sense in London. It was in a different installation, so it had a different status in a way. I came to feel that putting these strange-looking objects into a room was not very radical. What was more critically powerful was giving people nothing to look at, or giving them a text to read – requiring people to construct the object out of what they read. The work becomes animated from the moment when someone is thinking about it and actually engages with it.

JR: *By including the four English artists, did you intend to give an impulse to the internationalisation of English Conceptual art?*

CH: In a way that was forced on me by what happened. I certainly had a very strong commitment to trying to draw attention in an international

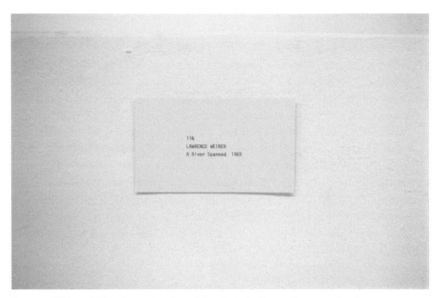

Lawrence Weiner, *A River Spanned*, 1969, at *When Attitudes Become Form*, ICA, London

context to the work of English artists whom I liked and who were my friends. One of the things my own research on earlier English art had taught me is that the artists who matter are the ones who don't want to call themselves 'British artists', but want to be international artists. England was not the centre of the art world. In the 1930s it was Paris. If you wanted to be taken seriously you showed in Paris. In the 1960s and early 1970s, if you wanted to be taken seriously you showed in New York. So I was certainly concerned to try and get the English artists whose work I liked known about in an international context. The chance to include their work in an international show was an opportunity to be taken. I subsequently put together a show of English art to be shown in New York – but that's another story and that was a disaster.

JR: *Since you seem to have met the artists in the Art & Language group between 1968 and 1969 – i.e. before the exhibition – why did you not include their work?*

CH: I planned the show of English artists for the ICA before I got to know the Art & Language artists. I didn't really come to understand their work

until around the time of the *Attitudes* show – until the end of 1969 or early in 1970. I was first drawn to it partly through Kosuth, whom I'd met in New York in the spring of 1969. I got to know Kosuth well before I really got to know the Art & Language people. But they had independently made contact with Kosuth. I have to say that after the experience of doing the *Attitudes* show my own interests became more clearly focused. If you handle works like that you get to know it a lot better and you get to understand which is the good work and which is the weak work, in a practical sense. So by the time I had finished with *Attitudes*, I had a strong sense that while some of these works were very interesting, a lot of it was junk. That's always going to be true with any movement. There was only a minority which was really strong, and by the end of autumn 1969, I think, I was very clear that my own interest was towards the more hard-line Conceptual art. That was partly due to people that I'd met in New York in the spring of 1969,

Keith Sonnier, *Flock Pulled from Wall with String*, 1968, installed in *When Attitudes Become Form*, ICA, London

163

largely through Kosuth.

JR: *Why did you not include John Latham, for example, whose work was in a way coherent with the other works of the show?*

CH: The answer is, I don't know. It was a mistake. He should have been included. I suppose there are two reasons. He wasn't in the original show. You might ask why Harald Szeemann didn't include him – which he should have done, certainly (Latham was quite upset about that). Yes, he should have been included. I think he was probably seen outside England as a sort of eccentric painter. He was also associated with an older generation, while the show of English artists that I proposed to the ICA was of people who were of my generation; they were my contemporaries, and Latham was a lot older. That's not an adequate reason why he shouldn't have been in *Attitudes*, but it is a reason why he wouldn't have fitted in the show that I proposed to the ICA. In fact, before that I had also submitted a proposal to the Whitechapel for another similar show, and I had included Latham in that proposal. But that wasn't accepted.

JR: *Szeemann conceived the exhibition as a 'structured chaos'. Did you agree with this way of displaying the work, or, had you been given more freedom, would you have chosen a different arrangement?*

CH: I had complete freedom over the arrangement. I had the photos of the show in Bern, but the gallery was so different and the selection of work was also very different. For instance, in Bern there was that long line of rubber pieces by Richard Serra, which didn't come to London. And he did his lead-splashing piece there, which attracted a lot of attention. I think Serra was another of the artists I invited. I am not sure whether I did or not, but perhaps not, because I'd phoned him when I went to New York in the spring to ask if I could visit his studio, and all he said was, 'Why is Barry Flanagan doing my work?' – which pissed me off and led me to think of him as somewhat paranoid. But in fact, nothing of his came from Bern, so he was only represented in the catalogue. Unless he came to London to do a new work, there was nothing else by him to put in. So in a way it was a very different kind of selection.

I had a strong sense that what was important in the Bern show was the

idea of artists coming and installing their own work; I was not particularly interested in the idea of the site-specific, but rather in the idea of the artists controlling the installation. I wasn't really interested in Szeemann or in his installation or in his ideas. I was even less interested after he came to London. I thought he was an asshole. I was interested in the artists and in the idea of the artists getting together, meeting, being able to exchange ideas and working within the exhibition space. That's what I liked. I didn't feel constrained by Szeemann's ideas, partly because *Attitudes* was displacing an exhibition which was going to have been my own project anyway.

JR: *Do you think that 'institutional' spaces such as the ICA and the Bern Kunsthalle diminished the revolutionary impact of Conceptual art?*

CH: You are making two assumptions here. One is that all institutional spaces are the same, and have the same kind of power. But there is a lot of difference between a relatively independent sort of avant-garde institutional space, which the ICA was supposed to be, and a kind of state-sponsored Kunsthalle like the one in Bern, or a commercial corporation like the Museum of Modern Art in New York. Something like the *Information* show at MoMA the next year had a lot more institutionalising power than the ICA did. Even in its premises in the Mall, the ICA still had a history of being a sort of artist-friendly, slightly co-op-like organisation.

That's one sort of correction to your question. The other correction is to the assumption that Conceptual art had radicalising power in the first place. Actually, there is another assumption, which is that all the work can be called 'Conceptual art'. One of the things that I was made very clearly aware of by the *Attitudes* show is that Conceptual art was one component of a large international avant-garde, in which there was Earth art, Arte Povera, Installation art, Performance art, Process art, all these various tendencies. They were all very different. For me, Conceptual art was art that used language, that was specifically addressed to certain aspects of the crisis of modernism and particularly the crisis of modernist painting, and that sought to address that crisis through theory and through the promotion of theory as a kind of art. That was the understanding that I acquired largely through Art & Language and to a certain extent through Kosuth. That work certainly seemed to me to have a very strong radical

power, but it had that radical power through its critical power – through its critical and theoretical power – and I wouldn't see that power as diffused by big shows within art institutions, because it was largely invested in the text and in the formal presentation of the work, and if the work was properly sorted out then the presentation would survive whatever the context of the exhibition.

Whereas in fact the kind of art which depended for its installation on the character of the institution seemed to me to be much more likely to be affected by the nature of the context. The work that took its initiative from the dimensions of the space – or proposed some subversion of the space in some way – seemed to me to be much more vulnerable to institutionalisation. Installation art, which sees itself as subverting the institution, seems funnily enough to be almost naturally institutionalised by its exhibition. The same goes for much of what is referred to as 'Institutional Critique'. One of the great advantages of Conceptual art as I understand it – the sort of text-based Conceptual art – is that it's self-contextualising and therefore not so easily diffused.

JR: *Before organising* Attitudes, *did you ever imagine a perfect space for works like these?*

CH: Oh yes, a lot. Obviously I had to think about the space in which the work of English artists I was involved with would be shown. In the exhibition that I proposed to the Whitechapel in 1968 that they didn't accept, each artist was to have had one work in the gallery and one work out in the landscape somewhere, or somewhere outside the gallery. And my idea was that there would have been directions within the gallery to the site where the second work was shown, so that people could travel and see the work outside the gallery. So it was intended as a kind of dialogue between inside and outside. It was a sort of naive avant-garde idea, but that was 1968, and I was young. This was before I got involved with Art & Language. I was interested in the work of Long out in the landscape, and in De Maria's *Two Lines in the desert* (1969). Although I was living in London, I had grown up in the country and I liked the idea of work using the landscape. At that time, I had slight ambitions to make art myself – or at least to try out the kind of art I was seeing. So I used to spend a certain amount of time writing out proposals for works which were intended to

Roelof Louw, *Hampstead Heath*, scaffolding poles placed around the base of a hill, London, 1968

be realised out of doors. I also spent some time in the winter of 1968–69 making things out in the landscape, floating things down rivers, spraying stuff on the grass, things like that. As I say, I was young and it was 1968! So yes, I was thinking quite a lot about where art might be and the idea that art might be anywhere, that you might encounter art without expecting it, that you might encounter something and not know whether it was art or not. That was something that cropped up in outdoor pieces by Vic Burgin and Roelof Louw at the time. I was certainly interested in those kinds of ideas.

JR: *How did the public and the press react to* Attitudes? *How did the English critics react?*

CH: I think the English critics reacted as English critics often do: by diffusing the work, by pretending that they knew all about it in advance, as critics always do. Critics never like to show that they are completely surprised by something, that they were ignorant about it. Critics very rarely work in print at understanding something – which is what good criticism does. So I found the reaction English, urbane and very uninteresting. But then, I was a sort of passionate believer. I wanted everybody to think that some of this art was the best there had ever been, and I was disappointed that nobody said so. I had felt completely absorbed in the exhibition and the work. I had a sort of missionary feeling about it. I took it very seriously,

very earnestly. Too much so probably. I wanted everybody to see that it was the most fantastic exhibition there had ever been, the most wonderful art that ever was. So I was disappointed by the reception. The other people didn't take the work as seriously as I did.

JR: *Which kind of public were you hoping to reach?*

CH: Art students mainly. I was teaching at St Martin's then. And I got the ICA to employ some of the students from my seminar group at St Martin's, to come and help install some of the works. So, for instance, I gave one of them the instructions for the Sol LeWitt wall drawing and he installed it. Another one installed the Robert Morris felt piece. I wanted to involve them in the show.

Robert Morris, *Felt Piece no. 4*, 1968, at *When Attitudes Become Form*, ICA, London, 1969

JR: *Would you have expected to reach a larger kind of public, like the show in Amalfi in 1968?*[1]

CH: No, not really. And I have to say, I have never been very involved with performance art. I have a great admiration for people who want to go out and engage with the public, but I've never been somebody who does that. So I may be very concerned about what I support, but I've never been very concerned with audience. I suppose my attitude has always been that you do what you can and you support what you think should be supported as best you can, and then you leave it to whoever listens or responds or understands to do so. You don't target an audience.

JR: *Do you subscribe to Umberto Eco's idea of 'Open Work'?*[2]

CH: I understand those kind of ideas; I think that they are important, and I believe very strongly that a work that has no public has something wrong with it. But I also believe that the work has within it the power to create its own public and that it can be dangerous to identify a public in advance and try to target it. I think the danger of that approach lies in the idea that what you need to do is to create a new public; it is always liable to be patronising and to underestimate the public that it's trying to address. I mean nobody ever says, 'I want to create a more elite public.' When they say, 'I want to create a new public', they mean, 'I want a public which is of a lower class', and that is already presuming something about that lower class: it's presuming that the lower class needs to be spoken to, needs somebody to take its side. But it has its own side, and if it has reasons to be interested, it will be interested. I don't think the working class needs assistance from the kindly liberals, particularly where the arts are concerned.

JR: *In a previous interview you said that you did not realise what power you had as a curator. When did you become aware of the new role that the curator started to have in the late 1960s?*

CH: Did I say that? I don't think I ever wanted a career as a curator. I wanted the artists that I liked to be taken seriously, and I thought, perhaps mistakenly, that given the position I was in, given that I had potential entrepreneurial credibility and a position within *Studio International*, given

that I was somebody who was teaching modern-art history and so on, that it followed that I had a sort of power. But more importantly, I thought I had a responsibility to try and create opportunities for the exhibition of those artists' work. But I had to learn that that sense of my own responsibility actually separated me out from the very artists that I thought were my friends and colleagues, because it was like taking on a role as a kind of head boy, a prefect. I suppose my class and culture were showing.

It was the experience of doing the show called *The British Avant Garde* in New York that taught me how disastrous that can be and that I was not as well equipped as I thought I was to play that role. In that case, I thought that what I was doing was getting together a group of English artists, creating an opportunity for them to show in New York and thereby helping to promote their work. In actual fact, the show was a disaster, partly because it turned out I had very little control. It turned out I wasn't doing the artists any favours. That was the end of my career as a curator. I didn't have the right kind of power, I didn't have the right kind of competences, and I didn't have the right kind of ambitions to be a curator.

JR: *Do you think the new type of 'curator as creator' followed on from the emergence of this new type of art?*

CH: Yes. Well, there are two answers to that question, I think. One is that curators seeing themselves as celebrities like the artists is a part of the same tendency as chefs seeing themselves as celebrities. Nowadays, we have celebrity chefs and celebrity curators; it's all part of the tendency of management to inflate itself. It used to be very clear who were the artists and who weren't, and people who were in management were not artists. Now, people who are in management call themselves 'creative', and it's the same with curators. It's part of a much wider economic and social tendency – a part of some great managerial revolution. Small curators becoming self-important is a small part of that tendency. That's one part of the answer.

The other part of the answer, ironically, is that Conceptual art – which was supposed to be radical, which was supposed to be about artists taking over more of the control of the apparatus for themselves – actually enabled that very process, because what it did was to create artist-managers. One kind of Conceptual artist became somebody who establishes their work as a kind of logo: like Daniel Buren, with those logo stripes. Once Buren

has got stripes associated with 'Daniel Buren', he spends all the rest of his career managing his logo. He becomes a sort of self-manager. And the artist self-manager and the curator-manager are meeting in the middle. They have a sort of mutual interest.

JR: *Do you think it was modified further in the 1980s and 1990s?*

CH: Yes, and we get artist celebrities as well; you know, the artists who have to fill the Turbine Hall at Tate Modern and continually outdo the last thing they did. Ambition is important to art, but it used to be a kind of ambition generated within the nature of the art itself. When the artist's ambition is generated by the institution, I think that the art tends to suffer, or is at least liable to, particularly nowadays, for complex reasons.

JR: *How do you think the increased importance of the artist's role in determining the arrangement of the works modified the relationship with the curator?*

CH. In a way, I think I just answered that. You get the curator who wants to take responsibility for stage-managing a spectacular show and the artist who wants to provide the latest great spectacle. So they have the same end in view. I think that Szeemann was one of the people who started that. Germano Celant was another.

JR: *Did you have a chance to meet Celant before curating the show* When Attitudes Become Form *and so become aware of what was happening in Italy?*

CH: A little. I didn't know so much about what was happening in Italy. I can't remember when I first met Celant. He stayed with me for a couple of nights at one point, and I went to see his Arte Povera show in Turin in 1970. I also went to Turin with Joseph Kosuth and Christine Kozlov when Joseph had a show at Sperone's gallery in 1970. A lot of the Arte Povera artists tended to hang around the Sperone gallery. Salvo and various others, getting free lunches off Sperone. All these artists would gather, and everybody would go off to lunch and Sperone would pay.

JR: *Was the Arte Povera movement relatively independent, or should it be interpreted as the Italian translation of the international Conceptual art movement?*

CH: I don't think Arte Povera had anything to do with Conceptual art. But it was certainly an independent component of the wider avant-garde. Let's put some of the pieces of that together. You had Arte Povera in Italy, you had a group of artists around Beuys in Düsseldorf, you had Anti-Form artists and Process artists in New York, there were artists like Flanagan, Long, Louw and McLean in England. But I see the Conceptual art in England – the Art & Language people and Burgin – as part of a separate tendency. It's funny, because in New York the Conceptual artists like Weiner, Barry and Kosuth were much closer to the Anti-Form artists – to people like Andre, Morris, Eva Hesse and so on. It was a much more integrated avant-garde, a much more integrated community in New York, with Lucy Lippard and Seth Siegelaub very much at the centre of it. There wasn't the same sense of community in England. I think there was in Italy. The Arte Povera people were a very close-knit group, and again in Germany there was a group of sorts. There wasn't the same coherence in England.

JR: *Do you see a contradiction in the fact that an exhibition of art aiming to reveal and criticise the contradictions of Western society was funded by an archetypal capitalist company such as Philip Morris?*

CH: No, because I don't think the aim of the art to undermine Western capitalist society was very serious. Artists don't undermine society. And it was very clear that even though the politics were sometimes serious – like Carl Andre, his political position was sort-of serious – it needed an art-world context to show it off. All this stuff needed an art-world context, and the art-world context is provided by capitalism. We may not like it. I certainly don't. It was Greenberg – in 'Avant-Garde and Kitsch' of 1939 – who talked about the avant-garde being tied to the bourgeoisie because it needed its money.

JR: *They seemed to be against institutions, fighting against consumerism.*

CH: My guess is that most of the artists in the show didn't even know that it was sponsored by Philip Morris. Artists have got a bit more faddy about that kind of thing now because sponsorship has become such a public business, but in those days nobody talked about sponsorship very much, not the way they do now. I suspect that most of the artists would

have been quite surprised to know about it and wouldn't have paid much attention to it or to the implications. They wouldn't have known as much about Philip Morris and the nature of its operations as people may do now. I think what's more surprising is that Philip Morris should have chosen to sponsor the exhibition. That's more surprising and it was a very smart move. It was one of the first instances of a big commercial company sponsoring an avant-garde show – that I know of, anyway. I don't know who was responsible for that, but it was somebody quite smart. I'd be quite interested to know how that happened, but I don't know myself. What I do remember is that in London there was a representative from Philip Morris public relations called Mary Covington. She was Philip Morris's representative. She was very busy in London, and generally speaking, very helpful.

Did I tell you about Ger van Elk and the shaved cactus? That was the one case in which there was a problem. He had offered to shave a cactus as a new contribution to the show. It was something he did; a kind of slightly trivial art joke. We got everything set up with the fuzzy cactus and the can of shaving foam and the razor and the film cameras, and Van Elk was just getting going when Mary Covington appeared and said, 'Charles, you can't do this to me!' And I said, 'What have I done?' And she said, 'That's a can of Gillette shaving foam, and we own Persona' (or it may have been the other way round). So we had to go out and buy the right kind of shaving foam and start all over again.

JR: *Do you still agree with the thesis that you put forward in 1980 in the article 'The Late Sixties in London and Elsewhere': 'It was quixotic though to hope, that perturbation in the economic base would be achieved by superstructural artistic tinkering ... That ideas can move mountains has been a recurrent fantasy in the twentieth century ... Its incorporation into the world of business-as-normal was smooth enough, and by some was accomplished almost unnoticed.'[3] Did the avant-garde eventually lose its struggle against the dominant order?*

CH: In so far as the avant-garde really was struggling against the dominant order. The cynical part of me now would say the avant-garde is part of the dominant order: artistic avant-gardes in bourgeois cultures are bourgeois; I don't know of any working-class avant-garde, any working-class artistic avant-garde, not even in Russia. The Russian avant-garde was mostly

Ger van Elk, *Shaved Cactus*, 1969,
at *When Attitudes Become Form*, ICA,
London

composed of bourgeois artists – as Lenin understood very well. So the
struggle between the avant-garde and the dominant order was always a
super-structural one and not a basic one. It was never a practical part of a
revolutionary movement. Okay, it may have been part of a culture-critical
tendency in a sense, but if you really want to look at avant-garde critical
theory – the anti-institutional critical theory that emerges in that period
– you don't go to the artists, you go to the sources of the critical theory;
you go to other people, and to more powerful currents of analysis. I don't
mean completely to dismiss the critical power of art. I think that art has
great power to encourage the individual to think a little differently about
the world and perhaps to think a little differently about how powers are
distributed in the world. But someone who needs to go to art to learn about
that must have been going around with their eyes closed.

JR: *During your interview with Sophie Richard in 2003, you talked about the avant-garde as a necessary transition from the demise of modernism, which was then followed by a renewed interest in figurative art. Do you think that the significance currently accorded to Conceptual art represents another transition (and if so, to what?) or has it become an end in itself?*

CH: I don't think that what is called Conceptual art now has very much relationship with what I understood as Conceptual art in the late 1960s and early 1970s. I have used this analogy before. In the period from the 1930s to the 1960s, a lot of stuff was called 'abstract art', popularly and journalistically, much of which wasn't abstract at all. It just wasn't very recognisably figurative. And that kind of work was a very very long way away from the cultural, technical and aesthetic circumstances under which Kandinsky, Malevich and Mondrian tried to imagine what it would be like if you could have an art that didn't depict, a modern art that was not representational in that sense – whether it could still have content, could still be art. This was a strange and difficult and problematic and exciting idea, and it was the product of very particular kinds of artistic and cultural, and indeed political, circumstances. It was an attempt to imagine a different kind of culture. So to get from the sense of abstract art used journalistically, say in the 1950s, back to those conditions in 1914 is a very big step.

What's called Conceptual art now is linked in the same kind of way to the very strange and exotic circumstances of the late 1960s and early 1970s in which a fairly small group of people tried to imagine an art that had no objects, or no necessary objects, that annexed theory, that annexed reading and writing in a way, that left behind the secure categories of painting and sculpture, and tried to make something that used language but was not literature, that still had some of the aesthetic potential and content that painting, for instance, had had, but without representation, without painting on canvas and so on. And if this was possible what did it mean? Those circumstances were also artistically, intellectually and politically very specific.

Under these circumstances there are two things that you can do. You can do something completely different and call it 'avant-garde', which I think is what a lot of artists did at the time, like saying 'Oh we can make art without objects!' and competing to make the next most minimal thing.

Art & Language, *Title Equals Text*, 1967

Or you can try and analyse the circumstance and see it as a set of problems
to be addressed practically. You can see the task of art not as one of making
new exotic kinds of readymades, but rather of trying to understand what's
different about the situation, and making that your work. That's the
direction I personally favour. That's why I work with Art & Language.

We are talking about very particular kinds of circumstances and what
makes them like this. Certainly some of what makes these circumstances is
political, is economic, is part of a larger intellectual tendency, but some of
it is to do with the autonomous conditions, the internal conditions of the
art form. The analogy here that I think is useful is with what happened in
music at the end of the nineteenth century, when you get a situation where
there's been a long move away from medieval plainsong into polyphony
and there's been an increasing build-up of harmony. There's this tendency
in music to become more colourful, more chromatic, more complex, until
you get to Wagner and Mahler, where you have this incredibly complex,
incredibly chromatic music. I play the horn with an amateur orchestra and
if you're playing Mozart, you've typically got a couple of horns playing in
harmony, an interval of a third apart, moving to the same rhythm and so

on. But if you play Wagner, you may have six horns and every one is playing a different part, every one is moving to a different rhythm, contributing a little part to this chromatic mix, and this mix becomes incredibly rich and complex. Where do you go from there? Do you go on complicating it, do you go on adding detail, do you go on increasing the degree of chromaticism? Or do you say, 'Okay, we've got to the end of this tendency', and you become Schoenberg and invent the 12-tone system – which is like sterilisation, like scrubbing everything clean and starting again?

Conceptual art was a bit like that – like saying, 'Okay, so we've all got so rich, so complicated; we've got colour-field painting, we've got gigantic modernist sculpture, we've got Performance art and so on. Let's scrub it clean and try and find something to start again with.' There are conditions internal to the development of the arts – never mind the political background – which create those kinds of pressure. Now a really powerful art history would be one which somehow mapped those two things together, which recognised both the internal development of the art and the wider historical and economical developments, and which found the common ground on which to bring those things together. But that's incredibly complicated. What one can say is that there are certain periods in art where there have been signs of these two things coming together: the external, larger historical and political conditions on the one hand, and the internal conditions within the art forms on the other. One certainly occurred in the early twentieth century and I think another occurred in the late 1960s and early 1970s. Quite why, I am not enough of a historian to be able to tell, but I do know that it was an important moment.

1 *Arte povera + azioni povere*, Antichi Arsenali della Repubblica, Amalfi, 1968. This three-day exhibition and performance event, curated by Germano Celant and held in early October 1968, included the core Arte Povera artists, Anselmo, Boetti, Fabro, Gilardi, Mario and Marisa Merz, Kounellis, Paolini, Pascali, Pistoletto, Prini and Zorio, as well as Mario Ceroli, Paolo Icaro, Pietro Lista, Gino Marotta, Gianni Piacentino, and non-Italian Conceptualists Dibbets, Long and Van Elk.
2 Umberto Eco published his book *Opera aperta* (*The Open Work*) in 1962. Here, he argued that literary texts are open fields of plural meanings where the interpretation depends on an interactive process between reader and text. He distinguishes between this type of work and literature that limits potential understanding to a single, unequivocal line – a closed text. Umberto Eco, *The Open Work*, trans Anna Cancogni, Harvard University Press, Cambridge, Mass, 1989.
3 Charles Harrison, 'The Late Sixties in London and Elsewhere', in *When Attitudes Become Form*, Kettle's Yard/University of Cambridge, Cambridge, 1984.

Conversation Six

Sophie Richard | May 2003

SR: *How did you first make contact with Art & Language?*

CH: Before I went to New York for the first time in the spring of 1969, probably the year before, I got to know an American woman who was living in London, Barbara Reise. She was a graduate student who came to the *Studio International* office, which was a kind of contact point for artists and critics passing through London. We shared an interest in contemporary art. Barbara had a part-time job, teaching art history at Coventry College of Art, which was where the Art & Language people were. So I first heard about Art & Language from Reise. She told me about the strange Conceptual art they were making. So I had a sort of interest in knowing more about that. Then, two of the Art & Language people, Terry Atkinson and Harold Hurrell, showed up at *Studio* with some examples of their work. This must have been late 1968 or early 1969. I was interested, not so much in the works, but in them. They were people who were not like normal artists; they were different.

SR: *What made them different?*

CH: They were not making a pitch in the same way artists tend to do. They just had a completely different social style. To some extent, they were more serious. Terry carried an executive briefcase and looked like a car salesman and Harold just looked completely miserable. I had already, at that point, started to feel very uncertain about what I was doing, writing articles and being an art critic. I felt very uncertain about the basis from which I was making judgements. I also felt very unsure about the sociology

179

of the world I was working in. It just seemed very unpleasantly corrupt. I can't remember having talked so much about Art & Language's work with Reise. She worked for *Studio* on a special issue on Minimal art in 1969, and one on Barnett Newman the next year. She was very interested in Minimal art. I must have talked a bit with her about these artists. You have to remember, Minimal art wasn't shown in England before 1969. I think the first showings came after April 1969, when *Studio* published its special issue about Minimalism. Before that, there was no Donald Judd, no Robert Morris, no Carl Andre, no Sol LeWitt. None of them was shown in London before 1969.

SR: *Could we go back to when you first met Joseph Kosuth, in spring 1969?*

CH: I met Kosuth at a Ken Noland exhibition in Larry Rubin's gallery in New York. I was in conversation with the receptionist of the gallery. I told her I was in New York to have a look at art and meet American artists. She said, pointing at Kosuth, that he was an artist. I told him we had a mutual friend in Barry Flanagan. So we went out for a coffee. He discovered I was working as an assistant editor for *Studio* and he took me around to some shows in New York and introduced me to some people. Kosuth also showed me his work and I was fascinated and very impressed by it. In fact, part of my brief for the trip to New York was to find new material for *Studio International*. So I asked Joseph to write a piece for the magazine, which turned out to be 'Art after Philosophy'. I went to America for two reasons. I wanted to meet Clement Greenberg, which will tell you a bit about the state of my enthusiasms. But I also wanted to see some more American art on its home ground. As a sort of youngish art critic, I was also looking for the avant-garde art of my generation.

SR: *What kind of work did Kosuth show you that you found so interesting and radical?*

CH: I remember very clearly, 'Definitions'. Almost entirely 'Definitions', in fact, and a few pieces with Plexiglas with letters on. One was *Clear, Glass, Square, Leaning* (1965). He didn't have then any of the pieces that were later shown as early works – or 'proto investigations' – the neon pieces and 'one-and-three' works that appeared for the first time at Sperone's gallery

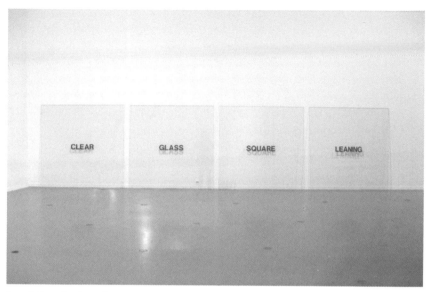

Joseph Kosuth, *Clear, Glass, Square, Leaning*, 1965

in Turin in 1970. I think he didn't have any of those made by that time. So it was mostly 'Definitions'. I can't remember very clearly how he presented his work to me. I wasn't so much surprised by his work as fascinated by his personality and his conversation. He was a very energetic and amusing person then. I liked his extremism. He was very young. I liked his courage, his determination, his ambition. Joseph was a very unusual person. When I look back at it, I find it very hard to explain why I thought his work was important. And I am still not sure. Maybe it's just a feeling of something radically new, something you couldn't have imagined.

SR: *At that time, what did you think of the work of other Conceptual artists, like, for example, Lawrence Weiner?*

CH: It was much more whimsical, light and poetic, almost romantic. Robert Barry's I was less sure about. Weiner and Kosuth were the two I thought were the most interesting. What I liked about Kosuth was something to do with why I started feeling insecure with writing art criticism. I'm now making sense of things that weren't so clear for me

at the time. One of the problems with trying to write art criticism in the mid-1960s was that modernism was dying on its feet. A whole system of criticism that was based on a significant discrimination between forms and colours was becoming more and more unreal. It was as though the discriminations had less and less of the world behind them. The job for a standard art critic at the end of the late 1960s was to stand in front of a painting – let's say a Ken Noland – and talk about the incredible balance between the colours within the stripes, and about why he got it right and somebody else got it wrong. There was a very high degree of arbitrariness in that. At the same time, there was a very high degree of rationalism inside the critical system. With the work that Kosuth was doing in 1969, this just wasn't an issue. It raised questions that just weren't there before. You either had to say, 'It's not art at all', and just dismiss it – which I was not inclined to do – or you had to say that you didn't want to worry about colour and so on anymore. The problem had changed and that's why it was so interesting.

When I came back from New York, I felt very changed by what I'd seen; I had a different sense of myself. I felt more impatient about the art I'd been interested in. I was very keen to discover other artists of my generation, to meet other artists who might be part of this movement. That's what led me to Vic Burgin. I liked him and found his work very interesting. I've always found that if you like the work, you like the person and vice versa. I asked him if he wanted to be in the show I was proposing for the ICA. That's how he came to be in *When Attitudes Become Form*. I must have proposed the show of English artists to the ICA after I came back from New York, as an attempt to try to make something out of the things I found out when I was there. I wanted to put on a kind of avant-garde show. But I wanted to put on a show of English artists, I think partly because I wouldn't have known how to organise a show of any other artists.

Art & Language weren't in *Attitudes*. My contact with them was separate. I barely knew them and the kind of work they were doing at the time. The only artists I added in to the show were those I was already committed to. I didn't have a sense of my potential power as a curator. I didn't know I had the authority to include other artists.

But for me, within less than a year, the avant-garde became more specifically identified with Art & Language – or certainly with Conceptual art. I came to feel that putting a lot of strange-looking objects into a room

was not very radical. What was more critically powerful was giving people nothing to look at, or giving them a text to read – requiring people to construct the object out of what they read. The work becomes animated from the moment when someone is thinking about it and actually engages with it. So, after *Attitudes*, I got to know Art & Language much better. I liked what was so radical about their work.

SR: *Was it at that moment that Kosuth became the American editor of* Art-Language?

CH: No, that had happened before. I must have met Atkinson again as soon as I came back from New York, and I told him about Kosuth. He was about to go to New York himself and I told him he should be sure to make contact with Joseph. Kosuth had heard about Art & Language – the first issue of *Art-Language* was published in spring 1969 – so he was keen to make contact anyway. In fact, when Terry arrived in New York, Joseph was waiting for him at the airport. He took him straight back to his loft and Terry stayed with him, while Joseph was writing 'Art after Philosophy'. They got on and established common cause there. Terry invited Joseph to be American editor then.

I went back to New York in the autumn of 1969, just after doing *Attitudes*, in order to further my contacts with people there – I talk of 'contacts', but the people who mattered were friends. I also went back in 1970. When I went back in the autumn of 1969, Joseph came with me to stay in London. Then we went to Düsseldorf together for a show there.

SR: *Would Düsseldorf have been, for you, the place to go in Europe, culturally speaking?*

CH: Yes, definitely. Also Cologne, at the Paul Maenz gallery. I met Maenz through Art & Language. He published a collection of Art & Language articles in 1972. In Paris, Art & Language was shown by Daniel Templon. He came to England in 1970 and asked Art & Language to exhibit in his gallery. About that time also [the Swiss gallerist] Bruno Bischofberger came to England. He bought a large amount of Art & Language work for cash. He also negotiated the sale of the Art & Language *Index 001* (1972) from the 1972 *Documenta*.

Art & Language, *Index 01*, 1972, installation at Documenta 5, Kassel

I see the Documenta *Index* as the most clearly sorted-out piece for the kind of circumstances that the new form of exhibition presented. We had a lot of discursive material incorporated in such a way that it worked as an installation. Even there, I think very few of the people who visited Documenta actually had much sense of what it was about.

SR: *What about the* Art-Language *publications?*

CH: The *Art-Language* journal was a sort of complement to the exhibited work. One of the important things about the situation at the time was that it was never clear where the art was: whether the text was something that pointed you in the direction of the object, or whether the text itself was the object. Conceptual art was in some ways made of that very uncertainty. You don't really know if the text you are reading is an essay about art or an essay as art. In some ways, that uncertainty stayed – with Art & Language anyway. The recognition of a border line between something you call 'text' and something that you call a 'work of art' is an administrative battle. A huge number of issues were raised at that time. We're still living

with the consequences of some of these questions. Not all have clear and easy answers. Certainly that question – where the edge of an artwork is – remains.

The publication of the first issue of *Art-Language*, as well as Kosuth's 'Art after Philosophy', changed things in England and in America within that avant-garde. It made for distance between a sort of 'analytical' Conceptual art group and the rest. This was what Joseph wanted: he wanted to be the Conceptual artist. In America, Weiner, Huebler, Barry and him were seen as a group. They'd been put together in a show that Seth Siegelaub staged in New York in January 1969.[1] But relations became strained after Kosuth published 'Art after Philosophy'. He advertised himself as the person who made the first Conceptual art work – in 1965 – and relatively disregarded the work of the others. So there were a lot of mixed feelings about that. He also allied himself to the group in England, partly as a way to distinguish himself from the other Americans. Similarly, the English group was happy to identify itself with an American artist. So for a while, there was a mutual interest. Joseph would come over to England and stay with the English group. He got on very well with Baldwin, until it became clear that Joseph's ambitions were really personal ambitions, and at the expense of Art & Language. Joseph couldn't work with a group. He never really was the American editor. It began and ended with the second issue of the journal, when he wrote his introduction. That was the only thing he ever did. Then what he would do was stamp his address on the inside front cover of the issues we sent over and he would just give them away, not even trying to sell them. That was actually all the work he ever did – that and reserving the space for Art & Language at Documenta in 1972. But of the American Conceptual artists, Kosuth was the one Art & Language was most interested in. I still think that the work he did in 1966-69 was very important. But then, at one point, it became clear that it was just impossible to collaborate with him anymore.

SR: *Can one say that something changed for the Conceptual art network at Documenta 5 in 1972? A sort of disillusionment?*

CH: Yes, there was a sense of division – not just with Art & Language, but generally in the movement. Conceptual art became business, commercial stuff. With Documenta 5, Conceptual art got its official recognition. It

was the end of the 'pure' Conceptual art movement – if there ever was such a thing. After that, two things happened. On the one hand, certain dealers had a market for a kind of picturesque Conceptual art, and for what Paul Maenz called 'classic Conceptual art'. There were collectors who saw a potential avant-garde. The other thing is that Conceptual art became intellectualised and academicised. It was absorbed into a more standard intellectual life, particularly through semiology. It turned into a kind of university art. There came to be a sort of intellectual fashion for a new kind of political art. And it became sort of transparent, in the sense that Socialist Realism is transparent – transparent in its content, in its ideology. For me, what was always fascinating about Conceptual art was that it was opaque. It shared the opacity of poetry, while not having the same artistic pretensions. It was very dry in one sense, but it just wasn't transparent, not simple. In the early 1970s, Conceptual art just became less interesting. It was more consumable. The art historians and art critics loved it.

SR: *Were the artists aware of that change?*

CH: I think so, but I am talking from the Art & Language point of view. Certainly that was the perception within Art & Language. And this is partly why the group abandoned Conceptual art for something else. After Documenta 5, there was a change in the personnel of Art & Language. David Bainbridge had pulled away. Terry Atkinson and Joseph Kosuth became less engaged. Michael Baldwin became more clearly the dominant figure. Mel Ramsden and I became more involved. The implications of the indexing system also changed the work of Art & Language. It's not easy to distinguish between the art world changing and the changes in terms of practice, in how you actually make the work. The publication of *Art-Language* didn't change; that was always crucial for the movement. One thing that made things change within Art & Language was the fact that after Documenta there was a group of people in England and there was another set in New York. The people there increasingly felt that they were not properly represented by Art & Language, in opposition to those in England. The New York art world was very different from the one in London, where the art schools played a much larger part. There was a sort of tension, which led in the end to the publication of *The Fox* in 1975.

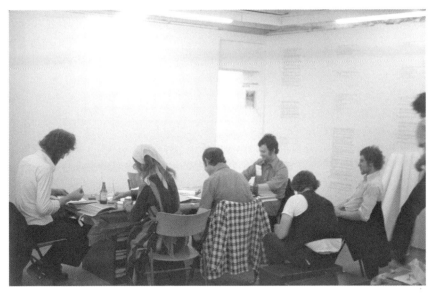

Art & Language (David Rushton, Sandra Harrison, Harold Hurrell, Terry Atkinson, Philip Pilkington, Michael Baldwin) at Documenta 5, Kassel, 1972

Art & Language, wall label for *Index 01* at Documenta 5

Joseph wanted a journal of his own, though it was Mel who did most of the real work on it.

SR: *After Documenta 5, did Art & Language and Kosuth have anything in common?*

CH: After Documenta, Mel Ramsden became the major figure in New York. He worked a lot on the *Index*. He came over and did a lot for the installation of the work at Documenta. He became quite close to Michael and to a certain extent to me and to my first wife. Then, after the exhibition, he went back to New York. He set up a sort of indexing system in New York, a collaborative conversational practice, which included Joseph. So a group developed then in New York. Joseph was a kind of figurehead there, but Mel was doing much of the actual work. Also, he and Ian Burn had their separate history of collaboration. So it was a strange and messy situation, with tensions within the group in England, with Terry Atkinson pulling away, and tensions between the English and New York-based groups. There were also tensions between the people in New York. We don't have any contact with Kosuth now. We met him in Barcelona for a symposium in 1999; that was the last time.

SR: *What were the questions you had to ask yourself as an art critic?*

CH: Well, it took me a lot of time to try to figure that out. At the time, I didn't really know. I made some terrible blunders. With Kosuth's art, the question you would have to ask is, how does it change the definition of art? That's how he represented it himself in 'Art after Philosophy'. I suppose I would have gone along with that at the time. Now I think that's wrong or limited. I think it's not enough, because in a way it assumes that art can survive without content. Which is what 'Art after Philosophy' means: that art doesn't draw its content from outside itself; it operates only on its own definitions. But any definition would actually be made under particular circumstances, and those circumstances are part of its content. I still ask myself those questions and I still don't have good answers. Art is a part of the social system, not just of the artistic one. You have to consider all the changes that are happening in the society, not just the ones in the art world. They're part of what you make your culture from. But it doesn't

follow that you can just read the papers or watch TV and go ahead and make critically significant art. At the time, I was definitely very confused. Writing about Conceptual art is extremely difficult. Anything I wrote about Conceptual art during the 1970s was rubbish. I didn't really know what I was dealing with, or how to sort it out.

SR: *Do you feel more comfortable now?*

CH: I feel more comfortable now in writing on its history. I write about it in relationship to what else was happening at the time. I am much clearer about that relationship than I could have been at the time, though I hope I'm still learning. In a way, what Conceptual art was made of was a sort of crisis in modernism. You can't make any sense of Conceptual art without considering the condition of modernism in art and culture generally: what had happened to it, why it didn't work anymore, why it had become ineffective. Conceptual art was inescapable – but very much as a transition. Nobody knew at the time what it was a transition to, but it certainly wasn't more Conceptual art. One of the things that I would now criticise about Joseph's work is that he treated his practice as if it could be non-transitional, as if it was sufficient for itself, as if it could be justified as a continuing style. He was in a way considering that his work was the only and last possibility for art.

SR: *What about the big comeback of figurative painting in the late 1970s and beginning of 1980s?*

CH: It was a big release for the dealers! But there was no getting round the fact that modernism had lost its intellectual content. Conceptual art was a way of reintroducing an intellectual depth into art and thereby keeping it alive somehow. But I don't think that that life came back with the figurative painting of the 1970s and 1980s. Most of that stuff looks pretty empty now.

1 *Barry, Huebler, Kosuth, Weiner, Seth Siegelaub, New York, 5–31 January 1969.*

Conversation Seven

Elena Crippa | January 2009

EC: *I wanted to ask you about the critical context of the period between the end of the 1960s and beginning of the 1970s, and in particular in relation to the development of Art & Language's works such as* Index 01 *(1972) and* Annotations *(1973). To me, there are interesting connections with texts and thinkers that have become seminal. In particular, I was thinking of Umberto Eco's* Opera Aperta, *which was published in Italian in 1962, and the writing of Walter Benjamin, which you refer to in the first part of* Essays on Art & Language.[1] *Were these your cultural references at the time? Or what were you reading?*

CH: Not Eco. I can't claim to have contributed to the intellectual work on the *Indexes*. The design of the indexing systems was very largely Michael Baldwin's. Philip Pilkington and Dave Rushton were also involved with it.[2] So I was trying to catch up, and work out what the work was about. I was learning. The kind of ideas that were behind the work were ideas of indexing itself, about linguistics. I don't think anybody in Art & Language was really reading Benjamin at that time until a bit later. I think it was not until the mid-to-late 1970s that Benjamin became interesting. And I don't remember anyone in the group reading Eco. I remember other people reading Eco, like Victor Burgin. He was interested in that trend of continental linguistics. Art & Language came very much more out of the English philosophical tradition. More Wittgenstein.

EC: *This is what you would read and talk about? And what else?*

CH: I honestly don't remember. There is this idea that Art & Language was terribly intellectual, that we all sat around talking about theories and

191

books, but we were much more likely to sit in pubs and talk about cars breaking down.

EC: *With the* Index, *as a sort of intertextual device, and with the* Annotations, *was the way in which texts were fragmented, circulated and re-connected something that related more to the sharing of knowledge in relation to the collective nature of the group than to a specific theory or series of theories?*

CH: What happened is that the *Index* itself generated problems, ways of thinking about the work. It also produced a very strong sense of Art & Language as a kind of conversation-community, which is what the *Index* itself in a way described. The *Index* provided a kind of description or model of Art & Language and that then generated kinds of work and enquiries on what a community like that may be like and what further kind of work can be done to develop that community and to learn about it. So in a way, the Index itself generated reading and theory, generated an interest in linguistic theory and in the whole question of the relationship between texts; how you might analyse the relationship between texts; how you might analyse relationship between different speakers; what it might mean to talk about a community that shared certain idioms, shared a language, even. As the indexing project between 1972 and 1974 led to an interest in certain kind of theories, that interest was to a certain extent shared between people in England and people in New York. But the two communities tended to develop apart, because we were in two different places and had different concerns. The group in England was very much more concerned with the conditions of teaching. The New York group was more concerned with the problems of living in the middle of the art world. Slightly different considerations fed into the work in different places, and the work that was going on generated different kinds of problems. In England, different kinds of indexes were done. There was more interest in linguistic analysis. In New York there was more interest in the *Annotations* project as a kind of socialising device.

EC: *Having seen the* Index *at Documenta, would you say that the work was successful, considering that it had the ambition not just of revealing itself as the outcome of a collaborative conversation, but also to truly engage the visitor in a different, more active way? Did this happen?*

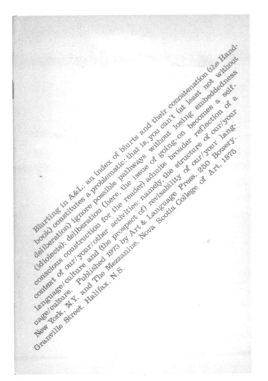

On the cover image:

Blurting in A&L: an index of blurts and their concatenation (the Hand-book) constitutes a problematic; that is, you can't (at least not without deliberation) ignore possible pathways without losing embeddedness (idiolects); deliberation (here, the issue of going-on becomes a self-conscious construction for the reader) admits broader reflection of a context of our/your/other activities: namely, the structure of our/your language/culture and (the prospect of) revisability of our/your lang-uage. Published 1973 by Art & Language Press, 250 Bowery, New York, N.Y. and The Mezzanine, Nova Scotia College of Art, 1975 Granville Street, Halifax, N.S.

Cover: *Blurting in AL*, 1973, Art & Language and The Mezzanine, Nova Scotia College of Art

CH: Very little. The main effect of the work was on the people that were involved in it. It was very decisive for Mel, and for me in a way, because what it seemed to provide was that it defined a place of work; it defined working relations, a place to do work, and a kind of work to do in that place. It was not a physical place; it was an intellectual place. That's what Mel took to New York when he went back. And I think he was very committed to what he intuitively learned from the *Index*. Similarly, for me – it changed my sense of how I wanted to work and who I wanted to work with. I got to know Mel first in 1971 while he was still working closely with Ian Burn, but the first time I remember working practically with him was in setting up the *Index* display for Documenta. My contribution to the Index – unlike Mel's – was small, post-hoc and largely mechanical, but I think Mel and I shared a sense of the seriousness of its implications, and I'd like to think that a continuing commitment to those implications has been a bond

of sorts ever since – however different the kinds of activity in which that commitment might be felt. As has been said before, Documenta 1972 was the point at which it first became clear both that Joseph Kosuth's individualism was incommensurable with the ethos of Art & Language and that the productive core of Art & Language was no longer to be identified with an Atkinson/Baldwin collaboration. By then, a considerable strain had anyway been put on that collaboration by the circumstances of Michael's exile from Coventry,[3] where he lost his part-time post while Terry remained as a full-timer. Documenta in 1972 was also the first time that Michael, Mel and I found ourselves together engaged on the serious practical activity of sticking pieces of paper on the wall.

EC: *How did it change the way you wanted to work?*

CH: It gave me a model of a kind of community, and of a continuing kind of activity. At the time, I was still trying to hold on to a fragmentary presence in the art world, when I was attempting to make a living writing criticism, organising exhibitions. All of that seemed not possible or interesting. That was the time when I withdrew from *Studio International*, left London, and moved down to the country. It was a way of exchanging the art world for Art & Language, I suppose.

EC: *You are saying that the work provided a sense of community. So it might not have been very successful in relation to the public, but was very successful internally, for the group.*

CH: Maybe some people got a sense of what it was, but I think the majority of people saw it as a kind of minimal installation. It was quite hard work if you wanted the Index to work for you. You had to spend some time. But it was successful in another sense, because it sold.

EC: *The larger group split up around 1976. You, Mel and Michael continued to work together as the new formation of Art & Language. Do you think there was something that somehow did not work in the attempt to make art that formally reflected the dynamics of the group, its conversations? Was there something unsustainable, in the long term, in the coexistence of different entities within the group?*

CH: There are two sides to that. One is that from the point of view of producing work – anything other than a series of publications – Art & Language became very unwieldy. There were about 20 people between England and the States, and they were not all going to get together to make work. There was also a sort of intellectual and political split. I know the group in England found some of the aspects of the politics of the American group very embarrassing and crude: a slightly crude kind of Marxism, which was addressed, of course, to the very different sets of circumstances in New York. I know the New York group felt very impatient with the English people because they would say: 'You do not have to deal with the world we have to deal with.' At the same time, people in England felt: 'Well, we do not want Art & Language to be entirely defined by the politics of the New York art world.' So there were two sides to that split: one was political and intellectual; the other was the fact that it seemed that Art & Language had become an entity that all kinds of people would sort of claim to be part of. I remember – it must have been in 1975 or 1976 – going over to Michael's house to meet him for a drink and there was this woman I had never seen before – Carol Conde, I think – and we were talking about Art & Language, and I jokingly asked her: 'Are you a member?' and she said: 'Of course I am a member of Art & Language. Who are you?'

EC: *Yet there was a desire to continue collaborating. You said that you realised you needed that, you wanted that.*

CH: Yes, that sense of a community of people you talk to and work with was very important. But to me personally, that was largely restricted to the people in England, with the exception of Mel, who came over to England quite regularly and maintained correspondence. I didn't go to the States at all any time between 1971 and 1991. I didn't have any first-hand contact with what was going on in New York. And I had fallen out with Joseph Kosuth by about 1974. I was fairly distrustful of certain aspects of the American operation of Art & Language.

EC: *Was it because you felt it was too entrepreneurial?*

CH: Partially, yes. Joseph's ambition was always a problem. But it became very clear from about 1973 onwards that Joseph was a real problem.

195

EC: *Interesting. Ambition is now generally perceived as a positive quality within the contemporary art world.*

CH: The problem with Joseph was always that, on the one side, he wanted to maintain his associations with Art & Language, because it had good intellectual credentials, while on the other hand, he wanted an individual career that had the name 'Joseph Kosuth' on it. That was a problem.

EC: *In relation to your particular role within the group, you have written that, from around 1971, your position had been formalised as the one of 'general editor'.*

CH: I originally became practically involved with Art & Language because I was working as an editor on *Studio International* and I was very intrigued by the journal *Art-Language*. By 1970, I had got to know the people involved. I had got to know Terry Atkinson first, and offered to help with the magazine to try and get the mistakes out. I thought I could help make the magazine a better production. Which was a bit silly. It was part of a sort of middle-class sense of responsibility: I can improve this thing and make it look more respectable, more professional, and have it taken seriously. Whereas in fact the strangeness of the style of Art & Language was quite important to it.

EC: *How would you describe the strangeness of its style?*

CH: It was uningratiating, deliberately resistant to interpretation, particularly in the case of Michael's writing. It was a mistake that both Mel and I made. We have both talked about it at different times – this idea that Michael's writing was very strange, and that what one should do was try to clarify it. But in fact if you clarified it, you turned it into something else. It was the strangeness of it that was interesting.

EC: *Could one go as far as to call it poetry?*

CH: No. It was art. That is what was so strange about it. It was definitely not any genre of literature. It was not aspiring to be literature. Michael himself said that: 'It was art in case it was philosophy and it was philosophy in case it was art.' It was much closer to the borderline

VOLUME 1 NUMBER 1 MAY 1969

Art-Language

The Journal of conceptual art

Edited by Terry Atkinson, David Bainbridge,
Michael Baldwin, Harold Hurrell

Contents

Art-Language *is published three times a year by*
Art & Language Press 84 Jubilee Crescent, Coventry CV6 3ET
England, to which address all mss and letters should be sent.
Price 7s.6d UK, $1.50 USA All rights reserved
Printed in Great Britain

Cover: *Art-Language*,
vol.1 no.1, May 1969

between art and philosophy than between art and literature. And that was interesting, because there wasn't material that lived between art and philosophy at that time – and that wasn't aesthetics. Aesthetics seemed a more or less dead end at the time.

EC: *Did this new, completely different type of writing have something to do with the idea that, in order to express something new, you need a different language, a different way of expressing yourself?*

CH: With hindsight, one can see that the written word was responding to the very strange circumstances that were thrown up by the collapse of modernism as a critical and theoretical authority, and as a set of ways of thinking about how you made art, how you criticised it, how you thought about it. And, as these particular prescriptions and protocols collapsed,

197

they just lost validity and authority. There was a kind of indefiniteness, or loss of regulation, loss of rules. In these circumstances it seemed possible and necessary to think some rather strange thoughts about art – what it was, how you define it, what it might be, how you distinguish between one kind and another. And so, with hindsight, I would see that early Art & Language writing as realistic, in the sense that it confronted a situation which many people were trying to cope with in all kinds of different ways. It had for me a very fine grip on what was strange and complex about this situation, these circumstances.

EC: *And this was a time when you felt the need of being anti-aesthetics?*

CH: Yes. Certainly against aesthetics as 'aesthetics' was defined in conventional terms. I would now say it was highly aesthetic in a way, but it provided the basis for a new sense of the aesthetic. And a new way of establishing autonomy. It did not look like that at the time. But, in retrospect, one can see that that was part of what the problem was.

EC: *Wasn't this the wider problem about Conceptual art?*

CH: The wider problem, I think, was the loss of validity in modernism, the loss of faith in certain notions of the aesthetic, of medium, of judgement, all of these things. In a way, what had happened was that what was critically powerful within modernism had been compromised, in all kinds of ways and for all kinds of reasons, some of which were economic, some of which were political, some of which had to do with the autonomy of artistic tendencies; some had to do with the playing out of the possibilities of abstract art, which I think is a very important component. So that if you wanted to try and establish an artistic practice, to put your feet down, it was very hard to find firm ground. There is a nice quote of Michael's somewhere where he talks about modernism as a shifting surface: 'You put your foot down and that bit moved away from you', which is very nicely matched by a quotation from Delacroix at the beginning of the last phase of modernism, in the 1860s, where he talks about this volcano under our feet, which is changing the world. Again, the sense of the earth moving under your feet.

EC: *It seems that there was a very striking awareness that there was this material boiling underground, that you were living in a very important time of change. It was a time of broad concepts and statements. Art & Language were doing their writing, and people were referring to it. Everything was moving very fast. How would you describe the relationship between the different players at the time in New York? For example, with Minimalism: how relevant was its position, how would Art & Language relate to it, or with other movements or groups?*

CH: Minimalism was very important. You have to remember that no Minimal art was shown in England before 1969; it came very late, so Minimalism very largely came through the medium of *Artforum* and other kinds of publications, unless you had the chance to travel to New York and have a look for yourself. It is significant that both Terry Atkinson and Michael went to New York in 1966–67 and made contact with people like Sol LeWitt, Robert Smithson and Donald Judd. So in a way, they had a bit of a grip on American Minimalism, but it was very rare in England at the time. Generally speaking, the people I knew in England in the mid-to-late 1960s, if they were interested in American art, it was basically Pop art, or maybe Frank Stella, but there was very little discussion of the work of Judd, Smithson, LeWitt, Andre and so on before 1968 or 1969. So those kinds of contacts and understanding that Minimalism represented – the kind of new apostate variety of modernism – that was very important within early Art & Language.

EC: *I guess it was straight away very clear that Minimalism had quite a strong aesthetics itself.*

CH: Yes.

EC: *And how would you describe the aesthetics of Minimal work?*

CH: There's an early essay by Terry Atkinson called 'An Extravaganza of Blandness',[4] which was prompted by the idea that Minimalism offered a new aesthetic that was not about bright colours and complicated forms, but was a new kind of purism – a new aesthetic adjusted to urban life, office buildings, art galleries. It was an aesthetic which offered itself up

to the very physical architectural conditions under which the work was shown – a new sense of modernity, I suppose.

EC: *I always find it interesting how all these artists were also interested in writing, as in the case of Smithson and Judd, but that the work and the writing did not reflect each other in the way it did in the work of Art & Language and Conceptual art. These artists used to write, but the two practices were quite separate.*

CH: Judd was working as a critic. He was writing about whatever he had to cover in a magazine. It was not programmatic, artist's writing, although it was quite important. But Judd's taste was quite catholic.

EC: *And what about Sol LeWitt? How important was his writing and his work?*

CH: I don't know. His work was kind of important. I don't know how important his writing was. It always seems very graspable when you go back to it. Very quotable. Whether it was seen by other people as theoretically interesting, I am not sure.

EC: *But do you think the work was interesting at the time?*

CH: Yes. I am not sure that it was quite as powerful as either Judd's or Andre's.

EC: *Could one go as far as to say that part of the reason why LeWitt's work became so important is because it was so quotable?*

CH: Yes. I always think of LeWitt as the most consumable Minimalist in a way. It is very friendly art. Like Sol himself. He was such a nice bloke.

EC: *And Lawrence Weiner?*

CH: He was a sort of primitive. Interesting. I think his early work was quite important, quite well sorted out, but in a strange way. But it's very primitive.

EC: *Regarding the formal references in the work of Art & Language, my vague*

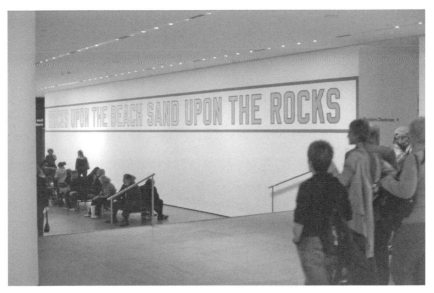

Lawrence Weiner, *Rocks upon the beach sand upon the rocks*, 1988, installation at Museum of Modern Art, New York, 1999

understanding is that the group, as Mel, Michael and you, shared an interest and desire to go back to addressing the formal aspects of the work, and maybe, in the 1970s, to go back to a more art-historical understanding of the positioning of the work.

CH: There's an element of a sort of coincidence here. If we go back to the moment in which Art & Language contracted, after 1976, when there were all these expulsions and departures in New York, the break up – Mel moved over here; that was a crucial moment. By then Terry Atkinson was long gone. So Michael represented the English community, Mel the community in New York, and they came together. And I maintained my connections. By then I was teaching full-time. I started working at the Open University in 1977, so I always had a job and work to keep me alive. I think it was pretty clear from 1975/76 that Conceptual art was really over. It could only be kept going as a kind of logo, a style that people like Weiner and Kosuth could continue to repeat, so that they could go on being authentic Conceptual artists. Consistency was everything and what that really meant was

that the only way in which development was possible was to make the text bigger, to turn the text into installation, to become a sort of eternal self-curator, get bigger and bigger shows. But basically, the work did not develop, because there was no way that it could without radical change. That was one way Conceptual art went. The other way it went was into an intellectual, rather academic, art-plus-semiology, university Conceptual art. It became academicised and it took on a kind of transparent politics, possessed by the idea of subverting the social codes, and by the interaction of art and advertising. This was another way Conceptual art went. Art & Language was not going down either of these routes. So what do you do? What was the next possible move?

To explain that, I have to go back. This is a slightly personal interpretation, I suppose. This is something I am only trying to work out for myself now, and very much with the benefit of hindsight. One of the reasons, I think, for the crisis that could produce Conceptual art, the crisis of modernism, was both the development and at the same time the decline of abstract art. What high modernism meant – the highest values of modernism in the 1950s and 1960s – was invested in immaculate abstract paintings: in Pollock, in Rothko, Morris Louis, Barnett Newman. This was the best art of the time, no question. Anyone who was serious knew that. But it seems to me that what this art was doing was making the very best of the price that modernism itself had had to pay for its initial critique of the academic, the literary, the mythological – all that – things that had propped up academic art. In a way, what modernism did was to strip away literature, and in doing that it also deprived itself of certain possibilities of intellectual content, complication and depth. There was no clearer sign of that than the absolute antinomy – the separation – that high modernism made between art and text. So the most unimaginable thing would be a word written on a Rothko painting. It would be a complete act of vandalism. It is conceptually ruled out.

But then, if abstract art has no further to go, what's art left with? Where to find its content? The smart people in the 1950s – Jasper Johns is the paradigm – see that problem. What does Johns do? He starts putting words into abstract paintings, putting the text back in. He says 'I'm believing art to be a language' and so on. That's the ultimate critique of Abstract Expressionism – to put words into the painting. But of course, Johns's gambit is limited, in the sense that the words are always assimilated to

Mel Ramsden, *Guaranteed Painting*, 1968–69

a pictorial surface, so they are always subordinate to a painterly kind of representation.

The next move, in the wake of Johns's work, is to make the text pictorial – as people like On Kawara did – finding ways to make textual subjects into pictures; the text as picture. Kosuth's 'Definitions', paintings with words, Mel's early 'Guaranteed Paintings', 'Secret Paintings', *100% Abstract* (1968), again are texts turned into pictures. That's happening in the late 1960s. That's sort of primitive Conceptual art. In a way, things like Weiner's 'Statements' are a bit more sophisticated because they are not pictorial texts, but they are texts that create the strange sense of 'What's the work?' Is it the text or is it the material surface that the text evokes? Actually, Weiner's early work has that in common with early Art & Language work in England, whereas Michael and Terry Atkinson produced texts which referred to material circumstances like the *Air-Conditioning Show*.[5] The difference is that these are much longer texts, so the text becomes a sort of essay.

At this point, I think the future of Conceptual art divides. It can either stick with the text as a kind of picture, which I think is the case with

American Conceptual artists on the whole. Weiner and Kosuth are stuck with the idea that all you can do is make bigger and bigger installations of texts, so that they take up more and more space on the wall. Or alternatively, you see the text as a much longer segment, as an essay, and what you are trying to hold on to is the possibility of a relationship between the essay and the artistic character of the text. The essay has the character, the intellectual depth that pre-modernist art always had, that kind of content that modernism tended to abjure, to pass up on, in its critique of the academic. So there's a sense that at the point at which, by the mid-1970s, Conceptual art was either going to have to be a kind of continued pursuit of the readymade, or a continued pursuit of the text as intellectual endeavour, it was effectively over as a continuing critical possibility.

But what remains is this idea of what Art & Language has called an 'essayistic practice' – an essayistic practice as a kind of art. What that does – if you are not too afraid of the idea of tradition – is it re-opens the history of art. And I think what is really important about Art & Language – far more important than its contribution to Conceptual art – is that in 1977–78, in the practice between Michael and Mel, it becomes possible to look back at that moment at the beginning of modernism. And it is quite interesting that what happens is that Art & Language starts looking at pictures – at early broadsheets, at documentary photos, at Socialist Realism – working with the idea of the different uses that a picture might have as a kind of black propaganda, and looking back at the point when the academic tradition starts to collapse. And then there is that moment of bringing modernism and Socialist Realism together with the *Portraits of V. I. Lenin in the Style of Jackson Pollock* (1980) – continuing a conservative 'realist' practice on the one hand, and high modernist abstraction on the other. So you get to the point of going back to Pollock. And in a way, what happens is, through Pollock – through that confrontation between Pollock and picture-making – it becomes possible to look further back again into the history of art, into Manet, into Courbet, into the beginnings of modernism, the beginning of that separation between modernism and the academic tradition, and to re-establish a kind of connection between the essayistic text on the one hand and a painting as a thing that can have content and depth on the other. So it makes possible a re-connection to the tradition – to the ambition of fine art – in a way that is not a continuation of Conceptual art, but has been worked through by working through

Art & Language, *V.I.Lenin by Charangovitch, 1970, in the Style of Jackson Pollock,* 1979–80, scrambled photocopy, installation at Van Abbemuseum, Eindhoven, 1980

Conceptual art. Basically, it's an ambitious practice that looks up at fine art, which has its eyes not just on the avant-garde of the recent past, but on a much larger history of art.

Well, of course, that was meat and drink to me, as an art historian, because I could see this happening. I am not claiming to have been an agent or a cause of it happening at all. My only real input into it was that I had been working on Pollock at the time. And as soon as Michael and Mel started work on the 'Artist Studios' in 1981–82, I got interested in the whole history of the artist's studio as a genre. I guess I could then feed certain kinds of references into the conversation, but only because that was the way the art was going. So one consequence of that re-connection of modern artistic practice to historical tradition – with some of the themes and contents of that tradition – was that it gave me, as an art historian, a more secure place to work in connection to the practice.

EC: *You have written that this moment represents an actual return to aesthetics.*

CH: That was a sort of acknowledgement that was made among the three of us. The *Portraits of V. I. Lenin* were done to make an installation for an exhibition at the Van Abbemuseum in Eindhoven in 1980. The idea was that the paintings would be cut up into A4-sized sheets and exhibited as photocopies – and that some of these would be scrambled. So the paintings were really made to make material for an installation. What happened is that, after the exhibition, the paintings were stuck back together again. Why? The reason why is because they were interesting to look at. What does that say? If you are saying you want to keep them because they are interesting to look at, you are making an aesthetic judgement. And this is something to do with them having been made – and with how they were made – with the fact that it mattered that these things were made, and in being made had to be made right or wrong. Well, if you are back in a situation where you are making things, and it really matters whether they are made well or not, then you are back in a more traditional circumstance – or at least in one that the technologies and aesthetics of Conceptual art had largely eschewed.

EC: *Was defining 'the well' of how their works were made something completely new?*

CH: It was very surprising to Michael and Mel. They were very reluctant initially to see what had happened, because in the entire history of Conceptual art, you would not take decisions on that kind of basis. You were not too concerned about saving the object. But somehow the object turned out to be something that was worth saving again.

EC: *How much were you involved in this process of making? Would you spend lots of time with them in the studio?*

CH: At that time, yes. I had no practical input into the Lenin/Pollocks, though I was involved in the writing that partly drove them. But I had a continual view of the works as they emerged because they were painted in the house I was living in. My wife and I had a spare room and turned it over to Michael and Mel. In fact *Ils donnent leur sang: donnez votre travail* was the first work to be done in our house, and that was in 1977, soon after we moved into it. So yes, I had a constant view of what was happening, and

we would meet pretty regularly. The major works done in our house were the series of 'Studios'. I watched them emerging at every stage. And I'd interrupt Michael and Mel occasionally and get them to listen to stuff I was writing.

EC: *How would you describe their studio practice?*

CH: In many ways, very efficient. My impression has always been that Michael and Mel work astonishingly well together. I have never noticed a problem about the practical division of labour – who does what. There may be serious arguments about what to do next, about whether to continue a particular body of work, but in the actual making of stuff, they always seemed to me to work extraordinarily efficiently together. And there's a sort of general principle, which is quite important, that nothing goes out that has only one person's mark on it. The work is very much a joint product. Decisions about what to do next – about how to define a particular project – were much more likely to be initiatives of one rather than the other. But I've not been aware of serious problems in deciding how to go about doing something.

EC: *It seems to me that in the early work there was a desire or need for the collaborative nature of the practice to manifest itself in the physicality of the work.*

CH: Absolutely.

EC: *How did this change when Art & Language became a much smaller group of people working in a studio? Was it still equally important for this conversation to be visible in the physicality of the work?*

CH: It always remained important, in part perhaps, as a means of ensuring the discursive character of the work – its capacity to evade the stereotypes of artistic authorship and personality, which tend to function as kinds of closure.

EC: *My impression, looking at the work, is that, as the relationship became closer, more symbiotic, the conversation becomes less visible, or the urgency of making it visible changes.*

Michael Baldwin and Mel Ramsden painting *Index the Studio at 3 Wesley Place painted by mouth II*, 1982

Art & Language, *Index the Studio at 3 Wesley Place painted by mouth II*, 1982

CH: The nature of the work changes. In the indexing work of the early 1970s, you are dealing with very large bodies of texts, in which there may have been many contributors, many different authors, so that that variety and extent of authorship is very clearly declared in the work. If you are talking about an individual object, a painting, the different components don't separate out in the same way. It's one surface. And it would be absurd to get obsessed with trying to identify who made which brushstroke. So the relationship between the form of the work and the character of the conversation changes, inevitably. It does not follow that the conversational input in the work is not important. The work retains its essayistic and discursive character. A lot of art is self-insulating, self-sealing. I don't think that Art & Language work has ever been like that. It has always been a fairly open and discursive kind of work – however difficult.

EC: *And why has it always been said that the work is difficult?*

CII: Well, it is. It is made of fairly complex, diverse materials. It tends to be technically quite complex. It is not all like that. Some of the work, it seems to me, is very straight-forward. Some of the series of big paintings like the 'Studios' and the 'Museums' are very complex in one way, but they are not very difficult to explain. Things like the *Portraits of V.I. Lenin* are not very complicated. This work has a very rich content, and there is lots to be said about it, but I would not say it is difficult. I suppose the difficulty comes more with work that has text in it. That takes a bit of work, a bit of reading. And of course, there is the writing, but then if this is difficult it is difficult for two reasons. One is because the issues that the writing tends to address are highly specialised, which I think art is now. Secondly, it is a consequence of the character we talked about before, that the work is not generally done in the spirit of literature, and is not quite philosophy. It exists on a slightly strange borderline between different genres of writings – and necessarily so because it needs to maintain its life as a slightly anomalous kind of presence.

EC: *Regarding the relationship between the work, the writing and the critique of the work, all of you have had a special role in writing extensively about the work, while not very substantial or interesting critique has been written by others. Had it all been written about, or was it maybe too difficult for other critics to step up to*

the challenge of writing anything more interesting about it?

CH: I have always worried about the fact that maybe if I didn't write about Art & Language's work so much, other people would write more – that I put other people off. But it would have been very stupid of me to hold off writing about the work of Art & Language in the hope that other people would do it. And actually, I don't think I could bear to.

EC: *I know other artists that collaborate, for example, the Paris-based collective Claire Fontaine. They take all decisions about the work jointly, but one of them does most of the writing, and writes very beautifully, also on the edge of a philosophical discourse. Yet they were recently quite frustrated by the fact that no one else seems to write interesting texts about their work, and they were saying that maybe they should stop doing it, and see if other writers would start to critically engage with it. But, of course, they cannot stop writing, because this is part of their work, their practice. It would not be the same work otherwise.*

CH: I don't know the answer – obviously we talk about this quite a lot. In fact, we are trying to write something at the moment that's partially about this issue – about why no one listens. I think at least one reason has to do to with what happened to art criticism. Art criticism just collapsed when modernism collapsed. You get a kind of university art writing which has its roots in semiology, which led to the kind of writing that *October* represents, which is highly intellectual and engages with a particular, fairly narrow view of the constituencies of art history. But otherwise, there has not really been any interesting art criticism, I would say, for forty years. It is as if the role of critique collapsed, turned into something else, into art history, into art-world press releases, into cultural studies, journalism and so on. But the kind of art criticism which starts off from a very careful definition and analysis of the work – that idea that you start with description and analysis – became very unfashionable, was associated with formalism, a dirty word; whereas in fact, you cannot get very far with Art & Language's work unless you start with the problems of definition and analysis. So it may just be that there are not enough people around with the right competences.

EC: *Despite the lack of this discourse, at least in my experience visiting young artists in their studios, there is an incredible amount of work being made right now*

for which the formal qualities and aspects of the making are extremely important, not least in the UK. You cannot really get away without being interested in and engaging with the physical qualities of the work.

CH: Yes, it is serious – with art you have to first establish what it is. If what it is isn't complex and problematic, it is probably not very interesting.

EC: *You said the last good art criticism was written 40 years ago. What were you referring to?*

CH: I suppose Michael Fried.

EC: *Yes, of course, you have referred to Michael Fried's writing a number of times. One of the issues I find interesting in the critical writing of the time, and in Fried's writing in particular, is the notion of 'theatre': when the beholder is suddenly put into the equation in a central position, the autonomy of the artwork is threatened. To a point, you seem to share this view.*

CH: Yes I do, and so I think do Michael and Mel. They share it to the extent that they would agree with Fried's position that art tends to degenerate as it approaches the conditions of theatre.

EC: *Both Clement Greenberg and Michael Fried discuss the relation, or degeneration, of art into theatre. Yet this concept of 'theatre' is never defined, is always considered a given. Could you define it for me?*

CH: Not easily. What I can say is that it seems to me that Fried was making an important point about the possibility of keeping a fine-art tradition going. He was not quite saying this at the time, but he might have with hindsight. At that moment in 1967 it seemed as if the alternatives were either to try and keep the fine-art tradition going, or to adulterate that tradition with things like performance, happenings, whatever. When he was talking about the theatrical, he was really talking about the relationship between the spectator and the object, and how that could be theatricalised – he did not quite mean theatre literally. He was talking about the changing relationship between work of art and spectator, which he saw in Minimalism. I think he was right about the adulteration

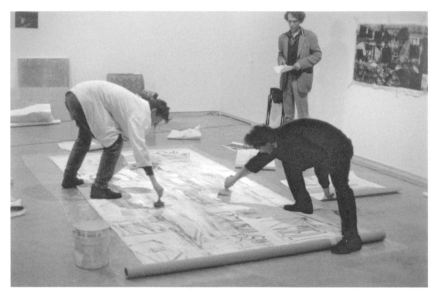

The Jackson Pollock Bar, performing *Theory Installation: Art & Language Paints a Picture*, Antoni Tapies Foundation, Barcelona, 1999

of the fine-art tradition. But I think he was wrong about his sense of how that tradition was to be kept going, because I think that what he wanted was over already. The kind of art that he supported no longer had the potential in it that he thought it did. The question becomes: what are the alternatives? Do you diversify art into forms of installation, environment, performance and so on, and welcome this as a breaking down of barriers? That, it seems to me, has been the all-dominant tendency of the art world, partly because it is very good for business, because art can become spectacle, it can become fun, it can become Tate Modern, it can be something for everyone, it can be a big tourist attraction and so on. But the much harder question, I think, is how we might hold on to these distinctive traits of concentration and virtuality that art, and particularly painting, always stood for. That, in a way, seems to me to be the question that Art & Language have asked, if not very explicitly. It is certainly the case that Art & Language seemed always to be very reluctant to go down the path of installation or the theatrical, or the environmental, or the performative and so on. And that must be because there was a sense that these

possibilities were always somehow obscuring something else. What that something else might be is not so easy to establish. There is no absolute dogmatism in this. We have, after all, collaborated with the Jackson Pollock Bar in providing material for their *Theory Installations* – which are performances of a highly structured kind.

EC: *In my understanding of Michael Fried's writing on the subject, at that moment when artworks become theatrical and objects establish a relationship with spectators, the fundamental problem, together with re-defining what the inquiry of art is, lies in the loss of autonomy.*

CH: Yes, Fried's position – this idea that what matters is presentness, and presentness is something that is experienced in a one-to-one relationship between the autonomous work of art and the autonomous spectator – is open to criticism on two particular grounds. One is that it involves privilege, necessarily, because this relationship requires increasingly specialised and refined kinds of circumstances, which are not easily assimilated into a democratic kind of public life, and that means that there is something wrong with them. That's one criticism. And during the late 1960s and early 1970s that criticism had very considerable power behind it. The other criticism, which is connected, is that the whole notion of presentness depends upon notions of essentialism and autonomy and, to a certain extent, on an unreal disinterest on the part of the spectator, and that this is idealism. The work of art can only be seen as having autonomy insofar as it is part of what we have already defined as a highly privileged dimension. The modernist concept of autonomy has always had the potential to serve as a means of insulating art against certain kinds of criticism and certain kinds of enquiries into what it's really made up of and reliant on. Both of these objections have had plenty of mileage. Too much in some ways. Both criticisms can, I think, be answered. First: the relationship that involves privilege. One answer to that is that it is indeed true that privilege is involved, in the sense that the experience of art is one to which very high values are attached. But the answer to that is not that nobody should have it, but rather that you should try and remove the barriers that stand in the way of anybody having it. So you do the best you can. You don't say: 'We don't approve of autonomous art because only a few people can appreciate it.' You say: 'If there's a high value in

autonomous art, then we should try and make that experience available to more people.' This seems to be a stronger response. The response to the criticism of autonomy seems to me to be that the forms of art which have been advanced as kinds of answers to the idea of autonomy – types of readymade, ways of nominating, work 'in the space of the spectator' and so on – all actually still depend upon powerful contents of autonomy. It makes no sense to talk about something as a work of art unless you have some means of singling it out against the background of everything else. So you've always got some sort of autonomy thesis at work as soon as you start talking about art at all. And really, I think people confuse arguments about autonomy with arguments about privilege, and they are not the same.

EC: *Am I right to see Adorno in the background, as a sort of philosophical reference?*

CH: If so, it is not because I know Adorno's work backwards, because I certainly don't. What I have read of Adorno, I have always responded to. I think one recognises him as a powerful thinker who at least has some sense of the contradictions between a commitment to the high value placed on art on the one hand and some realistic sense of what the political and social world is made of on the other.

EC: *Going back one more time to the subject of theatre, in* Homes from Homes II[6] *there is a transcription of a conversation between you, Mel and Michael, in which Michael defines one of the trajectories of post-Conceptual art as 'institutional theatre', the other being the kind of essayistic practice you defined. Mel gives a few examples of 'institutional theatre', including works by Daniel Buren, Ilya Kabakov and the large installations in the Tate Modern Turbine Hall. This is the tendency you described as being more branded, the one that turned into a pursuit of personal styles. You commented that by the early 1970s, various types of fashionable postmodern theory and – under the sign of the curator – informal versions of a theory of 'institutional theatre' were spreading. How would you comment on the spreading of 'institutional theatre' in relation to the development of the role of the curator?*

CH: What drives the role of the curator are much larger tendencies within the culture as a whole – the economics of culture, the demographics of culture, the way in which the art world has changed, the way art

institutions have changed. All of these are factors which create a sort of demand and stage for certain kinds of art, for institutional theatre, and make it increasingly hard to hold on to a kind of art that requires relatively quiet and concentrated and demanding attention. You can see that even in some large traditional institutions with non-modern kinds of art like the National Gallery. Even then, there's a tendency to pick out the exciting masterpiece and direct people to it, and then get them into the café and the bookshop where the money is made. The idea that what art requires is a certain amount of silence and concentration is just not very good for business.

EC: *Is it a reversible situation?*

CH: I don't know. It is certainly the case that we seem to be sliding fast down the other side of a kind of precipice, economically speaking. A lot of the economic conditions which have been inflating the bubble of the last 25 years are now seriously discredited. The bubble has burst, economically speaking. Whether that will have similar consequences for the cultural bubble is hard to tell. One might hope so. It is generally the case that the kind of economic circumstances we are surely going to be living though in the next ten years tend to prompt tendencies to the Right rather than the opposite, I fear. So it is a bit hard to tell what we are going to get.

EC: *Apart from Art & Language, who are the other artists, if any, who have been able to develop the work in a similarly sophisticated way, bridging an intelligence in the making with an interesting conceptual development?*

CH: I always find this a very difficult question, because I feel I ought to be able to come up with a list of names, but I never can. There are three possible reasons, none of which necessarily eliminates the others. One is just that I am out of touch, which I am. I don't know enough, I don't see enough, I don't go around seeing what's on offer and exercising discrimination, so I'm very ignorant about what's there. That's certainly true. It is also possible, and connected to that, that I am just out of my generation. I am a tired old fart who's fallen behind the pace. I can't make the effort, or my intellectual arteries have hardened and I can't respond to stuff. That's also quite likely. The third possibility is that I have become so

completely bound up with Art & Language that I can't see beyond it. That's certainly what lots of people would say. And there is probably some truth in that too. There is one more possibility, which is that the conditions of art have changed very substantially over the last 30 or 40 years; we are living through a period when there is a lot of art that's sort of moderately okay, but just not very serious. Art being serious is just something which is not happening very much currently, and in that respect, Art & Language is very exceptional. Art & Language's work is serious in a way that very little else that I see is. I am inclined to think that there is lot of truth in this.

When people ask me which other artists I am interested in, I can cite a few remaining artists of my generation or slightly older – I think Gerhard Richter is a very substantial artist, and Carl Andre remains a very important artist. But after that, I start running out, or I start to lose interest. I occasionally see stuff that I think is quite amusing, or quite interesting. One acid test for me is a kind of desire for possession. As you may have noticed, I acquire objects and they are all pretty old – sometimes they are very old. I am fascinated by the art of other cultures. There have been occasions with Art & Language's work when I really want it, like an obsessive collector. I want to have it, I want it on my wall, I want to own it, I want to live with it. I very rarely feel like that about any other contemporary art. I would love to have a Carl Andre. There are certain works by Richter that I have really coveted – not exactly a controversial choice. But among works made in the past 25 years by younger artists, there has been nothing I wanted in that sense.

EC: *Thinking in terms of the work of Art & Language throughout the decades, have there been periods of higher experimentation and moments of more significant failures and successes? And at what point does the quality or value of the work become manifest? When exhibiting the work, or later?*

CH: Although I can't answer for Michael and Mel, I think it is pretty clear before the work gets shown. This is one of the reasons why one wants to have a show. There are two paintings in the studio at the moment, the two most recent things they have done, which I think are extraordinary, absolutely fascinating, and we all want to see these works properly exhibited. Because of the very strange nature of the work, it requires a gallery such as Kasmin's in Bond Street in 1967, which was the absolutely

archetypal, large white cube. What the work needs is a white cube gallery with one of these paintings at one end and the other at the other end. And then we could see if they are really as strange and fascinating as I am sure they are. Sometimes the work needs to be alienated from the studio and put in different conditions so that you can see how it lives in the world. But I can remember two shows in particular that were just disappointing. The works just did not do what they were supposed to do. It just happens that some phases of works don't get cherished. Sometimes Art & Language's work is tried out in the world – put on show – and it becomes fairly clear sooner or later, maybe during the exhibition, maybe some time afterwards, that it is just not going anywhere and will not go anywhere. Quite often, that means that the work gets reabsorbed and reworked into a different project.

I can think of one particular example. I think it was the last show at the Lisson, four or five years ago. There was a big work [*Sighs Trapped by Liars 910–1027*, 2004] made of tables with vitrines on top. The vitrines had pictures of illusionistic bowls and saucers floating into space. There were twelve of these tables – a big work and pretty interesting. But since then, that work had been stacked up in the studio under dustsheets. It has never come out again. It was never clear where it might go, what its destination might be, who would buy it, why, and so on. Michael had an idea about how some of its components might be re-used, and the table-tops finished up making frames for one of these new paintings. So that work has been abandoned, because it did not have a life, but it has been contributing to very different kinds of lives with these other works. That happens with a certain amount of the works. It is not easy to say quite why. Is that a decision just about the work? Is it a decision partially about the world? Or is it a decision about the relationship between the work and the world? I suppose, it is a decision about the work, because in a way you let the work out into the world, and if it doesn't fit, it doesn't have a life in some way; that's a kind of criticism of the work. Though one has to be careful, because there are also phases of works, like with the big pink paintings – the series *Index: Now They Are* (1992–93) – which were greeted with absolute blankness, silence and incomprehension, certainly in this country, and they're now very highly regarded and sought after. Now they have finally found their place. I always thought they were very good. But sometimes work takes quite a long time to have a life outside the studio.

EC: *How important is the laborious engagement with the making of the work to its success?*

CH: I certainly think it is a defining characteristic of Art & Language's work that it tends to be thought through, and tends to be well made. I mean, technically it is very well made; it is very robust. There is a very strong ethical character to the work in that sense: Michael and Mel don't let work go that is going to fall apart. And they don't have work made by other people. That's a very strong aspect of the morale of the practice. I would not say that the amount of effort that is put into the work is a reliable measure of how good it is. There are some works that are highly complex and had lots of work put into them that just don't come off in the end. That's going to happen in any practice. And there are some works that seem to be easy by-products, perhaps moments of relaxation, that turn out to be quite serious and maybe open up a new series of works. I am sure that these are common eventualities.

EC: *Why is it important that all work is made by them?*

CH: It is a sort of practical decision they took at a certain point. I think it is a decision about what kind of career not to have. Because if you start having work made by other people there is a temptation to get involved in the competition, to aggrandise, to use more and more resources, to get bigger and bigger, become more and more impressive, and finish up in the Turbine Hall – that kind of rage for a sense of status. I think there was a conscious decision not to get involved in that. There is also a sense of the need to maintain a certain kind of control. And also to set certain kinds of practical limit to the work, which are to do with what can be handled in the studio, but also with what can be readily rendered subject to criticism. There are very good practical reasons to make only that which you can actually physically handle and move about in the studio.

EC: *Is this one of the aspects of a practice that you defined as being 'serious'?*

CH: 'Concentrated' is a better term. Maintaining concentration. If you have stuff made outside you lose a certain level of concentration. It's to

do with the need to control a certain range of stuff, to maintain certain standards and retain certain potential values.

EC: *You never make practical decisions on the making of the work, but you are a member of Art & Language. Would you say your conversations on the work had an input in shaping it?*

CH: I don't think I have any very clear, measurable effect on the work. I have never told Michael and Mel what to make. I might join in a conversation about what to do next, or how to extend a series, but my suggestions virtually always turn out to be inappropriate. My role is very much more to respond to what they do make, and particularly to stuff that I think has real potential, and to talk about it. I think I have helped to open the work to interpretation and to criticism, including among ourselves. And I am very sure that that sense of conversation about the work is important. But I always operate on the whole in relation to work that has been made rather than in relation to ideas of works that might be made.

EC: *It has now been over 30 years of collaboration among the three of you.*

CH: Nearer 40.

EC: *It is quite extraordinary. What makes a collaboration possible and fruitful over such a long period of time? Is it friendship, or the shared interest in the work?*

CH: I couldn't distinguish between the two. It is certainly to do with a common commitment to a tradition of work, which is very important. That commitment would not be nearly so easy to maintain if there were not certain conditions of friendship as well, I am sure. But then the friendship is grounded in the shared commitment.

EC: *Do you see your role as having changed over the course of the decades?*

CH: Yes, I am much less concerned to try and impose my notions of order and organisation on Art & Language, to think I should do so, and of course, as the nature of work has changed, so too my relationship has changed.

When the exhibited work largely took the form of writing, there were obviously ways I could contribute to it – or at least to some of the materials out of which it was made. That changed as the potential of Conceptual art was exhausted. But we still do quite a lot of writing and publications together, so in this sense my role remains very similar, as co-author and editor.

EC: *What is the relationship between the writing and the object? Has this stayed the same?*

CH: No, I think it has changed a bit. I think it used to be more the case that the writing and talking tended to feed into the artwork – certainly during the indexing. I would say the work was partially made of the materials of the writing and conversations. Now it's quite often the case that the writing and talking that we do is generated by a particular phase of work, while my own writing is much more devoted to trying to make sense of the work, trying to establish a position for it. So that has changed quite greatly I think.

EC: *Is there a particular moment in the making of the work, when it is still open or unfinished, when it feels that conversation is needed?*

CH: It depends on the nature of the work. I do sometimes get a phone call saying 'There's something in the studio we'd really like you to come and look at and talk about', and I think that the resulting conversation can be important, particularly where I feel I can confirm a sense of excitement about a new phase of work. In the case of these two paintings in the studio, which are certainly very interesting, I would really like to write about them, partially for my own sake, partially for the sake of the paintings. I don't quite know where that impetus comes from. It's partly to generate further conversations with Michael and Mel, I suppose.

EC: *Is there something in the work that generates the desire to write about it?*

CH: Absolutely.

EC: *What is it? Can you define it?*

CH: It is fascination. This is a dangerous analogy, but it is like meeting somebody that you would like to get to know better. A sort of attraction in that sense.

EC: *Do you think the pleasure that comes from writing about the work relates to the desire to make things more clear for yourself, or for the reader? Or is it about establishing further connections, keeping the analysis and interpretation of the work open?*

CH: It is probably both. One thing it is not, I am afraid, is a concern for readers, because I never think about the reader. I certainly hope, writing something, that other people might find it interesting, that it might give them a way in to the work. But when I am actually writing, I am not writing for other people.

EC: *Not even for Michael and Mel?*

Paper chain in Art & Language studio, Oxfordshire, December 2008

Art & Language, pallet with paper chains, 2007

Art & Language, *Portrait and a Dream 1*, 2007

CH: No, at least not initially. I am writing for the work, I think. But at a certain point it becomes about writing for Mel and Michael, because I give it to them to read, comment on and correct. Initially, though, it is for the work. It's to establish a relationship with the work, and to learn more about it, because you never really know something properly until you have puzzled at it – and I suppose my way of puzzling is to write about it.

EC: *Do you ever fear, writing about a work, that you are actually closing its interpretation down?*

CH: No. If I knew I was writing badly I would fear that. But not if I am writing reasonably well.

EC: *What would you say 'writing well' means?*

CH: I suppose it means being able to keep an argument going. And being able to stick to the work. You usually know if a bit of writing is all right.

EC: *How do you know?*

CH: Firstly, if it hangs together as an argument. Secondly, if you can be sure that that argument has been significantly decided by the specific character and properties of the work. Thirdly, if it makes what you are writing about more interesting, if it illuminates it.

EC: *It's interesting you say you do not think about your readers. This is normally what one would expect: to think of your readership, if not of your editor.*

CH: There was a case recently – a work by Michael and Mel based on paper chains [*Singing on a Sunny Bed*, 2008–09]. I got fascinated by that and I had to give this paper in Germany last February,[7] so I started writing about the paper chains. I thought at the time it might be the last presentation about the work of Art & Language I would have the opportunity to give – an hour's talk as a kind of swan song – so I put quite a lot of effort into it. I called it 'Party Time: Decoration and Abjection'. I was quite pleased with the result and so were Michael and Mel, partly because I think it helped to show what might be substantial and interesting in that phase of work. And the Mulier

brothers, dealers from Belgium, turned up in the studio. They were going to show some of these works and wanted to publish the text of my lecture in the catalogue. A collector came to their exhibition, sat down, read the article and immediately bought one of the works. I was really pleased that it made someone want the work. So in that sense, of course I care about the reader, about the fact that my text may have helped the work get into a good home. I was really pleased about that.

EC: *With this new teaching book that you have been writing, the* Introduction to Art *for beginners,*[8] *can you still avoid thinking of your readership?*

CH: No, that's very different. I have spent a lot of my life writing teaching material for students. But even then, actually, it's still more important to be true to your subject than to be true to your reader. What I object to in some of my teacher colleagues is that they are so concerned about their imaginary picture of the student that they forget to attend to the quality of the argument – to attend to the subject that they are supposed to be teaching. So it all becomes a kind of social work on behalf of the student rather than teaching, and I hate that. Yes, the *Introduction to Art* is written for beginners, so I have deliberately tried to keep the prose straightforward. That's really the main sense of me trying to think about the reader, but not much more than that. I hope what keeps the book alive is that it is written from a real interest in the works of art it discusses. While I am writing, I am not thinking about the reader, I am thinking about that object. I am thinking: 'Okay, how do I get somebody else interested in this object; how do I teach them; how do I show them what you do first?' If someone who has never really seriously looked at a painting comes into a museum, well it is can be quite a complicated business. What's a picture space? A picture space is a complex thing. What's the relationship between the picture space and the picture surface? Most people could not tell you. But if you don't know that you can't make sense of it. So what I am doing is to say: 'This is what a picture space is; this is how it's set up; this is what the relationship between space and surface means.'

EC: *Do you only ever write about art works you like?*

CH: I try to. I try not to write about stuff I don't like. I have done it occasionally, but it is not a good idea. I am lucky in that I do not need to write a weekly column or something where you can't choose what to write about. I can choose entirely what I want to write about and it would be rather stupid to spend time writing about something I don't like. I might not in any case have anything very interesting to say about it. There are sometimes occasions – let's say when a particular kind of work is getting lots of attention, when everyone is getting hung up on the values that this work is supposed to have, and I think it doesn't – when it might seem an almost necessary job to try and explain why people have got it wrong.

EC: *In what cases have you done that?*

CH: The last time I did it was probably over 20 years ago. It was when Howard Hodgkin won the Turner Prize. In actual fact, it was just before, when he was in the running for the Turner Prize. He had a show at the Whitechapel or somewhere, and everybody was cooing about these paintings as they were doing about Howard Hodgkin himself. I can't stand Howard Hodgkin's work. It seems to me to be very deceptive, empty and pretentious. So I wrote an article about how empty I thought the work really was. I think that was the last time – apart from occasional asides.

EC: *In relation to what you were saying about the attitude of other art teachers towards their students, museums seem to me to act in a fairly similar way. The text panels in many modern and contemporary art museums seem to be written so as to be easily understandable for 12-year-old visitors. To me, there is a general tendency to belittle audiences.*

CH: Yes, and to set lower and lower standards. Which is one of the problems for Art & Language's work. In a world in which that's where your standards are set, how do you really expect anybody to take it seriously? Who is going to?

1 Charles Harrison, *Essays on Art & Language*, Blackwell, Oxford, 1991 (reprinted by MIT Press, Cambridge, MA, 2001).

2 Philip Pilkington and Dave Rushton were students at Coventry College of Art, where three members of Art & Launguage, Terry Aktinson, David Bainbridge and Michael Baldwin had introduced an 'Art Theory' course in 1969. Along with fellow student Graham Howard, Pilkington and Rushton produced a magazine entitled *Analytical Art* (two issues, 1971–72), and later contributed to the Art & Language journal and project. Rushton was also later to write, with Paul Wood and others, a highly critical study of the politics of British art education.

3 In 1969, Michael Baldwin started teaching at Coventry College of Art. He joined two other members of Art & Language already teaching at the same college: Terry Atkinson and David Bainbridge. The three tutors developed the 'Art Theory' course, which involved intense seminars and study taking place in the studio. The studying of any text, conversation or object to come from it would be considered as artwork. The course only ran for two academic years, between 1969 and 1971. When, in 1970, the Coventry College of Art became the Faculty of Art and Design of Lanchester Polytechnic, new dean Robin Plummer opposed the 'Art Theory' course for failing to generate tangible visual objects. Plummer took the case to the National Council of the Diploma in Art and Design, which determined that studio practice should produce physical artworks. Such a determination implied that the 'Art Theory' course deviated from the norm and could jeopardise the diploma credentials of the school, giving Plummer ground to suspend the course. As sessional tutors, Bainbridge and Baldwin were summarily dismissed. Atkinson, who held a full-appointment, stayed on until 1973, then resigned.

4 Cf. Michael Baldwin, 'Remarks on Air Conditioning: An Extravaganza of Blandness', *Art News*, November 1967 (Atkinson used the subtitle of this essay as the title of his own text).

5 *The Air Conditioning Show*, The Visual Arts Gallery, New York, 1972.

6 Charles Harrison, Michael Baldwin and Mel Ramsden, Art & Language: *Homes from Homes II*, Distributed Art Publishers, New York, 2006.

7 Charles Harrison, 'Party Time: Decoration and Abjection', paper for the conference 'Our Literal Speed', ZKM Center for Art and Media, Karlsruhe, 29 February 2008.

8 Charles Harrison, *An Introduction to Art*, Yale University Press, New Haven, 2009.

Conversation Eight

Christopher Heuer and Matthew Jesse Jackson | November 2007

CHE: *Throughout your book* Painting the Difference,[1] *the question of 'difficulty' often comes up. It's raised in your description of artists' working processes (for example Degas's monotypes), in certain receptions of postwar American abstraction, and most personally, in your account of what you see as increasingly lacking in art criticism. At one point you lament certain writers' tendency to avoid nothing less than 'the difficult enterprise' of description. The book, at least as I see it, offers a corrective to this development in its very form, consisting as it does of (among other things) a scrupulous set of accounts of individual works, and with an eye on the minutiae of their production – in sum, a collective argument for specificity. Given the current ideological moment's overt hostility to notions like 'difficulty', are you at all optimistic about art criticism, or about the writing of this kind of art history? I ask this question, of course, against the backdrop of Art & Language, which has its own reputation for 'difficulty' and whose long-standing approach to the institutionalisation of the avant-garde (and more recently, the institutionalisation of 'avant-garde' art criticism) would seem to raise any number of related issues.*

CH: I certainly wouldn't want to defend difficulty for its own sake. But in a world in which what appears to be expected is instant ease of transmission, it seems important to stress both that the work of critical cultural production tends to require a degree of exertion, and that a matching concentration may be required to recover what's of value in art – as in much else. The enterprise of description is linked to this, since it is through description – and, I believe, only through description – that we gain an understanding of what that exertion entails. What I mean by 'description' is some adequate representation, whether articulated or not,

that is checkable against the produced properties of the work in question. While there may be no such thing as a fully objective account of a work of art, it remains the case that interpretations are always open to being falsified if the readings they produce can be shown to fail as descriptions in this sense. Of course, as problems are encountered in generating descriptive accounts, those accounts tend to become interpretative and value-impregnating – as it were involuntarily. It is through this process that the real historical character of artistic work is recovered. But it is precisely for this reason that I distrust those kinds of description that are the mere creatures of historical and cultural generalisations. As I understand it, what's meant by closure is a refusal to persist with the enterprise of description beyond the point at which the results are of service to a particular theory or set of assumptions. For some while now (over 30 years), that kind of refusal has found spurious justification in the reaction against modernist 'formalism' (which is to say, its emphasis on descriptive analysis), and in the critique of those claims to disinterest that lay at the heart of modernist criticism. It is a consequence of the resulting prevalence of institutional theories of art that individual works are typically treated as kinds of signposts directing attention back into the culture. Under this regime, the writer who once identifies the indicated direction need do no further descriptive work, but can go on to generate limitless copy on the analysis of cultural context. In so far as the ensuing art history and criticism have been generative of critical judgements on specific works, those works have generally been made to appear quite unresistant to the tendency of the art history and criticism in question – and thus of little interest in themselves, at least as the objects of the writing.

As regards the practice of Art & Language, however, it can be said that the objects that practice has generated – whether textual or pictorial or whatever – have generally been difficult to describe, and often contradictory in their apparent direction. They are consequently frustrating attempts to escape from their internal detail into the vocabulary of cultural topicalisations. This may not have been good for business, but it has certainly been good for me. The need to confront the difficulties in question has remained central to my education as a writer on art over the course of nearly 40 years.

CHE: *Speaking of internal detail (and of you as a writer), didn't you just author a chapter on Renaissance printmaking?[2] How did this come about?*

CH: That's much easier to answer. The book in which the chapter appears is one of four that comprise an Open University course on Renaissance Art. I joined the course team out of interest, and I volunteered a contribution on prints partly with a view to some self-education. I've been a very amateurish collector of prints for a long time. Years ago, when I was a student, I found an early impression of Marcantonio Raimondi's engraving of *The Angel Appearing to Joachim*, made after Dürer's woodcut. It hangs over my desk as I write. The chapter was written as a teaching text, and I started it with a close comparison of the engraving and the woodcut, as a means to introduce the virtues and differences of the two main print media – and the ways in which they served the development and exchange of pictorial imagery in the Renaissance. Getting out of the modern can sometimes feel like being on vacation.

CHE: *Vacation or no, earlier art – particularly 'early modern' art – often seems to figure heavily in your writing on more contemporary developments, more so than with other critics. I'm thinking not just of* Painting the Difference *(which opens with a discussion of Titian and Sophonisba Anguissola), but also of your earlier work on landscape painting. Is this a function of your teaching? Institutional structures being what they are (and I'm speaking just about the US), this kind of rigorous, cross-epoch analysis seems to be becoming rarer and rarer.*

CH: I guess I've always looked at a lot of stuff. I'm rarely happier than with a large museum at my disposal. At the point when I switched from undergraduate study of literature to art history, I had it in mind to be a medievalist: a fascination with Arthurian and related poetry got transferred to an enthusiasm for French Romanesque sculpture. That and Raphael's *Stanze* (another undergraduate subject) are still markers for me of how good art can be at first hand. I do try to keep a larger history in mind when I'm teaching, and I relish any opportunity to draw from a wide field of examples. Each year for the past 30, I've taught on a specialised modern art summer school run by the Open University, but where possible I've combined that with working on introductory courses in the Humanities, where there's a much wider survey. And this year I got to work on a broadly

based introductory course using the British Museum – with the global art and culture of some 5,000 years to play with. My teaching may not have been very rigorous, but I had a great time. I've no patience with antiquarians, but I do think that art indifferent to history tends to show it. Abstract art was the great adventure of the twentieth century and I've always wanted students to see how good it can be. But – if we're honest – how much abstract painting matches up to the best figurative art of, say, the seventeenth century? A very small minority, I'd say. I know that such comparisons are a bit unreal – ahistorical, essentialistic and so on – but it does matter that our art be as good as we are able to make it (isn't that what 'art' really means?). And the cultures of the past offer diverse instances of what it has been possible for humans to achieve. It used to be the case that the market offered a kind of crude index of the relativities in question. It may be of interest that in recent years the market has often seemed to have settled for less – or to settle on less.

CHE: *A professionalised art world now less than interested in actual professionalism, perhaps?*

CH: Yes, though one has to acknowledge that professions get redefined – or rather the relevant competences do – and if the world changes around you, there's not much future in sitting there moaning in whatever bit of ground you've managed to cling on to.

MJJ: *This conversation is like an art-historical 2001: A Space Odyssey, where Charles gets to play HAL. Charles, your response to Christopher's question about difficulty illuminates one direction of your work – towards an intense concentration on the art object's internal complexity – yet I've always been struck by your commitment to projects that make complex theoretical writing available to a broad public. Whether you are in Berlin, Paris or New York, the bookstores offer Art in Theory[3] as the definitive compendium of writing on art in the twentieth century – and the Open University series has become a standard text for modern-art surveys. Is there a kind of contradiction at work here? I can imagine a certain kind of art historian who might say that descriptive precision is all well and good, but maintaining an allegiance to resistant discursive complexity – at all levels of instruction – is equally critical (something that the Art Since 1900 survey,[4] for example, might imagine itself as doing). In other words, do the contextualised,*

necessarily edited and sometimes fragmentary texts in Art in Theory *lose some of the very qualities that you most value in artworks? One could even say that these texts are rendered much more pliable for mobilisation in projects of bland cultural contextualisation. Am I comparing apples and oranges?*

CH: Well, we all know what happened to HAL. He had his plugs pulled out one by one and lapsed into a pathetic incoherence.

I don't think that allegiance to 'resistant discursive complexity' should ever mean either that one celebrates difficulty for its own sake or that one puts up or maintains barriers against those who might want to be able to join the discourse – and I'd hope that that number might always include some of the people one gets to teach. One of the points about description is that it's a way of showing someone else what is there to be seen, so that they can at least get started. I don't see a contradiction – merely a different kind of answer to a different problem. The aim of the *Art in Theory* anthologies was not to mediate · though of course you can't help mediating to some extent – but rather to put a wide range of texts into people's hands. Yes, you edit. Some of the texts we excerpted in the 1648–1815 volume came from two-, three-, or four-volume works. One of Diderot's *Salons* runs to some 400 pages. What do you do? Put the lot in and leave out everything else? I get pissed off with people who moan about the editing and only want complete texts. They're always specialist academics who probably have the texts to hand on their personal shelves – the ones they know about, anyway. In fact, in each of the three *Art in Theory* books, the original source is given for every text; so is the location and extent of the edit. I'd be quite happy – though very surprised – if someone just used the books as a means to locate the original texts. In any case, I don't think that what you lose by reading just one passage from a long theoretical text generally equals what you lose by failing adequately to attend to an individual artwork.

Okay, I've been involved with an artistic practice that has produced difficult works in textual form, and it's certainly the case that one of the motives behind that production was to get people to pay attention or else keep quiet. But Art & Language has always been an advocate of irresponsible or insurgent reading. And one of my reasons for involvement in the *Art in Theory* project was to equip students to become better read than their teachers. As for bland cultural contextualisation, that's going to continue

whatever one does – but it does tend to be harder to get away with the more the diversity of the materials on offer has to be taken into account.

CHE: *I think this is a crucial distinction – anthologising and editing are of course not good or bad per se, but can be done badly or well; one of the most interesting things I find about the* Art in Theory *books (besides their heft, and, as Matthew noted, their omnipresence) is the way they, strangely enough, effectively demystify much of the writing on art in the process of what would seem to be tacitly eulogising it. I'm thinking specifically of my little sub-field (Dutch art history) which is shot through with a kind of logocentrism while not really having any meaningful 'source' texts whatsoever; until recently it was bland cultural contextualisation that held the day for many historians of this area because everybody refused to make a judgement about it, to clip and edit what few texts there were (and which, as writing, are dreadful). It seems the* Art in Theory *compilations aim for a unique kind of encylopaedism that's rigorous but also detached from any blind passion for completeness.*

CH: Heart-warming comments on the AiT anthologies, which my co-editors will be cheered to read!

CHE: *We'll send an invoice. No, more seriously, since Matthew brought up* Art since 1900, *I wondered if I might ask about Art & Language's recent response to the 'Octoberists' (its term), specifically their presentation of certain strands of 1960s/1970s Minimalism – as it relates to institutional critique.*[5] *Correcting what they see as a mischaracterisation of their work, Art & Language here seem to be objecting to a conflation of means and ends, writing: 'It would be false, however, to suggest that the technical aesthetics of minimalism were exhausted by its role in creating the conditions of institutional critique.'*[6] *I wonder if you could say more about this.*

CH: I think this should be understood in the light of the article's ensuing argument. The tendency of *Art Since 1900* is to see Minimalism's supposed ushering in of institutional critique as consistent with a 'radical' opposition to the late high modernism espoused by Clement Greenberg and Michael Fried, and to distinguish a progressive Conceptual art in these terms from a reactionary Conceptual art (including Art & Langauge) that is seen as still in thrall to modernism. Our argument is: a) that

Minimalism's specific attention to context and contingency entailed a constructive address to modernist orthodoxy, and that this was in itself 'already' an effective kind of institutional critique; but that b) there is an aspect to Minimalism – and to some US post-Minimal Conceptual art – that depends on a literal interpretation of the reductivist tendency in modernist theory (which was always that theory's Achilles' heel); and c) that a consequent problem posed by Minimalism and its legacy was the risk that the baby of virtuality – for which modernism had offered a robust defence – would be thrown out with the bathwater of immanent 'presence'. A motivating concern for Art & Language's early Conceptual art was 'that the intellectual and imaginative space that virtuality had kept open would be closed down by a logically collapsing argument for literalism before that space had been thoroughly explored'.[7] We would certainly now see that concern as justified by subsequent events. Two reservations need to be entered. 1) There is no thought that the strong wall-bound virtuality of early modernist painting can simply be recapitulated; we have to be thinking – in technical terms – of some kind of equivalence; which is to say that you can't just go on drawing the lines between the virtual and the literal or between 'art' and 'language' in one and the same place. 2) This was never and is not now just a short-term argument about how to get by in the coming season; there's no knowing how much time might be entailed by the 'before' in the sentence quoted above.

MJJ: *Besides challenging certain kinds of art history, the 'Voices Off' article lays out a compelling description of Art & Language's activities. I wonder if you could elaborate on some of the article's key terms. You just deployed one of them – 'virtuality' – which the article frequently juxtaposes with 'literality'. Could you discuss the appearance of this term in Art & Language's writings? 'Virtuality' rings pleasantly in my ear, as a more flexible, less academic rendering of modernist 'conventionality'. Following this line of reasoning, I wonder if Art & Language's practice has not been grounded from the start in the struggle to identify 'virtual spaces' – zones that lend themselves to 'more complex, less mechanical, less literal, and less sentimental'[8] procedures of production and description?*

CH: In computing parlance, a virtual space or surface is one not physically existing but made by software to appear so – and what follows, of course, is a vast market in interactive games. But the same resources are deployed in

quite robust kinds of research and invention. We might think of virtuality by analogy with the way the picture plane functions in painting to avail certain kinds of engagement on the part of the spectator (if I may refer back to a topic I spent some words on in *Painting the Difference*). This is a virtual plane, marking the line of division between the world of the spectator's present and the imagined, represented world of the picture. It is, as it were, the condition of possibility of certain kinds of transaction – social, sexual, historical and so forth – between the two; a technical instrument in the service of the realistic imagination. The picture plane may coincide with the literal surface of the picture, but it is conceptually distinct. Imagine a portrait where the painted figure points a finger out towards the spectator. If you could reach out in turn, the picture plane defines the point where your fingers would touch. In fact, all you'd actually feel would be the literal surface of the canvas, and at that point the imaginative power of the representation would be suspended. But it's important to note that you would not thereby be putting an end to a *fiction*. I suspect that a tendency to confuse the virtual with the fictional may have been responsible for some of the less justifiable claims made on behalf of 'the Art of the Real' in the later 1960s and early 1970s – Robert Morris's admonitions about painting's 'non-actual elusiveness', and so on. The other side of that coin – of that confusion – is the more recent tendency of those who exploit on-line virtual worlds in order to 'live' fictional lives. The virtual 'zones' that Art & Language has in mind are, on the contrary, conditions of the possibility of realistic inquiry and conjecture.

MJJ: *While we're in territory that straddles your role as a member of Art & Language and your writing as an independent art historian, could you discuss the practical significance of this bifurcation? How do the two roles currently inform each other in your writing, your thinking? Are there precedents for your position?*

CH: It's never – or very rarely – just my thinking and often not just my writing. I've been immensely fortunate in being able to draw – for nearly 40 years now – on the shared critical and conversational resources that Art & Language represents. As an artistic practice, Art & Language is the work of Michael Baldwin and Mel Ramsden. I aim to be the first and best-informed critic of that work. In turn, for most of what I write, Michael and Mel are the first and sharpest readers of drafts, and often substantial contributors

Michael Baldwin and Mel Ramsden, Art & Language studio, Oxfordshire, 2007

to the arguments of finished texts. Such thoughts as I may have about art or anything else are of course informed by whatever I personally may have looked at and read, but I rarely make much of that looking and reading without some reference to the work and conversation of the studio. While I might try to bring an art-historically informed eye to discussion of work in the studio, the changing character of that work has served continually to reanimate and to recomplicate my interest in the art of the past. That's the main – and considerable – practical significance as regards work published under my own name. (There are two prevalent and polar misconceptions about the character of our working relations. One is that I tell Michael and Mel what to paint, the other that they tell me what to write. Both are unimaginative and demeaning.)

For texts published in the name of Art & Language there are various modes of production: some go out – usually into art-world contexts – without any intervention from me; some are written by Michael and Mel and passed to me for an editorial polish; some are composed of written contributions from each of us; some – like 'Voices Off' – are based on transcripts of conversations, or arguments thought- and talked-through

between us in the studio.

I don't know about precedents. I think most artists have tended to need someone they can trust who will come and look at emerging work and talk about it – so that's nothing new. And apart from those academics who are scared of art – which I'm not – anyone who writes seriously about art must want to get close to the practice. For as long as I can remember I wanted that – to be close to the practice, not just any practice but *avant-garde* practice. (Put it down to my youthful reading of Apollinaire – or not.) I was lucky to be part of the generation of the original Conceptual art movement in the late 1960s and early 1970s, when the barriers between 'art' and 'writing' got tunnelled through from both sides – by some people at least. I first became involved with Art & Language by writing about the work, putting it in exhibitions, and finally offering my services as editor of the journal, *Art-Language* (out of an entirely mistaken sense of mission to sort out the typos and make it all more readable). But Art & Language doesn't offer 'executive' roles. My commitment to the enterprise meant that I became part of the work – part of the strange critical project that Art & Language represents. I don't really see myself as an artist – simply because that's not how I make my living – but it's with an eye to the idea of 'art' rather than, say, to 'academic standards', that I try to work, and my commitment to the practice is unabated.

CHE: *I suspect there exists a body of criticism which would see being 'close to the practice' as in fact a hindrance to writing seriously about contemporary art.*

CH: I'm sure you're right. But I can't really see that it ever helps to be ignorant about how things are made – whatever it is that they may or may not be made from. Of course, there's this idea – often advanced by those with secure institutional backing or with other unacknowledged loyalties – that one should aim to be 'objective'. I've published a couple of books of essays on Art & Language and there's this sniffy kind of question that reviewers tend to ask: can I really write proper criticism from within the practice? I guess my answer would be, judge the criticism on its merits then address the question. I don't pretend to objectivity, nor do I seek to conceal my association with the practice. But I'm quite happy for what I write to be tested for its adequacy against anyone else's account of the work in question.

1 Charles Harrison, *Painting the Difference: Sex and Spectator in Modern Art*, University of Chicago Press, Chicago and London, 2005.

2 In Kim W Woods (ed), *Making Renaissance Art Renaissance Art Rediscovered*, Yale University Press, New Haven, 2007.

3 Charles Harrison and Paul Wood (eds), Art in Theory *1900–1990*, Blackwell, Oxford and Cambridge, Mass, 1992 (updated in 2003 as Art in Theory *1900–2000*); Charles Harrison, Paul Wood and Jason Gaiger, Art in Theory *1815–1900*, Blackwell, Oxford and Cambridge, Mass, 1998; Charles Harrison, Paul Wood and Jason Gaiger (eds), Art in Theory *1648–1815, An Anthology of Changing Ideas*, Blackwell, Oxford and Cambridge, Mass, 2000.

4 Hal Foster, Rosalind Krauss, Yve-Alain Bois, Benjamin H.D. Buchloh, *Art Since 1900: Modernism, Antimodernism, Postmodernism*, Thames & Hudson, London, 2005.

5 'Voices Off', in *Critical Inquiry 33*, 2006.

6 *Ibid.*, p.125.

7 *Ibid.*, p.127.

8 *Ibid.*, p.116.

Charles Harrison

11 February 1942 – 6 August 2009

1970 Visiting Lecturer in Art History, School
of Fine Arts, University of Essex

1973 Visiting Lecturer in Art History,
Gloucester College of Art, Cheltenham

1973-74 Visiting Lecturer in Art History, School
of Art, Watford College of Technology

1976 Visiting Lecturer in Communication
Studies, The Hatfield Polytechnic

1976-79 Visiting Lecturer in Art History,
Stanford University overseas
programme at Cliveden

1978 Tutor: A351 Modern Art 1848 to the
present: styles and social implications,
The Open University

1979-81 Tutor: A352 Italian Art 1480-1580,
The Open University

1982-83 Durning-Lawrence Lecturer in Art,
University College London and
Westfield College, London University

1983-86 Visiting Lecturer in Art Theory, MA Fine
Art course, Birmingham Polytechnic

1984-89 Project Tutor: A403 Arts and Society in
Britain since the Thirties, The Open
University

1986 Tutor: A353 Art in Fifteenth-Century
Italy, The Open University

1988 Visiting Professor in History of Art,
School of Art History, University of
Michigan

1991 Visiting Professor in History of Art,
Department of Art, University of
Chicago

1996 Alexander White Visiting Professor in
History of Art, University of Chicago

1997 Visiting Professor in History of Art,
Department of Art, University of Texas
at Austin

CONSULTANCIES

1987 The London Institute, St Martin's
School of Art: to design a core
programme in 'Theory, Criticism and
Practice' for a proposed postgraduate
course in sculpture.

1988 Kent State University, Ohio, School of
Art: to design a component in 'Theory
of Art' for an undergraduate course in
Fine Art.

1990 International Selection committee,
Mastère, École Nationale Supérieure
des Beaux-Arts, Paris, 1990. Consultant
academic reader for University of
Chicago Press, University of Minnesota
Press, MIT Press, Yale University Press,
Ashgate publishing and others.

OTHER

2001-02 Scholar, 'Frames of Viewing'
programme, Getty Research Institute,
Los Angeles

2004 Visiting Scholar, 'Markets and Values'
programme, Getty Research Institute,
Los Angeles

EDITORSHIPS

1962-63 *Pawn* (Cambridge University Poetry):
Editor

1966-71 *Studio International*: Assistant Editor

1972-75 *Studio International*: Contributing
Editor

1971-09 *Art-Language*: Editor

1981-86 *Art History*: Editorial Board

1991-09 *Modernism/Modernity* (Johns Hopkins
University Press): Editorial Board

HONORARY APPOINTMENTS

2003-09 Honorary Visiting Professor in Art,
London Metropolitan University

Ben Nicholson, Tate Gallery Publications, London, 1969, 72pp illustrated, Library of Congress Cat. Card No. 74-91553.

English Art and Modernism 1900–1939, Allen Lane and Indiana University Press, London and Bloomington, 1981, 416pp with 165 plates, ISBN 0-7139-0792-4 (Allen Lane), ISBN 0-253-13722-5 (Indiana); revised edition (incl. 'Preface to the Second Edition'), Yale University Press for the Paul Mellon Center for Studies in British Art, New Haven and London, May 1994, 416pp with 165 plates, ISBN 0-300-05986-8.

A Provisional History of Art & Language (with F. Orton), Editions Fabre, Paris, 1982, 89pp.

Blue Poles: some strictures on the deletion of the project 'Art and Society' (with M. Baldwin and M. Ramsden), Art-Language, vol.5, no.3, monograph edition, March 1985, 88pp.

Essays on Art & Language, Basil Blackwell, Oxford, February 1991, 302pp, 126 and XXIII plates, ISBN 0-631-16411-1 (hb)/-17817 (pb).

Art in Theory 1900–1990: an anthology of changing ideas (with Paul Wood), Basil Blackwell, Oxford, November 1992, 1,190pp, ISBN 0-631-16574-6 (hb)/-16575-4 (pb).

Modernity and Modernism: French Painting in the Nineteenth Century (with F. Frascina, N. Blake, B. Fer, and T. Garb), Yale University Press, New Haven and London, in Association with The Open University, 1993 (see 'Impressionism, Modernism and Originality', pp.141–201), ISBN 0-300-05513-7 (hb)/-05514-5 (pb); Spanish edition, Ediciones Akal, 1998, ISBN 84-460-0856-4; Portuguese edition, Cosac & Naify Edições, 1998, ISBN 85-86374-17-2.

Primitivism, Cubism, Abstraction: The Early Twentieth Century (with F. Frascina and G. Perry), Yale University Press, New Haven and London, in Association with the Open University, 1993 (see 'Abstraction', pp.184–264), ISBN 0-300-05515-3 (hb)/-05516-1 (pb); Spanish edition, Ediciones Akal, 1998, ISBN 84-460-0868-8.

Modernism in Dispute: Art since the Forties (with P. Wood, F. Frascina and J. Harris), Yale University Press, New Haven and London, in Association with the Open University, 1993 (see 'Modernity and Modernism Reconsidered', pp.170–260), ISBN 0-300-05521-8 (hb)/-05522-6 (pb); Spanish edition, Ediciones Akal, 1999, ISBN 84-460-1198-0.

Art en Théorie 1900–1990, une anthologie par Charles Harrison et Paul Wood (with Paul Wood), Hazan, Paris, November 1997, 1280pp, ISBN 2-85025-571-8.

Modernism, Tate Gallery Publishing, London and Cambridge University Press, North America (Movements in Modern Art series), 1997, ISBN 1-85437-184-3, 80pp with 60 plates. Portuguese edition, *Modernismo*, Ediciones Encuentro, 2000, ISBN 84-7490-577-X; Dutch edition, Modernisme, Uitgeverij Thoth, Bussum, 2000, ISBN 90-6868-256-3; German edition, *Modernismus*, Hatje Cantz, Stuttgart, 2001, ISBN 3-7757-1073-6, Korean edition, *Modernism*, Youlwadang Publisher, Gyeonggi-Do, 2003, ISBN 89-301-0064-3.

Kunst/Theorie im 20. Jahrhundert (with Paul Wood), Verlag Gerd Hatje, Stuttgart, Autumn 1998, 777pp with index, ISBN 3-7757-0739-5, vol.1 1895–1941 672pp, vol.2 1940–1991.

Art in Theory 1815–1900 (with Paul Wood and Jason Gaiger), Blackwells, Oxford and Cambridge, Mass., January 1998, 1098pp, ISBN 0-631-20065-7 (hb); 0-631-20066-5 (pb).

Art & Language in Practice: Vol. 1 Illustrated Handbook, Michael Baldwin, Charles Harrison and Mel Ramsden; bilingual English and Catalan edition, Fondació Antoni Tàpies, Barcelona, April 1999, 300pp, ISBN 84-88786-43-3.

Art in Theory 1648–1815 (with Paul Wood and Jason Gaiger), Blackwells, Oxford, December 2000, 1220pp, ISBN 0-631-20063-0 (hb), 0-631-20064-9 (pb).

Essays on Art & Language (2nd, revised edition), MIT Press, Cambridge, MA, and London, December 2001, 302pp with 149 illustrations, ISBN 0-262-08300-0.

Conceptual Art and Painting: Further Essays on Art & Language, MIT Press, Cambridge, MA, and London, December 2001, 234pp with 90 illustrations, ISBN 0-262-08302-7.

Modernizem in konceptualna umetnost (Modernism and Conceptual Art), SCCA, Zavod za Sodobno Umetnost (Zepna 7), Ljubljana, 2001, 114pp with 30 illustrations, ISBN 961-6271-37-7.

Art in Theory 1900–2000 (with Paul Wood), Oxford: Blackwells, 2002, /1211pp with index, ISBN 0-631-22707-5/0-631-22708-3.

Art & Language: Writings, with Michael Baldwin and Mel Ramsden, as Art & Language, separate Spanish and English editions; Madrid: Lisson Gallery, Distrito Cu4tro, February 2005, 300pp, ISBN 84-934236-0-2.

Painting the Difference: Sex and Spectator in Modern Art, Chicago University Press, Chicago and London, 2005, 300pp with 180 illustrations, ISBN 0226317978 C/ 0226317986 P.

Homes from Home II, with Michael Baldwin and Mel Ramsden, as Art & Language, Zurich: Migros Museum für Gegenwartskunst, and JRP/Ringier Kunstverlag AG, 2006; English edition, 272pp with 150 illustrations, ISBN 3-905701-56-1; German edition, 304 pp with 150 illustrations, ISBN 3-905701-57-X.

Albert, Joan and Sinbad, with Michael Baldwin and Mel Ramsden as Art & Language, Santa Monica and Madrid: White Wine Press and Distrito Cu4tro, 2007; bilingual English–Spanish edition, 41 and 45pp, ISBN 978-84-934236-3-6.

Since 1950: Art and its Criticism, 54 illustrations, Yale University Press, spring 2009 (UK), Autumn 2009 (US); ISBN 978-0-300-15186-2.

Art & Language writings (Michael Baldwin and Mel Ramsden), 'Art & Language: Sivuääniä: kirjoituksia käsitetaiteesta', EMMA, Espoo Museum of Modern Art, Espoo, October, 2009.

Introduction to Art, 300pp, 250 illustrations, Yale University Press, 2009, ISBN 978-0-300-10915-3.

Charles Harrison, Looking Back, Ridinghouse, London, 2011, ISBN 978-1-905464-29-6.

IN PREPARATION

Art in Theory: the West and the World (with Paul Wood and Leon Wainwright), for Blackwells, scheduled, 2012

BOOKS AND CATALOGUES EDITED

When Attitudes Become Form – London Location, Institute of Contemporary Arts, London, September 1969, unpaginated.

Idea Structures, Camden Arts Centre, London, June 1970, unpaginated, ISBN 0-901389-048.

The English Avant Garde, Studio International and New York Cultural Center, 1971 (catalogue and collection of essays).

Kunst und Sprache/Art and Language (German/English edition), Dumont, Cologne, 1972.

Art & Language (French/English edition), Editions Fabre, Paris, 1979.

Art & Language 1966–80 (Dutch/English edition), Stedelijk van Abbemuseum, Eindhoven.

Art & Language (French/English edition), Musée de Toulon, 1982.

Modern Art and Modernism: a critical anthology (with F. Frascina), Harper and Row, London and New York, 1982, 312pp, ISBN 0-06-318-2343 (hb)/-2335 (pb).

Modernism, Criticism, Realism: alternative contexts for art (with F. Orton), Harper and Row, London and New York, 1984, 280pp, ISBN 0-06-318289-0.

Art-Language, vols 1–5, 1969–1985, facsimile reprint with introduction and indexes, January 2000.

Art & Language in Practice: Vol II Critical Symposium, bilingual English and Catalan edition, Fundació Antoni Tàpies, Barcelona, April 1999, ISBN 84-88786-44-1, 278pp.

ARTICLES AND REVIEWS IN *STUDIO INTERNATIONAL* 1966–73

'Gauguin and the Pont-Aven Group', February 1966
'Roger Fry in Retrospect', May 1966
'Mondrian in London', December 1966
'Abstract Art in England in the early Thirties', April 1967
'Surrealism in Turin', February 1968
'British Critics and British Sculpture', February 1968
'Barry Flanagan's Sculpture', May 1968
'Kenneth Noland', July/August 1968
'Jules Olitski', September 1968
'Düsseldorf Commentary', November 1968
'Some Recent Sculpture in Britain', January 1969
'Anthony Caro', March 1969
'Morris Louis', April 1969
'John Hoyland', May 1969
'Against Precedents', September 1969
'Roelof Louw's Sculpture', October 1969
'Notes Towards Art Work', February 1970
'A Very Abstract Context', November 1970
'Art on TV', January 1971
'Virgin Soils and Old Land', May 1971
'Some Concerns in Fine Art Education' (2 parts), October and November 1971
'Richard Long', January 1972
'Educating Artists', May 1972
'Art and Language Press', June 1972

'Life and Times of the New York School' (book review), December 1972
'Abstract Expressionism' (2 parts), January and February 1973
'Drawings by Masson and De Kooning' (book review), March 1973

ARTICLES IN ART-LANGUAGE 1975–82
(as individual author or in collaboration)

'Pedagogical Sketchbook'
'Abstract Art'
'Bourgeois Revisionism, What?'
'On Chapter Five' (of John Berger's *Ways of Seeing*)
'The Building Blocks of the University'
'On the relation 'picture of''
'Abstract Expression'
'Author and Producer Revisited'
'Three Poems after Friedrich Nietzsche'

OTHER ESSAYS, ARTICLES AND REVIEWS

'The Foundation of the National Museums (1789–1871)', in *Art Treasures in France*, Hamlyn and McGraw Hill, London and Toronto, 1967.

'Phillip King: Sculpture 1960–68', in *Artforum*, New York, December 1968.

'The Sculpture of Roland Brener', in *Artforum*, New York, summer 1969.

'John Hoyland' and 'Anthony Caro', catalogue introductions for the X São Paolo Biennale, British Council, 1969.

'Art and Language Press', in *l'Art Vivant*, Paris, April 1972.

'Art and Language', in *Flash Art* no.35–36, September–October 1972.

'Abstract Expressionism', in A. Richardson and N. Stangos eds., *Concepts of Modern Art*, Penguin, London, 1973; revised ed. Thames & Hudson, London, 1981, pp.169–211, ISBN 0-500-20186-2.

'Retrospective Exhibitions and Current Practice', in *Art and Language 1966-75*, Museum of Modern Art, Oxford, 1975.

'Paintings of London by Members of the Camden Town Group', in *Art Monthly*, autumn 1979.

'A Portrait of V.I. Lenin in the Style of Jackson Pollock' (with M. Baldwin and M. Ramsden), in *Artforum*, New York, February 1980; trans., 'Portret V.I. Lenjina u stilu Jacksona Pollocka', in *Moment* 10, Belgrade, April-June 1989.

'The Ratification of Abstract Art', in M. Compton ed., *Towards a New Art: essays on the background to abstract art 1910-20*, Tate Gallery Publishing, London, 1980, pp.146-55 and 232-4, ISBN 0-905005-17-1 (pb)/22-8 (hb).

'Phillip King's Sculpture 1960-81: what kind of discourse?', in *Art Monthly*, June 1981.

'Sculpture and the new New Movement', in S. Nairne and N. Serota eds., *English Sculpture in the Twentieth Century*, Weidenfeld and Whitechapel Art Gallery, London, 1981, pp.103-112, ISBN 0-854488-054-2.

'Modernism and Modern *Art History*', in *Art History*, vol.4 no.3, September 1981, pp.328-331 ISSN 0141-6790.

'Manet's *Olympia* and Contradictions: a propos T.J. Clark's and Peter Wollen's recent articles' (with M. Baldwin and M. Ramsden), in *Block* 5, London, September 1981; reprinted in J-A.B. Danziger ed. *Mannerism; a Theory of Culture*, Vancouver, 1982, pp.16- 25.

'Art History, Art Criticism and Explanation' (with M. Baldwin and M. Ramsden), in *Art History*, vol.4 no. 4, December 1981, pp.432-56, ISSN 0141-6790; reprinted in F. Frascina ed., *Pollock and After: the Critical Debate*, Harper & Row, New York, 1985, pp.191-216, ISBN 0-06-433126-1/430147-8 (pb); reprinted in E. Fernie ed., *Art History and its Methods: a critical anthology*, Phaidon, London, 1995, pp.259- 280, ISBN 0-7148-2991-9.

'British Sculpture in the Twentieth Century' (2 parts), in *Art Monthly*, Nov. 1981, Feb. 1982.

'The Falsehoods of Pictures...' (with F. Orton), Documenta 7 (catalogue), Kassel, 1982. 'Some Songs by Art & Language and the Red Crayola' (with M. Baldwin and M. Ramsden), *Art Journal*, summer 1982.

'The Orders of Discourse: the Artist's Studio', in *Art & Language* (catalogue), Ikon Gallery, Birmingham, 1983 (edited version of 6th Durning-Lawrence Lecture).

'A Conversation with Clement Greenberg' (with Trish Evans; 3 parts), in *Art Monthly*, February, March, April 1984; Italian translation in *Il Giornale del'Arte*, February 1985 reprinted in Robert C. Morgan ed. *Clement Greenberg: late writings*, University of Minnesota Press, Minneapolis and London, 2003, pp.169-203, ISBN 0-8166-3938-8; reprinted in P. Bickers and A. Wilson eds., *Talking Art: interviews with artists since 1976*, London: Art Monthly and Ridinghouse, 2007, pp.185-214, ISBN 978-1-905464-04-3.

'Jasper Johns: Meaning what you see' (with F. Orton), in *Art History*, vol.7 no.1, March 1984, pp.78-101, ISSN 0141-6790.

'The Late Sixties in London and Elsewhere', in *When Attitudes Became Form*, Kettle's Yard, University of Cambridge, July 1984, pp.9-16, ISBN 0907074-21-9.

'Modernism and the "Transatlantic Discourse"' (edited version of the 1st Durning-Lawrence Lecture) in F. Frascina ed., *Pollock and After: the Critical Debate*, Harper and Row, London and New York, 1985, pp.217-32, ISBN 0-06-433126-1/430147-8 (pb).

'The Struggle for the Modern', in *Art Monthly*, July/August 1985 (review of T.J. Clark, *The Painting of Modern Life*).

'Francis Bacon' (with M. Baldwin and M. Ramsden), in *Artscribe*, July/August 1985, pp.14-20, ISSN 0309-2151.

'Art & Language: Studies for *The Studio at 3 Wesley Place*', Tate Gallery Publishing, London, September 1985.

'Present Art and British Art', in Artscribe, December 1985, pp.24-27; trans.,'Hedendaagse Kunst en Engelse Kunst', in Kunst Beeld, XI no. 1, Amsterdam, October 1986.

'Hodgkin's Moment', in Artscribe, December 1985, pp.62-64.

'Expression and Exhaustion: Art and Criticism in the Sixties' (2 parts; edited and extended version of the 2nd Durning-Lawrence lecture), in Artscribe, February/March and April/May 1986.

'LeWitt, Stella, Ryman, Andre, Flavin, Chamberlain at the Saatchi Museum', in Artscribe, February/March 1986.

'Daniel Buren', in Artscribe, April/May 1986.

'Art & Language; Incidents in a Museum', exhibition catalogue, Lisson Gallery, London, April 1986.

'Taste and Tendency', in F. Borzello and A. Rees eds., The New Art History, Camden Press, London, 1986, pp.75-81, ISBN 0-948491.
"'Sculpture', 'Design' and 'Three-Dimensional Work'", in Artscribe, June/July 1986.

'Triangle Workshop at Smith's Galleries', in Artscribe, June/July 1986.

'Cézanne insists on structure', in B. Bernard ed., The Impressionist Revolution, Macdonald Orbis, London, 1986, pp.109-122, ISBN 0-356-12877-6.

'Importance: Kiefer and Serra', in Artscribe, no. 60, November/December 1986.

'Critical Theories and the Practice of Art', in S. Compton ed., British Art in the Twentieth Century, Royal Academy of Arts and Prestel Verlag, January 1987, ISBN 3-7913- 0798-3, PP.53-61.

'Sculpture's Recent Past', in M-J. Jacobs ed., A Quiet Revolution: British Sculpture since 1965, Museum of Contemporary Art, Chicago, San Francisco Museum of Modern Art and Thames and Hudson, January 1987, pp.10-33, ISBN 0-500-23480-9.

'Julian Schnabel', in Artscribe, no.61, January/ February 1987.

'The Modern, the British and the Provincial', in Artscribe, no.62, March/April 1987, pp.30-35.

'The Modern, the Primitive and the Picturesque', in Alfred Wallis, Ben Nicholson, Christopher Wood (exhibition catalogue), Scottish Arts Council and Pier Arts Centre, May 1987, pp.1-23, ISBN 1-85119-015-5.

'Art & Language: some conditions and concerns of the first ten years', and 'Art & Language 1977-1987: a commentary on the work of the second decade', in Art & Language; the Paintings, Société des Expositions du Palais des Beaux-Arts, Brussels, April 1987 (separate editions in English, French and Flemish), D/1987/2256/3, pp.5-22 and 23-38; trans. 'Art & Language: Neki uslovi i preokupacije u provoj decenji', Moment 20 and 21, Belgrade, October-December 1990, pp.39-42 and January-March 1991, pp.49-54.

'L'Atelier des artistes: transformation du répertoire', in Les Cahiers du Musée d'Art Moderne no. 21, September 1987, pp.29-46, ISSN 0181-1525-18.

'Le modernisme: aux limites', in Les Cahiers du Musée d'Art Moderne no. 22, November 1987, pp.71-96, ISSN 0181-1525-18.

'Empathy and Irony: Richard Deacon's Sculpture', in Richard Deacon (catalogue), Kunstmuseum Luzern, Bonnefantenmuseum Maastricht, Fondación Caja de Pensiones Madrid and Museum van hedendaagse Kunst, Antwerp, November 1987 (text in English, German, Dutch and Spanish), pp.50-74, ISBN 90-72251-01-6; partial reprint in Farbe bekennen: Zeitgenossische Kunst aus Basier Privatbesitz, Offentliche Kunstsammlung, Basel, 1988.

'Informed Spectators; on Richard Wollheim's Painting as an Art' (with M. Baldwin and M. Ramsden), in Artscribe, no.68, March/April 1988, pp.73-78.

'The Works of Art of the Corporation of London' (review), in The British Journal of Aesthetics, vol.28 no.2, spring 1988, pp.184–186.

'The Suppression of the Beholder: Sculpture and the later Sixties', in Starlit Waters: British Sculpture, an International Art 1968–1988, Tate Gallery Liverpool, May 1988, pp.40–44, ISBN 0-946590-93-1.

'Vichy: the State of British Art: a review of some recent publications', in Artscribe, no.70, summer 1988, pp.92–96.

'Art & Language: Hostages', Lisson Gallery, London and Wolkenkratzer Verlagsgesellschaft mbH, July 1988.

'On the Surface of Painting', in Critical Inquiry, vol.15 no.2, Chicago, Winter 1989, pp.292–336, ISSN 0093-1896.

'Letter from England', in Arts Magazine (New York), March 1989 (review article), ISSN 0004-4059.

'Thoughts in the Black Museum' (English and Dutch texts), in E. Beer and R. de Leeuw eds., L'Exposition Imaginaire: the art of exhibiting in the eighties, Netherlands Office for Fine Arts, 's Gravenhage, 1989, pp.72–95, ISBN 90-12-06105-9.

'Art and Language: the Contest for the Modern', in I. Lavin ed., World Art; Themes of Unity in Diversity (Acts of the XXIVth International Congress of the History of Art), vol.II, Pennsylvania State University Press, University Park and London, pp.309–318, 1989, ISBN 0-271-00607-2.

'Abstract Art in the British Manner', in Artscribe, May 1989, pp.75–77.

'Some other Sense: on Hostage: Incident and a People's Flag', in Artscribe, summer 1989, pp.64–67.

'Malevich: Determination and Indifference', in Artscribe, September 1989, pp.66–68.

'Art Object and Art Work' (French and English texts), in L'Art Conceptuel: une perspective, ARC Musée d'Art Moderne de la Ville de Paris, November 1989, pp.55–64, ISBN 2.85 U 5346.071–x; and Musée d'Art Contemporain, Montreal, August 1990, (Spanish and English texts) Fundación Caja de Pensiones, Madrid, March 1990, (German and English texts) Deichtorhallen, Hamburg, May 1990 (catalogue essay); reprinted in Jason Gaiger and Paul Wood eds., Art of the Twentieth Century – a reader, Yale University Press, New Haven and London in association with The Open University, 2003, ISBN 0-3-10144-9, pp.205-212.

'The Limits of Depiction', in Arts Magazine (New York), December 1989, pp.33–39.

'Art and Language', in Giancarlo Politi ed., Flash Art: Two Decades of History, XXI years, Milan 1989.

'Conceptual Art – myths and scandals', in Artscribe, March 1990, pp.15-16,

'David: unsightly scenes' (with M. Baldwin and M. Ramsden), in Artscribe, March 1990, pp.59–61.

'On Writing About...; means and ends in the criticism of art', Museumjournaal, Amsterdam, vol.1 no.6, June 1990, pp.15-20 (Dutch and English editions), ISSN 0924-52X.

'Conceptual Art and Critical Judgement' (French and English versions), in C. Schlatter ed., Art Conceptuel Formes Conceptuelle/Conceptual Art Conceptual Forms, Galerie 1900–2000, Paris 1990, pp.538–554; reprinted in Lund Art Press, vol.2 no. 1, 1990, Department of Theoretical and Applied Aesthetics, Lund University, Sweden, pp.79–85, ISSN 1101-5462 .

'"Form" and "Finish" in Modern Painting', in Filozofski Vestnik, 1/1991, Slovene Academy of Arts and Sciences, Ljubljana, June 1990, pp.49–60, ISSN 0353-4510 (conference paper).

'Charles Harrison: Pet odgovora', *Moment* 20, Belgrade, October – December 1990, pp.38–39 (See also: Misko Suvakovic: 'Charles Harrison: Diskurzivni rezovi' in *Moment* 20, pp.35–37, and Suvakovic, 'Diskurzivni Incidenti: rasprava diskurzivnih poredka Charlesa Harrisona' in *Dometi* vol.XIII no.11, Rijeka, 1990, pp.745–753)

'The Critic's Part/de rol van de criticus', and response to Joseph Kosuth, in *Kunst & Museumjournaal* (separate English and Dutch editions) vol. 3 no. 4, February 1992 pp.13–17 and p.36 (Dutch edition pp.13–18 and p.39).

Review of M. Fried, *Courbet's Realism* and K. Herding, *Courbet*; to *Venture Independence*, *Art Bulletin*, vol.LXXIV NO.2, New York, June 1992, pp.341–44 (review article).

'Rembrandt: *The Artist in his Studio*'/'Rembrandt: *de Kunstenaar in zijn atelier*', in *Kunst & Museumjournaal*, Amsterdam, Vol 4 no. 1, September 1992 (separate English and Dutch editions), ISSN 0924-5251, pp.28–33.

'The Legacy of Conceptual Art', in I. Gevers ed., *Place, Position, Presentation, Public*, Jan van Eyck Akademie, Maastricht, January 1993, pp.41–58, ISBN 90-6617-111-1.

'Matisse at the Modern', in *Frieze*, 8, London, Jan-Feb. 1993, pp.10–15.

'Gossip Monumentalized', *Times Literary Supplement*, April 30 1993, p.18.

Review of P. Wollen, *Raiding the Icebox: reflections on twentieth-century culture*, The Guardian 2, June 1, 1993, p.10.

'Reflections on the Figure (On works in the series Index: *Now They Are*)/Réflexions sur la Figure (A propos des oeuvres de la Série *Index: Now They Are*)', in *Art & Language*, Musée du Jeu de Paume, Paris, November 1993 (English and French texts), pp.131–145, ISBN 2-908901-21-8.

'Art & Language's New Paintings: the Pleasures of Impersonation', catalogue essay, Galerie Grita Insam, Vienna, 1993, unpaginated.

'Disorder and Insensitivity (on the concept of experience in Abstract Expressionist painting)', in D. Thistlewood ed., *American Abstract Expressionism*, Liverpool University Press and Tate Gallery, Liverpool, 1993, pp.111–128, ISBN 0-85323-338-1.

'On Painting a Landscape/Over het schilderen van een landschap', in Kunst & Museumjournaal, Amsterdam, November, 1993, pp.1–11 (separate English and Dutch editions), ISSN 0924-526X.

'Roger Hilton: the Obligation to Express', in *Roger Hilton*, exhibition catalogue, The South Bank Centre, London, November 1993, pp.16–31, ISBN 1-85332-118-4.

'Ausgangspunkte: Art & Language Antworten auf Fragen von Tom Holert' (with M. Baldwin, M. Ramsden and P. Wood) in *Texte zur Kunst*, vol.3 no.12, Cologne, November 1993, pp.78–93, ISSN 0940-9596.

'The Effects of Landscape', in W.J.T. Mitchell ed., *Landscape and Power*, University of Chicago Press, April 1994, ISBN 0-226-53206-2 (cl)/-53207-0 (pb), pp.203–239; second enlarged edition, 2002, ISBN 0-226-53205-4.

'A Hard Eye on Modern Art', obituary of Clement Greenberg, *The Guardian* 2, 20 May 1994, p.23.

'On Conceptual Art and Painting and Speaking and Seeing: Three Corrected Transcripts': 1) 'The End(s) of End-Game Art'; 2) 'The Utterance of Painting'; 3) 'The Seeing of Painting and Painting's Seeing' (with Michael Baldwin and Mel Ramsden), *Art-Language*, New Series no.1, June 1994, pp.30–69.

'Ideje Postmoderne' ('Ideas of the Postmodern') (with Paul Wood) in *Projekat* 4, Novi Sad, December 1994, pp.51–52.

'Giotto and the "Rise of Painting"', in D. Norman ed., *Siena, Florence and Padua: Art Society and Religion 1280–1400, Vol.I: Interpretative essays*, Yale University Press and The Open University, January 1995, ISBN 0-300-06124-2 (hb)/-06125-0 (pb), pp.72–95 (co-published course text for A354).

'The Arena Chapel: Patronage and Authorship', in D. Norman ed., *Siena, Florence and Padua: Art Society and Religion 1280–1400*, Vol.II: *Case Studies*, Yale University Press and The Open University, January 1995, ISBN 0-300-06126-9 (hb)/-06127-7 (pb), pp.82–103 (co-published course text for A354).

'England's Climate', in B. Allen ed., *Towards a Modern Art World (Studies in British Art I)*, Yale University Press for the Paul Mellon Centre for Studies in British Art, New Haven and London, 1995, ISBN 0-300-06380-6, pp.207-226 [book contribution].

'Art & Language paints a Landscape', *Critical Inquiry*, Chicago, March 1995, ISSN 0093-1896, pp.611-639.

'The Ideal Place: a Vantage Point?', with Michael Baldwin and Mel Ramsden (as Art & Language), transcript of public discussion at HCAK, The Hague, *Art & Design*, vol.10 5/6 1995, London, pp.36-39.

'Modernism', in Robert S. Nelson and Richard Shiff eds., *Critical Terms for Art History*, University of Chicago Press, Chicago and London, 1996, ISBN 0-226-57164-5 (cloth)/-57165-3 (paper), pp.142-155; second enlarged edition, 2003, ISBN 0-226-571661(cl)/57168-8 (pb).

'D'entrée de jeu...', contribution to a symposium, with Michael Baldwin and Mel Ramsden (as Art & Language), *Art Press*, hors-série no.17: '69/96 Avant-gardes et fin de siècle', Paris, 1996, pp.18-20.

'Rosalind Krauss: un pétard mouillé', with Michael Baldwin, Mel Ramsden and Paul Wood, *Art Press*, hors-séric no.17: '69/96 *Avant-gardes et fin de siècle*', Paris, 1996, pp.174-178 (response to R. Krauss, 'Art & Language se met à la peinture: étrange aléa de l'art conceptuel', *Art Press*, hors-série no.16 '*Ou est passée la peinture?*', Paris, 1995, pp.54-58).

'(False) Memory and (Self) Patronage', with Michael Baldwin and Mel Ramsden (as Art & Language), Tate, London, winter 1996/7.

Review of Hal Foster, *The Return of the Real: the Avant-Garde at the Turn of the Century*, *Bookforum* (supplement to *Artforum*), New York, winter 1996/ spring 1997, pp.30-31 and 34, and correspondence, *Artforum*, February 1997, ISSN 0004-3532.

Entries on 'Abstraction-Création', 'Ben Nicholson', 'Seven & Five Society', 'Unit One', *The Dictionary of Art*, Grove/Macmillan, London, 1997, ISBN 1-994446-00-0, vol.1 pp.89-90, vol.23, pp.103-4, vol.28, p.506, vol.31, p.673.

'Memories of the Medicine Show: 1) Recollecting Conceptual Art; 2) We Aimed to be Amateurs' (with Michael Baldwin and Mel Ramsden), *Art-Language*, New Series No 2., June 1997, pp.32-49.

'Northanger Abbey' [reply to R. Krauss] (with Baldwin, Ramsden and Paul Wood), *Art-Language*, New Series no.2., Banbury, June 1997, pp.50-64.

'On Colour and Abstract Art: David Batchelor's recent Work', *Art & Design*, monograph edition on 'Sculpture: contemporary Form and Theory', London, August 1997, pp.38-41, ISBN 0-471-97694-6.

'Painting and the Death of the Spectator', in C. Matthiesen ed., *Art & Language and Luhmann* (proceedings of a conference at the Kunstraum, Vienna), Institut für soziale Gegenwartsfragen, Freiburg; Passagen Verlag, Vienna, August 1997, ISBN 3- 85165-272-X, pp.85-112.

'Cézanne: Fantasy and Imagination', in *Modernism/Modernity*, vol.4 no.3, Johns Hopkins University Press, September 1997, pp.2-18, ISSN 1071-6068.

'Konceptualna umest in problem predstavitve' (Conceptual Art and the Problems of Display) and review of a workshop led by Charles Harrison and Trish Evans, in L. Klancar and L. Stepancic, *Konceptualna umetnost 6o-ih in 7o-ih let* (proceedings of the World of Art programme on Conceptual Art), Ljubljana, October 1997, pp.42-47 and 61.

'Art & Language: Landscapes and Interiors' (English and Korean texts), in *Distinctive Elements: Contemporary British Art Exhibition*, British Council and National Museum of Contemporary Art, Korea, August 1998, pp.61–75, ISBN 89–85538–32–2.

'Conceptual Art: the History of the Unformed', with Michael Baldwin and Mel Ramsden (as Art & Language), in Michael Kelly ed., *The Encyclopedia of Aesthetics*, Oxford University Press, New York and Oxford, 1998, vol.1, ISBN 0–19–512645–9, pp.419–21.

'Unstringing the Bow', review of O. Bätschmann, *The Artist in the Modern World* (with M. Baldwin and M.Ramsden as Art & Language), *Bookforum* supplement to *Artforum*, New York, Fall 1998, ISSN 0004–3532; pp.36 & 40.

'"Englishness" and "Modernism" revisited', in *Modernism/Modernity*, vol.6 no.1, January 1999, Johns Hopkins University Press, Baltimore, ISSN 1071–6068; pp.75–90.

'Editor's Introduction' and 'The Moment of Depiction', in C. Harrison ed., *Art & Language in Practice: Vol II Critical Symposium*, bilingual English and Catalan text, Fondació Antoni Tàpies, Barcelona, April 1999, ISBN 84 88786 44 1; English version pp.11–14, 15 and 51–69.

'The Judgement of Art', Introduction to Clement Greenberg, *Homemade Esthetics: Observations on Art and Taste*, Oxford University Press, New York and Oxford, 1999, ISBN 0–19–850365–2, pp.XIII–XXX.

'Art & Language in Practice', exhibition guide for Fondacio Antoni Tapies, Barcelona, April 1999, unpaginated (15pp).

'Ben Nicholson: the late reliefs' in *Ben Nicholson reliefs*, exhibition catalogue, Wadddington Galleries, London, September 1999, pp.7–15.

'Artists' Writing', in *Art-Language*, New Series no.3, Banbury, September 1999, pp.16–35.

'Degas' Bathers and Other People', in *Modernism/Modernity*, vol.6 no.3, September 1999, Johns Hopkins University Press, Baltimore, ISSN 1071–6068, pp.57–90.

'On Exhibitions and the World at Large' (with Seth Siegelaub, 1970), 'Notes Towards Art Work' (1970), 'Having-Your-Heart-in-the-Right-Place-Is-Not-Making-History' (as Art & Language UK, 1976), 'We Aimed to be Amateurs' (with Michael Baldwin and Mel Ramsden, as Art & Language, 1995), 'Conceptual Art and Critical Judgement' (1990), reprinted in A. Alberro and B. Stimson eds., *Conceptual Art: a critical anthology*, MIT Press, Cambridge, MA, and London, 1999, ISBN 0–262–01173–5, pp.198–203, 204–208, 350–353, 442–448, 538–545.

'The Merits of Incompetence' and (Eda Cufer) 'An Interview with Charles Harrison', (Slovenian and English texts) in S. Glavan ed., *Geopolitika in Umetnost/Geopolitics and Art*,World of Art Program, Open Society Institute, Soros Center for Contemporary Arts, Ljubljana, December 1999, ISBN 961–90157–4–6, PP.8–15.

'Introduction' (with Michael Baldwin and Mel Ramsden) and 'Author and Title Index' to *Art-Language Volumes 1–5, May 1969–March 1985*, complete facsimile edition, Art & Language, Banbury, January 2000.

'El problema d'escriure/The Trouble with Writing' (Catalan and English texts), in M. Peran, C. Guerra and J-F. Ainaud eds., *Art i escriptura: l'escriptura d'artista*, KRTU, Department of Culture, Catalonia, Barcelona, March 2000, ISBN 84–393–5091, pp.37–51 and 158–168.

'Life after "Live in Your Head"' (with Michael Baldwin and Mel Ramsden, as Art & Language), *Modern Painters*, Summer 2000, ISSN 0953–6698, pp.23–25.

'A Portrait of V.I.Lenin in the Style of Jackson Pollock' (with Michael Baldwin and Mel Ramsden, as Art & Language), in Helen. A. Harrison ed., *Such Desperate Joy: Imagining Jackson Pollock*, Thunder's Mouth Press, New York, 2000, ISBN 1–56025–284–7, pp.330–5 and col. pl. 8.

'On the Condition of Finish in Modern Painting', 292 *Essays in Visual Culture*, 2, Edinburgh, December 2000, ISBN 0-9536025-2-4, pp.31-46.

'When Management Speaks...', in Antonia Payne ed., *Research and the Artist: Considering the Role of the Art School*, The Laboratory, Ruskin School of Art, Oxford University, 2000, ISBN 0-9538525-1-2, pp.58-68; reprinted in James Elkins ed., Artists with PhDs: on the new Doctoral Degree in *Studio Art*, New Academia Publishing LLC, March 2009, ISBN-10: 0981865453; ISBN-13: 978-0981865454.

'Art & Language: Indizes und Andere Zahlen' and 'Postscript: Wrongs Healed in Official Hope', in *Kunstforum*, 155, June–July 2001: *Der gerissene Faden; nichtlineare Techniken in der Kunst*, pp.120-135.

'Roma Reason: Luhmann's *Art as a Social System*' (with Michael Baldwin and Mel Ramsden as Art & Language), *Radical Philosophy* 109, September/October 2001, ISSN 0300 211X, pp.14-21.

'The Difficulty of Rothko' (review article), in *Art History*, vol.24 no.4, November 2001, ISSN 0141-6790, pp.598-601.

'Absolute Warhol' (review of Hans Belting, *The Invisible Masterpiece*), in *Bookforum*, New York, winter 2001, ISSN 1098-3376, p.38.

'Almost too Dark to See' (French and English texts), in *Art & Language: too dark to read - motifs retrospectifs 2002-1965*, Musée d'Art Moderne de Lille Métropole, Villeneuve d'Ascq, January 2002, ISBN 2-86961-062-9, pp.136-189.

'Sentir la terre bouger' (Feeling the Earth Move) French text, in *Sans Commune Mesure: image et texte dans l'art actuel*, Editions Leo Scheer, Paris, September 2002, ISBN 2-914172-53-2, pp.114-127.

'Conceptual Art', in Paul Smith and Carolyn Wilde eds., *A Companion to Art Theory*, Oxford and Malden, MA, 2002, ISBN 0-631-20762-7 (hbk), pp.317-326.

'Die Malerei und der Tod des Betrachters/Painting and the Death of the Spectator' (revised version) in *Ungemalt* 17.07-27.10.2002, Kunst er Gegenwart, Sammlung Essen, Vienna, 2002, ISBN 3-902001-07-0, pp.144-161.

'A Crisis of Modernism', in *Blast to Freeze: British Art in the Age of Extremes*, Kunstmuseum Wolfsburg, Hatje Cantz Verlag, Stuttgart, 2002; trans. as 'Une crise de modernisme' in *Blast to Freeze; l'art Britanninque au xxe siècle*, exhibition catalogue, Les Abattoirs, Toulouse, 2003, pp.75-78.

'Live in Your Head: Concept and Experiment in Britain 1965-1975', in M. Arnatt ed., *100 Reviews Backwards*, London, Alberta Press, 2002, ISBN 3-88375-649-0, pp.79-82.

'Gute Gründe: Die Arbeit von Gerry Schum'/ 'Grounds for Optimism; The Work of Gerry Schum', in Ulrike Groos, Barbara Hess and Ursula Wevers eds., *Ready to Shoot: Fernsehgalerie Gerry Schum/videogalerie schum*, Kunsthalle Düsseldorf/Snoek Verlagsgesellschaft, Cologne, 2003; German edition, ISBN 3-936859-06-X, pp.48-57 ; English edition, ISBN 3-936859-15-9, pp.47-54.

'Abstract Art: reading Barnett Newman's Eve', in Jason Gaiger ed., *Frameworks for Modern Art*, New Haven and London, Yale University Press in association with The Open University, 2003, ISBN 0-300-10140-6 (cloth), 0-300-10228-3 (paper), pp.104-151.

'Bonnard and Matisse: expression and emotion', in Steve Edwards and Paul Wood eds., *Art of the Avant-Gardes*, New Haven and London, Yale University Press in association with The Open University, 2004, ISBN 0-300-10141-4 (cloth), 0-300-10230-5 (paper), pp.108-132.

'Jackson Pollock', in Paul Wood ed., *Varieties of Modernism*, New Haven and London, Yale University Press in association with The Open University, 2004, ISBN 0-300-10142-2 (cloth), 0-300-10296-8 (paper), pp.116-145.

'Conceptual Art, the aesthetic and the end(s) of art', in Gill Perry and Paul Wood eds., *Themes in Contemporary Art*, New Haven and London, Yale University Press in association with The Open University, 2004, ISBN 0-300-10143-0 (cloth), 0-300-10297-6 (paper), pp.44-86.

'Theses on Feuerbach' (with Michael Baldwin and Mel Ramsden as Art & Language), in Ecke Bonk, Peter Gente, Margit Rosen, eds., 05-03-44: *Liebesgrüsse aus Odessa for Peter Weibel*, Merve Verlag, Berlin, 2004, ISBN 3-88396-194-9, pp.234-248.

'Deleuze's Bacon' (with Michael Baldwin and Mel Ramsden as Art & Language, and with Tom Baldwin), *Radical Philosophy*, 123, January/February 2004, ISSN 0300-211X.

'Richard Wollheim, 1923-2003', obituary (with Michael Baldwin and Mel Ramsden as Art & Language), *Radical Philosophy*, 124, March/April 2004, ISSN 0300 211X, pp.51-54.

'What work does the Artwork do?' (with Michael Baldwin and Mel Ramsden as Art & Language), published transcript of a symposium held on Thursday 22 May 2003, Sir John Cass, Department of Art, Media and Design, London Metropolitan University, 2004, pp.1-63.

'Emergency Conditionals' (with Michael Baldwin and Mel Ramsden, as Art & Language), paper given to the conference 'Philosophy and Conceptual Art', Kings College, London, June 2004, in *Art & Language*, catalogue of an exhibition at Centro de Arte Contemporáneo de Malaga, September 2004, ISBN 84-96159-18-3, English and Spanish texts, pp.73-81 and 118-122; French translation in *303 - Arts, Recherches et Créations*, no. 89, ISSN 0762-3291, December 2005, pp.54-63.

'L'Enseignment de l'art conceptual (The Teaching of Conceptual Art)', in Fabrice Douar and Matthias Waschek eds., *Peut-on enseigner l'art?* Louvre and Ecole Nationale Supérieure des Beaux-Arts, Paris, December 2004, ISBN 2-84056-164-6, pp.152-170.

'Looking Out, Looking In/Sguardi da dentro, sguardi da fuori', in *Faces in the Crowd/Volti nella Folla: Picturing Modern Life from Manet to Today*, Whitechapel Art Gallery, London, December 2004-March 2005, and Castello di Rivoli Museo d'Arte Contemporanea, Rivoli-Torino, April-July 2005, Skira, ISBN 88-7624-069-1, pp.40-47.

'Saving Pictures', in Darsie Alexander, with essays by Charles Harrison and Robert Storr, *Slideshow; Projected Images in Contemporary Art*, The Baltimore Museum of Art and Pennsylvania State University Press/Tate, ISBN 0-271-02541-7, pp.32-48, March 2005.

'Scenes and Details: a Rothko Sketchbook from the late 1930s', in Glenn Phillips and Thomas Crow eds., *Seeing Rothko*, Getty Research Institute, Los Angeles, 2005, ISBN 0-89236-734-2, pp.178-231.

'1900-1920: i testi teorici degli artisti e i dibattiti della critica'/1900-1920: Artists' Theoretical Texts and Critical Debates 1900-1920', in V. Terraroli ed., *Le avanguardie storiche 1900-1919*; *L'Arte del XX Secolo*, Vol. 1, Skira editore, Milan, 2005, pp.901-05.

'Wayne Andersen, *Cézanne and the Eternal Feminine*', book review, *Modernism/Modernity*, vol.13 no. 1, January 2006, pp.181-3, ISSN 1071-6068.

'Specialisation, Self-Criticism and the Boundaries of Practice', in S. Buchmann, M.Lehnhardt, M. Linger and N. Smolik eds, *Querdurch: Kunst + Wissenschaft*, Veranstaltungsheihe der Hochschule für Bildende Künste, Hamburg, January 2006, ISBN 3-938158-22-0, pp.17-32.

'Some Notes from 1973', in *InterReview*, vol.II no.6, March 2006, Los Angeles, pp.30-32.

'After the Fall', review of Hal Foster, Rosalind Krauss, Yve-Alain Bois and Benjamin Buchloh, *Art since 1900*, in *Art Journal*, vol.65 no.1, Spring 2006, ISSN 0004-3249, pp.116-9.

'Voices Off: Reflections on Conceptual Art' (with Michael Baldwin and Mel Ramsden as Art & Language), in *Critical Inquiry*, vol.33 no.1, Chicago, Autumn 2006, ISSN 0093-1896, pp.113-135.

'The Printed Picture in Renaissance Europe', in Kim Woods ed., *Making Renaissance Art*, New Haven and London: Yale University Press in association with The Open University, 2007, ISBN-10: 0-300-12189-X, ISBN-13: 978-0-300-12189-6, pp.210-247.

'Emergency Conditionals' (with Michael Baldwin and Mel Ramsden as Art & Language), in Peter Goldie and Elisabeth Schellekens, eds., *Philosophy and Conceptual Art*, Oxford: Oxford University Press, March 2007, ISBN 978-0-19-928555-6, pp.257-266.

'Talking Pictures', review of W.J.T. Mitchell, *What do Pictures want?*, *Journal of Visual Culture*, vol.6 no.1, April 2007, ISSN 1470-4129, pp.160-163.

'Now They are Surrounded' (with Michael Balwin and Mel Ramsden as Art & Language), in *Journal of Visual Art Practice*, vol.6 no.1, 2007, ISSN 1470-2029, pp.13-31.

'Partial Accounting', in Charles G. Salas ed., *The Life and the Work: Art and Biography*, Getty Research Institute, Los Angeles, May 2007, ISBN-10 0-89236-822-3/ISBN-13 978-0-89236-222-5 (paper), pp.97-107.

'A Place to Work' (with Michael Baldwin and Mel Ramsden as Art & Language), *Museum International*, 235 (special issue on 'The Stakes of the Collection in the 21st Century'), (vol.9 no.3), UNESCO, September 2007, ISSN 1350-0775, pp.31-40.

'Slow Difficulty: Christopher Heuer and Matthew Jesse Jackson interview Charles Harrison', and 'Artist's Pages', in *InterReview* 9, Los Angeles, spring 2008, pp.1-8 and 9-14.

'Innocence and Effectiveness: on the Idea of the Avant-garde', in Carolyn Christov-Bakargiev ed., *Revolutions; forms that turn – Biennale of Sydney 2008*, Biennale of Sydney and Thames and Hudson, London, 2008, ISBN 978-0-5009768-4-5, pp.45-50.

'Party Time: Decoration and Abjection', in *Art & Language* (Catalogue), Mulier Mulier, Knokke-Zoute, August 2008, ISBN 978-90-813222-2-5, pp.59-85; also in Finish translation in *Art & Language*, Museum of Modern Art, Helsinki, autumn 2009.

'Going Modern', in Chris Stephens ed., *The History of British Art: 1870-Now*, vol.3, Tate Britain and Yale Center for British Art, September 2008, ISBN 978-1-85437-652-7, PP.38-65.

'Conversation with Charles Harrison; Banbury 19 May 2003,' in Sophie Richard, *Unconcealed: The International Network of Conceptual Artists 1967-77; Dealers, Exhbitions and Public Collections*, London, Ridinghouse, 2009, ISBN 978-1-905464-17-3, pp.425-432.

'Artists' Theories and Critical Debates 1920-1945', in V. Terraroli ed., *L'Arte del XX Secolo Vol. 2*, Skira editore, Milan.

'Feeling Good: the Aesthetics of Corporate Culture' (with Baldwin and Ramsden as Art & Language), in Peter Osborne, ed., *Aesthetics and Contemporary Art*, proceedings of an international interdisciplinary conference, Centre for Research in Modern European Philosophy, Middlesex University, with Collaborative Research Centre, 'Aesthetic Experience and the Dissolution of Artistic Limits', Free University, Berlin, March 2008.

'Think Again', in *Art and Text*, London, Black Dog Publishing, 2009.

'Homework' – on Art & Language's recent work, June 2009.

'Keith Arnatt – an informal reminiscence', June 2009, for *Keith Arnatt*, catalogue, Karsten Schubert Gallery, London, 2009/2010.

'Art & Language in Helsinki', July 2009, for publication in Finland, autumn 2009.

BROADCASTS

'Westkunst: the managing of Modern Art', script and broadcast for BBC Radio 3, July 1981.

'Eric Gill', contributor to programme, Thames Television, 1989.

'Stanley Spenser', commissioned script, presentation of film, and studio discussion, The Late Show, BBC 2, March 1991.

'Art & Language', consultant and interviewee, The Late Show, BBC 2, April 1991.

'The Tate Gallery, St Ives', interviewee, The Late Show, BBC 2, June 1993.

'K: Kenneth Clark 1903–1983', interviewee, Illuminations, for BBC 2, 10 October 1993.

'The Power of Modernism', broadcast on III Program, Hrvatskog Radija, Zagreb, February 1999.

Review of T.J. Clark, Farewell to an Idea, BBC Radio 3, 'Book of the Month', 8 April 1999.

'The Centurions: Mark Rothko' (one of 3 speakers), BBC Radio 3, 2 May 1999.

OTHERS

Victorine: libretto for an opera (with M. Baldwin and M. Ramsden as Art & Language), Art-Language monograph edition, vol.5 no.2, March 1984; trans. Victorine: livret d'opéra par Art & Language, in Art & Language, Musée du Jeu de Paume, Paris, November 1993, pp.49–92, ISBN 2-908901-21-8.

'Theses on Feuerbach (2)' (with Michael Baldwin and Mel Ramsden as Art & Language), text for 'theory installation' by the Jackson Pollock Bar, Getty Research Institute, Los Angeles, March 2004.

PUBLICATIONS AND PROGRAMMES FOR THE OPEN UNIVERSITY

'Industrialization and Modern Art in England' (part course unit), in A101: An Arts Foundation Course, 1978.

'Modern Art and the Concept of Risk' (course unit), in U201 Risk, 1980.

'Jackson Pollock: what kind of risk?' (TV script and presentation), in U201 Risk, 1980.

'Experiment in Art and Science' (radio discussion), in U201 Risk, 1980.

'Picasso's Guernica' (part course unit), in U202 Inquiry, 1981.

'Representation and Learning' (tape cassette), in U202 Inquiry, 1981.

'English Art since the 1930s' (course essay), in A403 The Arts and Society in Britain since the Thirties, 1982.

'Introduction: Modernism, Problems and Methods' (course block), in A315 Modern Art and Modernism: Manet to Pollock, 1983.

'Impressionism and Degas' (part course block), in A315 Modern Art and Modernism: Manet to Pollock, 1983.

'Surrealism' (with D. Batchelor; course block), in A315 Modern Art and Modernism: Manet to Pollock, 1983.

'English Art and Modernism' (course block), in A315 Modern Art and Modernism: Manet to Pollock, 1983.

'Abstract Expressionism and Jackson Pollock' (with F. Frascina; course block), in A315 Modern Art and Modernism: Manet to Pollock, 1983.

'Cézanne and his Critics' (TV script and presentation), in A315 Modern Art and Modernism: Manet to Pollock, 1983.

'Nicholson, Wallis and St Ives' (TV script and presentation), in A315 *Modern Art and Modernism: Manet to Pollock*, 1983.

'Flatness and Roundness' (radio script and presentation), in A315 *Modern Art and Modernism: Manet to Pollock*, 1983.

'Vorticism' (radio script and presentation), in A315 *Modern Art and Modernism: Manet to Pollock, 1983.*

'Writing about Art' (with T. Evans; radio discussion), in A315 *Modern Art and Modernism: Manet to Pollock*, 1983.

'Art and Politics in France (1943-1954)' (with F. Frascina; course unit), in A324 *Liberation and Reconstruction in France and Italy – Politics, Culture and Society, 1943-1954*, 1990.

'Picasso and Taslitzky' (audio cassette), in A354 *Liberation and Reconstruction in France and Italy – Politics, Culture and Society, 1943-1954*, 1990.

'Impressionism, Modernism and Originality' (co-published course text), in A316 *Modern Art; Practices and Debates*, 1993.

'Abstraction' (co-published course text), in A316, Modern Art; Practices and Debates, 1993.

'Modernity and Modernism Reconsidered' (co-published course text), in A316 *Modern Art; Practices and Debates*, 1993.

'Matisse and Expression' (TV script and presentation), in A316 *Modern Art; Practices and Debates*, 1993.

'On Pictures and Paintings' (TV script and presentation), in A316 *Modern Art; Practices and Debates*, 1993.

'Giotto and the "Rise of Painting"', in A354, *Siena, Florence and Padua: Art Society and Religion 1280–1400, Vol I: Interpretative Essays* (co-published course text).

'The Arena Chapel: Patronage and Authorship', in A354, *Siena, Florence and Padua: Art Society and Religion 1280–1400, Vol II: Case Studies.*

'The Arena Chapel' (TV script and presentation), in A354 *Siena, Florence and Padua: Art Society and Religion 1280–1400*, 1995.

'Seeing', course unit, in A103: *an Introduction to the Humanities*, 1998.

'Rothko and Warhol', course unit, in A103: *an Introduction to the Humanities*, 1998.

'Framing and Forming', TV 1, in A103: *an Introduction to the Humanities*, 1998.

'Picturing the Genders' (with Trish Evans), TV 24, in A103: *an Introduction to the Humanities*, 1998.

'Rothko at the Tate Gallery', TV 30, in A103: *an Introduction to the Humanities*, 1998.

'Art in France 1954-1974' (course unit) , in AA304 *Liberation and Reconstruction in France and Italy, 1943-1974*, 2000.

'Daniel Buren' (TV script and presentation), in AA304, 2000.

'Abstract art: reading Barnett Newman's Eve' (co-published course text), in AA318 *Art of the Twentieth Century*, 2003.

'Bonnard and Matisse: Expression and Emotion' (co-published course text), in AA318, 2004.

'Jackson Pollock and the Status of Easel Painting' (co-published course text), in AA318, 2004.

'Conceptual Art, the Aesthetic and the End(s) of Painting' (co-published course text), in AA318, 2004.

'The Printed Picture in Renaissance Europe', (co-published course text) in AA315 Renaissance Art, 2007.

'Cézanne', in AA100: The Arts Past and Present, 2008.

'Painting the Seaside', in AA100: The Arts Past and Present, 2008.

PUBLIC LECTURES, INVITED CONFERENCE
PAPERS ETC.

'English Sculpture in the Sixties' (2 lectures),
School of Visual Arts, New York, 1969.

'Current Art and its Presentation', Newcastle-
upon-Tyne Polytechnic, 1969.

'Ben Nicholson', University of Manchester, 1970.

'Virgin Soils and Old Land' (2 lectures on
English Art of the Sixties), Centre for Art and
Communication, Buenos Aires, 1971.

'The Idealism of Abstract Art', University of East
Anglia, 1975.

'Art and Information Structure', Institute of
Technical Illustrators and Communicators,
London, 1976.

'The Legacies of Jackson Pollock', Courtauld
Institute of Art, London University.

'Jackson Pollock', Southampton University, 1979.

'Revolutionary Art' in England in the 1930s',
Research Seminar of the Faculty of Arts, The
Open University, 1980.

'Art History, Art Criticism and Explanation',
opening paper, Association of Art Historians
Conference, London, 1981.

'The Artist's Studio', University of Geneva, 1981.

'A Portrait of V.I. Lenin in the Style of Jackson
Pollock', Oxford University and Tate Gallery, 1982.

'Wyndham Lewis and Nietzsche', Wyndham
Lewis Symposium, Tate Gallery, 1982.

'Art and its Languages: the last twenty years', the
Durning-Lawrence Lecture Series for 1982–83,
University College London, 1982.

'Picasso's Graphics', Bristol City Museum and Art
Gallery, 1982.

'The Artist's Studio as a Modern Theme', Warburg
Institute, London University, 1983.

'Explanation in Art History', Interfaculty Research
Seminar, The Open University, 1983.

'American Modernism and English Art', Scottish
National Gallery of Modern Art, Edinburgh, 1983.

'Modernism, Class and Representation', Fine
Art Students Graduate Association, Harvard
University, and City University of New York
Graduate Center, 1983.

'The Newness of the New Art', Institute of
Contemporary Arts, Boston, 1983.

'Quality, Knowledge and Truth', Art History
Research Seminar, The Open University, 1984.

'Is there a Case for "Quality"?', Leeds University,
1985.

'Modernism and the Monument', Imperial War
Museum, London, 1985.

'The Politics of Quality', Birmingham University
and Ikon Gallery, Birmingham, 1985.

'The End of "Post-War Funk"?', 'New Thoughts on
Art and Criticism' series, Tate Gallery, 1986.

'Art and Language: the Contest for the Modern',
xxvith International Congress of the History of
Art, Washington, DC, 1986.

'Sculpture's Recent Past', Fruitmarket Gallery,
Edinburgh, 1986.

'Why Art and Language?', Tate Gallery, 1986.

'David Smith's Legacies', Whitechapel Art Gallery,
1986.

'L'Atélier des Artistes; transformation du
Répertoire', 'Art de Voir, Art de Decrire' series,
Centre Georges Pompidou, Paris, 1987.

'Painting St Ives', Kettle's Yard Gallery, Cambridge
University, 1987.

'The Politics of Modernism', the Herbert Art Gallery and Lanchester Polytechnic, Coventry, 1987.

'On the Surface of Painting', 'Visions and Revisions' conference, Mid-America College Art Association, Minneapolis, 1987.

'English Sculpture and American Criticism', University of Michigan, Ann Arbor, 1987.

'The Moment of Conceptual Art', Tate Gallery, London, 1988.

'Art & Language: Incidents in a Museum', Kent State University, Ohio, 1988.

'On Pictures and Paintings', University of Michigan, Ann Arbor, 1988.

'England's Climate', opening paper to Symposium 'Towards a Modern Art World: Art in Britain c.1715–c.1880', Paul Mellon Centre, Tate Gallery and Courtauld Institute, December 1989.

'Objecthood and After', 'The Objects of Sculpture' series, Leeds University and the Henry Moore Foundation, February 1990.

'The Unconscious as Image and as Text', Institute of Psychoanalysis, Tate Gallery, June 1990.

'Form and Finish in Modern Painting', international conference on 'Form', Slovenian Society for Aesthetics, Ljubljana, October 1990.

'Essays on Art & Language' (public discussion with Thomas Crow), Institute of Contemporary Arts, London, March 1991.

'On Painting a Landscape', Art History Graduates Association, University of Chicago, May 1991.

'Some Trouble with Theory', Theory Workshop of the Department of Art, University of Chicago, May 1991.

'Anthony Caro: 1967', The Tate Gallery, November 1991.

'The Critic's Part', Symposium 'On Writing about Art', Stedlijk van Abbemuseum, Eindhoven, Holland, November 1991.

'The Critic's Object', CREA Studium Generale en Kunstbeoefening, University of Amsterdam, December 1991.

'The Legacy of Conceptual Art', Symposium

'Place, Position, Presentation, Public', Jan van Eyck Akademie, Maastricht, April 1992.

'Art & Language: the Legacy of Conceptual Art', Kunst Akademie, Vienna, June 1992.

'Disorder and Insensitivity (the concept of experience in Abstract Expressionist painting)', Conference, 'Abstract Expressionism in Liverpool Now', Tate Gallery, Liverpool, October 1992 .

'On the Idea of a Committed Art', Spacex Conference, Exeter, February 1993.

'Raiding the Icebox', Institute of Contemporary Arts, London (discussion with P. Wollen, C. McCabe, S. Hall), April 1993.

'Art & Language; Peinture d'un Paysage', Musée du Jeu de Paume, Paris, November 1993.

'Ben Nicholson and the Decline of Cubism', Tate Gallery, December 1993, and 'Cold War Culture' conference, University College London, October 1994.

'On Painting and the Death of the Spectator', 'Art & Language and Niklaus Luhmann' symposium, Institut fur Gegenwartsfragen, Freiburg and Kunstraum, Vienna, January 1995.

'Mark Rothko: painting the unseeable', public lecture, Smart Museum and Department of Art History, University of Chicago, March 1996.

'The Simply Spectacular: New Art from Britain', public lecture, The Museum of Modern Art, Chicago and the Chicago Arts Club, March 1996.

'Cézanne: Fantasy and Imagination', invited paper to international conference on 'Cézanne and the Aesthetic', Tate and National Galleries, London, March 1996.

'1967', lecture, Stanford University in England, London, April 1996.

'Degas' Bathers and Other People: 1', lecture, National Gallery, London, June 1996.

'Degas: picturing the unseeable', invited lecture, National Gallery, London, June 1996.

'Looking out/Looking in: Rothko, Degas and Art & Language', lecture to Faculty and graduates, Department of Art, University of Texas at Austin, April 1997; and Department of Art History, University of Warwick, February 1998.

'Writing a New Art History', and 'Why I write as I do', lectures plus seminars, Department of Art, University of Washington at Seattle, April 1997.

'Conceptual Art and the Problem of Display', lecture and organisation of three-day workshop on Conceptual Art, World of Arts Programme, Skuc Gallery, Ljubljana, May 1997.

'Leaving go and going on', opening plenary paper to the conference 'Rethinking Englishness: English Art 1880–1940', University of York, July 1997.

'If Quality were King', inaugural lecture, The Open University, November 1997.

'Art & Language', lecture, Ruskin College, Oxford University, February 1998.

'Roger Hilton: truth to what?', lecture, Tate Gallery St Ives, April 1998.

'Degas' Bathers and Other People: 2', lecture in the series 'Impressionism Re-viewed', University of Bristol, October 1998.

'Painting, Detail and Nature', invited paper to conference of the Institute of British Geographers, Leicester, January 1999.

'The Power of Modernism', invited paper to conference on 'Art and Ideology: the 1950s in a Divided Europe', University of Zagreb, February 1999.

'The Merits of Incompetence', lecture in the series 'Theory, Geopolitics and Art', World of Art Program, Open Society Institute, Slovenia; Skuc Gallery, Ljubljana and Likovni Salon, Celje, February 1999.

'The Trouble with Writing', invited plenary lecture to 'Writing and Art' conference, KRTU, Department of Culture of Catalonia, Barcelona, March 1999.

'On a Picture Painted by Actors', invited paper, conference on 'Discursive Practices and Representation', Antoni Tàpies Foundation, Barcelona, May 1999 .

'On Research in Art and Art History', invited paper to conference on 'Research and the Artist', The Laboratory, Ruskin School of Drawing and Fine Art, Oxford, May 1999.

'Why Books, why then?', invited paper to Artists' Book Fair, Barbican Gallery, London, November 1999.

'Painting the Difference: the representation of Gender in Modernist Painting', University College Cork, March 2000.

'The Power of Modernism; American Painting and the Cold War', University College Cork, March 2000.

'On a Picture Painted by Actors: 2', invited paper, 'Art & Language and Luhmann No 2', Symposium, Zentrum für Kunst und Medientechnologie, Karlsruhe, April 2000.

'Indexing then and now' (with Michael Baldwin and Mel Ramsden, as Art & Language), invited paper, 'Art & Language and Luhmann No 2', Symposium, Zentrum für Kunst und Medientechnologie, Karlsruhe, April 2000.

'Feeling the Earth Move', workshop and conference on *Art History* and Criticism, Clark Institute, Williamstown, MA, and Getty Research Institute, Los Angeles, October 2001 and February 2002.

'The Sex of Modernism: reviewing the End(s) of Painting', College Art Association Conference, Philadelphia, February 2002.

'Need and Spirit', Rothko Symposium, Los Angeles County Museum of Art, February 2002.

'The Art & Language Seminars', with M. Baldwin and M. Ramsden, Duke University, N. Carolina, March 2002.

'Milton Avery', Arnold Hammer Museum, University of California, Los Angeles, June 2002.

'The Teaching of Conceptual Art', Musée du Louvre, Paris, January 2003.

'Painting Present' (with Michael Baldwin and Mel Ramsden as Art & Language), Tate Modern, March 2003 (script published on Tate website 2004).

'Biographical Knowledge', Getty/Cambridge Institute for Research in the Arts, Social Sciences and Humanities, Cambridge, April 2003.

'What work does the art work do?', with Michael Baldwin and Mel Ramsden (as Art & Language), exhibition by Art & Language and contribution to symposium, London Metropolitan University, May 2003.

'Complexity and Disinterest', invited paper to symposium, 'Art and Learning', Arteleku with the International University of Andalusia, San Sebastian, Spain, November 2003.

'Landscape through the Looking Glass', invited paper to conference, 'Landscape and Modernism: Space and Ideology', Fundação de Serralves, Porto, Portugal, November 2003.

'Theses on Feuerbach', (with Michael Baldwin and Mel Ramsden, as Art & Language) script for 'theory installation', commissioned by the J. Paul Getty Trust and performed by the Jackson Pollock Bar at the Getty Research Institute, Los Angeles, February 2004.

'Painting a Coming Storm', paper to Inter-disciplinary Research Seminar in Philosophy and Theory of the Visual Arts, University of Oxford, April 2004.

'Specialisation, Self-Criticism and the Boundaries of Practice', in the series 'Querdurch', Hochschule für bildende Künste, Hamburg, May 2004. 'Feeling the Earth Move (2)', in conference, 'Drawing Disciplinary Lines?' (keynote address), School of Fine Art, History of Art & Cultural Studies, University of Leeds, May 2004. 'Emergency Conditionals' (with Michael Baldwin and Mel Ramsden as Art & Language), in conference, '*Philosophy and Conceptual Art*', Kings College, University of London, June 2004.

'Pictures and Onlookers,' in conference, 'En Masse: the Crowd and its Subjects' (opening keynote address), Whitechapel Art Gallery, London, February 2005.

'A Place of Work (Conceptual Art as Realist Practice?)', College Art Association Conference, Atlanta, Georgia, February 2005.

'Criticism sans Frontières' (plenary address) and 'Whose Life? What Art?' (panel paper), to conference, 'Globalisation and Representation', University of Brighton, March 2005.

'Now They Are Surrounded' (with Michael Baldwin and Mel Ramsden, as Art & Language), 3-part paper to symposium,

'What Work Does the Art Work Do? II', London Metropolitan University and Guildhall Art Gallery, June 2005.

'Now They Are Surrounded 2' (with Michael Baldwin and Mel Ramsden, as Art & Language), three-part paper to symposium, 'Art & Language and Luhmann III: What Work Does the Art Work Do?', Zentrum für Kunst und Medientechnologie, Karlsruhe, November 2005.

'The Discourse and the Object', paper to conference, 'Art & Language and Luhmann III: What Work Does the Art Work Do?', Zentrum für Kunst und Medientechnologie, Karlsruhe, November 2005.

'Keeping Up', concluding plenary paper to Association of Art Historians Conference, University of Leeds, April 2006.

'Voices Off: Reflections on Conceptual Art' (with Michael Baldwin and Mel Ramsden as Art & Language), 'Modernism and Beyond: Interdisciplinary Seminar in Art Theory and Literary Theory', University of Oxford, May 2006.

'Drawing: Competence and Incompetence', symposium, Drawing Viewpoints, University of Gloucestershire, October 2006.

'Roger Hilton: Art as an Instrument of Truth', Tate St Ives, November 2006.

'Soft Iconoclasm', Clark-Getty workshop on Art History and Anti-Art part 1, Sterling and Francine Clark Art Institute, Williamstown, MA, October 2006.

'Virtual Iconoclasm and Real Expansion', Clark-Getty workshop on Art History and Anti-Art part 2, Getty Research Institute, Los Angeles, February 2007.

'Renoir's Landscapes: Exchanging Views', National Gallery, London, March 2007.

'Ben Nicholson and the Decline of Cubism', invited paper to Nicholson Conference, Courtauld Institute of Art, and panel member for 'Exhibiting Nicholson', London, May 2007.

'From a Dark Space', keynote paper to symposium, 'The Art and Politics of Memory and Identity', University of Brighton, November 2007.

'The Moment of Conceptual Art', Tranzit Art Centre, Prague, December 2007.

'Party Time? Decoration and Abjection – an illustrated lecture', and 'Not Quite the Belacqua Pose: a talk in three voices' (with Baldwin and Ramsden as Art & Language), to international symposium

'Our Literal Speed', Zentrum für Kunst und Medientechnologie, Karlsruhe, February/March 2008.

'Feeling Good: the Aesthetics of Corporate Culture' (with Baldwin and Ramsden as Art & Language), keynote paper to 'Aesthetics and Contemporary Art: an international interdisciplinary conference', Centre for Research in Modern European Philosophy, Middlesex University, with Collaborative Research Centre, 'Aesthetic Experience and the Dissolution of Artistic Limits', Free University, Berlin, March 2008.

'When Attitudes Become Form', in Curating Conceptual Art In the late 1960s, symposium, Kunstakademie, Vienna, 2008.

Annual Exhibitions for the Missenden Festival:

Henry Moore sculpture and drawings, 1963
Ben Nicholson paintings and drawings, 1964

Barbara Hepworth sculpture and drawings, 1965

Op Art, 1966

Modern British Sculpture, 1967

Recent English Paintings, 1968

Ben Nicholson retrospective exhibition, Tate Gallery, 1969

When Attitudes Become Form, Institute of Contemporary Arts, London, 1969

Idea Structures, Camden Arts Centre, London, 1970

Art as Idea, Victoria and Albert Museum Circulation Department, 1970

Art as Idea from England, CAYC Buenos Aires and tour of South America, 1971

The British Avant Garde, New York Cultural Center, 1971

Ben Nicholson; Still Life and Abstraction, Scottish Arts Council touring exhibition, 1985

Alfred Wallis, Christopher Wood, Ben Nicholson, Pier Arts Centre, Stromness, Kettle's Yard Gallery, University of Cambridge, and Scottish Arts Council touring exhibition, 1987.

Index